PHOTOS
THAT CHANGED THE
WORLD

The 20th Century

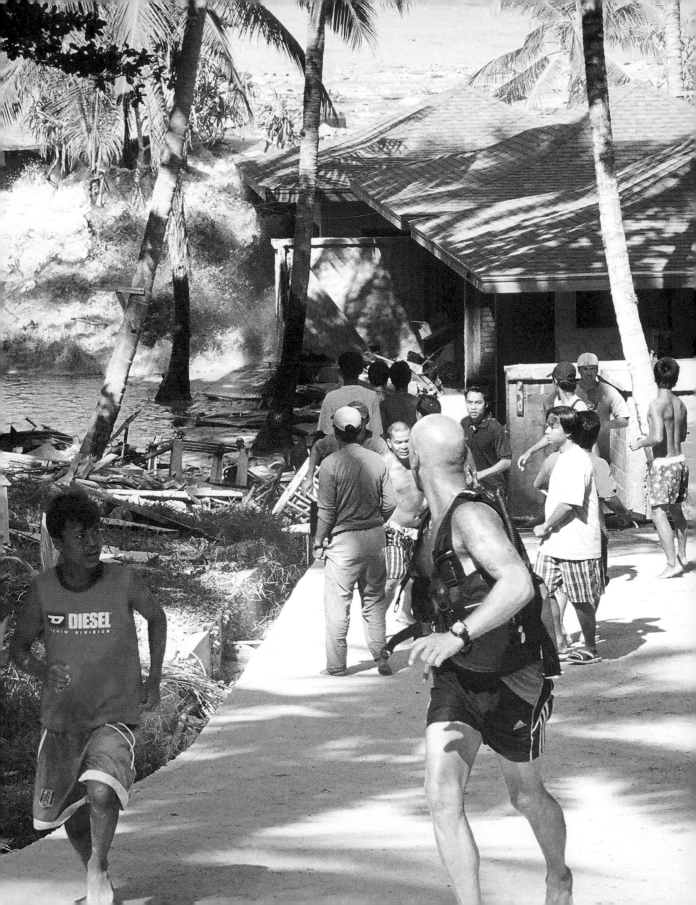

PHOTOS THAT CHANGED THE WORLD

Edited by Peter Stepan

With contributions by Claus Biegert, Eberhard Illner, Jonathan Jones, Lisa Le Feuvre, Barbara L. Michaels, Ingrid L. Severin, Peter Stepan, and Val Williams

Prestel
Munich · London · New York

The date given in the headline accompanying each photograph
refers to the date the photograph was taken. In cases where the identity of the
photographer is unknown or in doubt, no name has been listed.

The Authors
C. B. Claus Biegert
E. I. Eberhard Illner
J. J. Jonathan Jones
L. L. F. Lisa Le Feuvre
B. L. M. Barbara L. Michaels
I. L. S. Ingrid L. Severin
P. S. Peter Stepan
V. W. Val Williams

On the cover: Martin Luther King, "I Have a Dream," 1963 (p. 106);
Associated Press, Frankfurt/Main
Frontispiece: Tsunami in the Indian Ocean, 2004 (p. 188); photograph
by John Russell, Getty Images / Tony Stone

Edited by Meg Taylor, Toronto

Texts by Eberhard Illner, Ingrid Severin, and Peter Stepan (except
pp. 184–190) translated from the German by Elizabeth Schwaiger,
Toronto. Texts by Claus Biegert translated from the German by Craig
Reishus, Munich. Texts on pp. 184–190 translated from the German
by John W. Gabriel, Worpswede

The Library of Congress Cataloguing-in-Publication data is available;
British Library Cataloguing-in-Publication Data: a catalogue record for
this book is available from the British Library; The Deutsche Bibliothek
holds a record of this publication in the Deutsche Nationalbibliografie;
detailed bibliographical data can be found under: http://dnb.ddb.de.

© Prestel Verlag, Munich · London · New York, 2013
First published in hardback in 2000

Photo credits: p. 192

Prestel Verlag, Munich
A member of Verlagsgruppe Random House GmbH

Prestel Verlag
Neumarkter Straße 28, 81673 Munich
Tel. +49 (0)89 4136-0; Fax +49 (0)89 4136-2335
www.prestel.de

14–17 Wells Street, W1T 3PD London, England
Tel. +44 (020) 7323-5004; Fax +44 (020) 7323-0271

900 Broadway, Suite 603, New York, NY 10003
Tel. +1 (212) 995-2720; Fax +1 (212) 995-2733

www.prestel.com

Prestel books are available worldwide. Please contact your nearest bookseller
or one of the above Prestel offices for details concerning your local distributor.

Design and typography by Ulrike Schmidt
Production by René Fink
Cover design by René Fink
Lithography by Reproline Mediateam, Munich
Font: Apollo by Adrian Frutiger (1964)
Printing and binding by Druckerei Uhl, Radolfzell

Verlagsgruppe Random House FSC® N001967
The FSC®-certified paper *Hello Fat Matt* has been
supplied by Deutsche Papier, Germany

ISBN 978-3-7913-3628-2

FOREWORD

There are photographs that we appreciate for their beauty. And there are photographs that shake us, disquiet, and distress us so deeply that they are etched in our memories forever. This book is about those photographs.

Some of the images in this collection not only moved the public at the time of their publication—and continue to have an impact to this day—they set social changes in motion, transforming the way we live and think. The photographic research of Lewis W. Hine delivered dramatic visual proof of the scale of illegal child labour in early-twentieth-century America, and was instrumental in compelling Congress to pass stricter laws. The documentation carried out under the auspices of the Farm Security Administration in the South dragged the desperate poverty into which many had slipped during the Great Depression of the 1930s into the light of day, prompting the U.S. government to offer assistance. Similarly, Robert Capa's photograph of a dying Spanish soldier, photographs of massacres in Vietnam and China, images of starvation in Biafra—to mention but a few—mobilized public opinion. True, some photographs made no such impact, although they may have had the potential. Their appeal went unheard or reached the public too late: photographs of the genocides in Armenia and Tibet are such examples. Perpetrated "on the quiet" in obscure corners of the world, these crimes are in danger of being forgotten. Brazil offers a different kind of example: armed with images of the desperate work conditions of the Minero and the unconscionable treatment of farm workers and indigenous peoples, photographers have for decades waged a war-in-pictures against a system so corrupt that even the most professional investigative journalism seems doomed to failure.

Photos That Changed the World is first and foremost a book about photography, and only secondly a richly illustrated volume on the history of the twentieth century. The photographs themselves are the focus as we note their characteristics and consider their impact, supported by information essential to understanding the historical background. Art history and history are equally present, and complement one another.

A panorama of influential images of the twentieth century would be incomplete if in addition to the great historic events, the tragedies and revolutions, it did not also include images that have inspired and entertained—photos from the great cultural potpourri of the twentieth century, as well as key motifs from science and technology. Such images are like colourful glass beads strewn across a carpet woven in muted tones.

The number of photographs taken by photojournalists over the twentieth century—and most photographs in this volume fall into that category—is simply overwhelming. We have tried to contain the flood of images through a rigorous selection process, opting for a manageable number of carefully annotated works rather than quantity. Some photographs capture key moments and turning points in history and are particularly relevant for certain countries or groups of people, sometimes even for the entire world. We have deliberately looked beyond the borders of Europe and North America. Most of the photographs relate events that represent the culmination of a development or the eruption of social forces. The dockworkers' strike in Gdansk was one such moment. Andrzej Wajda, the renowned Polish director, wrote: "I feel that I am witness to a chapter in our history, a rare occasion. Usually history runs parallel to our own lives, but here you can feel it. Here you see the immediacy of history in the making."[1] Looking at the pictorial documentation of such revolutionary events we often get the impression that we are feeling the pulse of history more intensively than at other times. Many of the images in this selection have become icons of photojournalism, capturing an historical epoch and key events in an unusually intense manner.[2]

Thanks are due to many individuals for their participation in this project, above all to the photographers—those whose names are known and the many anonymous ones. The contributing authors must be thanked for their critical exploration of individual photographs, which often led them to challenge the authority of the visual document.

Peter Stepan

IMAGE AND POWER

by Peter Stepan

History, they say, is written by the victors. The same is true of the images that illustrate history. Nations defeated in the great battles of the centuries were threatened with obscurity unless they could leave visual proof for posterity. A victor was only a true victor once he had proclaimed his superiority for all the world to hear and only if pictures of his triumph were there for all eyes to see. Conversely, there was no greater posthumous infamy for a Roman emperor than the destruction of the marble busts in his image, the erasure of his name from public inscriptions and documents.

The powerful have power over images, too. They decide which images are made and distributed, and which are not. Confiscation and censorship, staging and retouching: anyone who believes that such practices are the exclusive domain of autocratic or dictatorial regimes is badly mistaken. Today it is impossible to wage war unless—long before the go-ahead by parliament—the whole political apparatus of the press has been won over to the operative goal. It all boils down to information and misinformation, the clever dance of the press, timing and knowing just when to launch a text and corresponding image whose effect is as politically targeted and calculated as the range and power of the artillery. This is image propaganda in the information age, standard even in a democracy, and evident most recently in the media manipulation on all sides during both the Gulf War and the Balkan wars. When we think of what is possible even in countries that guarantee freedom of the press, we shudder at the thought of the standard of journalistic ethics in totalitarian systems.[1]

Images have tremendous influence. They are suggestive, and what they show is casually accepted as truth and reality. We frequently challenge the statistics and content of written reports. But photographs enjoy an incredible presumption of veracity, and the belief in their objectivity is difficult to shake. The seeming impartiality of a technically governed piece of machinery, the camera, suggests authenticity. And the mechanisms of this seduction operate with great subtlety.

The Unphotographed Images

Images are a privilege. If you've got them on your side, you have a better chance of things going your way. Among the retinue of lobbyists, the picture makers are always there, ready to deliver the necessary material. But what happens to the less privileged peoples and groups that do not have the benefit of a lobby? Saudi Arabia had the support of allied squadrons in its war against Iraq. Yet which world power stood by the Armenians, who fell victim to Turkish pogroms in the middle of the First World War? Who came to the aid of the Tibetan people when the Chinese invaded in the 1950s, or the people in western New Guinea, whose land was simply annexed by Indonesia in 1969? Who protects the interests of the indigenous peoples of the Amazon today against clear-cutting and mercury contamination by gold prospectors? Who speaks up for North America's native peoples, the misery on their few remaining reservations compounded by the presence of uranium in the soil? Their oil wealth saved the Saudi Arabians, but for the Yanomami in Brazil, the Navajo and Laguna-Pueblo in New Mexico and Arizona, the Cree and Dene in Saskatchewan, and the Ogoni in oil-rich southern Nigeria, the lucrative resources in their land have been a curse. So we must ask: where are the photographs to document these stories? Were any photos ever taken? In the case of Tibet they were few indeed, and even those are rarely published. As for the indigenous peoples, image editors have preferred folklore to the harsh reality of these people's lives. This lack of images is particularly saddening when the "internal affairs" of a state result in the violation of human rights. It is pure chance that we have a snapshot of Salvador Allende stepping in front of the governmental palace one last time during the coup in 1973 (p. 139). What followed was raw right-wing terror which claimed thousands of political victims—a chapter in South American history that was almost never photographed. We are familiar with the Tiananmen massacre in Beijing in June 1989 (p. 163), but Western eyes never witnessed—or no one dared to photograph—what happened simultaneously in other large cities in China, where the people were equally frustrated with the corruption and tyranny of party functionaries and protested fiercely. The chiefs of the Chinese information bureau had been correct in their calculations. Still, the reports from courageous journalists in the capital that did reach us despite a news blackout were sufficiently devastating.

The prisoners of the gulags in the USSR or the labour camps in China were rarely recorded in photographs. The military juntas in Brazil, Argentina, and other South American countries were equally adept at eliminating anyone who stood in their way, without leaving a trace. The Grandmothers of the Plaza de Mayo in Buenos Aires hold up photographs, portraits taken of their relatives before they disappeared (p. 147), but no one

knows what really happened to them; at best there are a few oral histories. What has happened to the Kurds in Turkey, in Iraq, and in Syria over the past decades? Only when a country was defeated through outside intervention or as a result of war, as in the case of Nazi Germany, did photographs play an important role as documentation. In this case, photos were systematically gathered in preparation for the Nuremberg trials to support the prosecution's case against the accused (p. 67). In the case of the Pol Pot regime, following the example of the Nazi terror, many years passed before documentation of the crimes was discovered in archives kept by the camp photographers (p. 141).

Every journalist has a story about the difficulties of filing reports from countries where the press is subject to censorship. How much more dangerous then is the work of photojournalists in totalitarian states, especially when martial law is proclaimed or when war breaks out. Important chapters of the twentieth century must do without pictorial illustration. The photographs are absent not only because it was physically impossible to make them and would have endangered the photographers themselves, but also because they were simply not politically opportune or altogether desirable. In many cases, there was no lobby to catapult the events into the press. And the result? We cannot fully reconstruct the twentieth century by means of archival images alone. To be sure, we have an abundance of images from the "focal points" of the world—that is, those regions declared as such by headline writers and opinion makers—but the closer we get to regions that are socially, geographically, and ethnically "peripheral," the quicker the flood of images dwindles to a trickle or dries up completely.

The information we have about some behind-the-scenes events of the twentieth century is often due to the willingness of actively engaged eyewitnesses to take a risk. One need only think of Ladislav Bielik (p. 121), Nick Ut (p. 134), or Robert Capa (p. 50). Many of the photographers are unknown by name, at times deliberately and for good reasons. The author of the Allende photograph (p. 139), a Chilean, insisted upon negotiating with *The New York Times* under a pseudonym to escape reprisals. As a result, a deeply moving image reached the world and was voted the World Press Photo of 1973. We know the names of some of the figures in the snapshot, but the photographer had to remain anonymous to protect himself.

In addition to courageous individuals, it is important to acknowledge the initiatives of groups who have worked for decades to shed light into murky political zones. Organizations such as Amnesty International (founded in 1961), the Gesellschaft für bedrohte Völker (Association of Endangered Peoples, founded in 1968–70), Human Rights Watch (founded in 1978), and many others have always mistrusted official communiqués, finding their own sources of information in the "grey market" and through internal channels. The bulletins and statements of these organizations are the "black book" of twentieth-century

history, which offers a stark contrast to the official centennial retrospective; unsettling as it may be, it provides a look through rose-coloured glasses by comparison. The environmental organization Greenpeace (founded in 1971) should also be mentioned in this context, whose struggle to contain ecological destruction has often had tangible results. Whenever possible, human rights groups and other activists have tried to unearth photographic documentation to make their case. The Atomic Photographers Guild is an association of photographers who have devoted themselves to documenting the effects of uranium mining and nuclear testing, thereby making the invisible visible. Since the sixties, Yuri Kuidin, a member of the Guild, succeeded in taking photographs in Semipalatinsk in Kazakhstan, a former test site for Soviet nuclear weapons, which shook even our media-hardened eyes: newborns with genetic malformations so severe that they are barely recognizable as human beings. The Soviet Union had set off some 470 atomic bombs in the region for testing.

"Infotainment"

On the one hand, thousands of photos of Princess Diana (p. 151) and film stars whose every appearance and gesture is minutely observed; on the other hand, the great silence and failure of the media in the face of crimes against humanity. Photos are big business. Photos are products. The hunger for images is insatiable and needs to be fed every single day. Dailies and weeklies, high-calibre journals and the tabloids seem to survive on the market only if they engage in a bidding war for visual sensationalism. Today, the word "news" seems to be almost synonymous with "sensation." The concept of "news" contains within it the moment of the new, the until then undiscovered; it makes a direct appeal to human curiosity. *Life* magazine boasts of being present "on the newsfronts of the world." But is this the information we need? News has become fatally entwined with entertainment. The content of a message seems almost secondary. The primary aspect is the news value as such. Accidents and crashes, fires and abductions, intimate details in the lives of celebrities—all guarantee record editions. The most moving images, statistically, are not those of great political events, but the visual "top ten," the optic bytes of a Threepenny World. Yet the latest stories are always the same old ones. The potential of photography to enlighten, something that has only been able to develop with the democratization of information, threatens to go under with the total commercialization of the medium.

These are the conditions for news distribution that determine what our *image* of the world will be. Tailored for sensation, visually effective, easily readable, and colourful: those are the requirements for a commercially viable photograph, one that responds to the demands of "infotainment." The more it conforms to our expectations and clichés about certain countries or

ethnic groups, the better. The photo of a Muslim kneeling in prayer in front of a burning oil well—taken two days after the official end of the Gulf War—comes dangerously close to being staged, so perfect are the convergences of all the ingredients required for a Western media product (p. 169). The image meets all the prerequisites for a good film poster. Complex content, which would require us to linger over an image, would only limit its appeal and consumer-oriented "readability." Mind you, the professional emphasis on the essence of an action, the artistic mastery of photography, are not at issue here.

Newspapers and commercial magazines feed on events. Not a random hodgepodge of incidents, but events that can be divided into bite-sized, easily digestible visual information: fish sticks instead of fish. What good is news that describes a chronic state of catastrophe with which we are already familiar? Thousands of children die of starvation every single day. But these figures no longer shock as much as they once did, victims themselves of a cult of fast-breaking news perpetuated by the press and television. Statistics about the status quo of humankind—and the photographs to match them—are only pulled out for parade on special occasions, a UNESCO anniversary or other such celebrations. At all other times the motto is: horror that has become chronic does not merit an article or a photograph. While "good news is bad news," ever-new locales are vital to meet the requirements of "news." Images of famine, especially, seem to have lost their impact as a result of their mass distribution and repetition over the past decades; people have become visually satiated. The Sudan presents another such example: bankrupted by years of military rule, the country is in the grip of its second long-term war since 1983, a war that had claimed a quarter million victims by the mid-1990s and the same number of refugees.[2] The war isn't over yet, but as far as the Western media are concerned, it might as well be. What interests the media: the world as it is or a stylized version of the world?[3]

There's no doubt that the impact of an individual image is diminished by the deluge of them that washes over us day after day. Regardless of the news medium, its moment in the limelight is brief and even its echo soon fades away. Today, images are easy to ignore because the next one is already clamouring for our attention. Would Hine's photographs of child labourers (p. 17) inspire the kind of political change today that they did in the early twentieth century? Jeffrey Newman, the current chairman of the National Child Labor Committee, is skeptical. Child labour in the Third World certainly seems to call for another such photo-reportage, but contemporary social documentary photographers wouldn't even have to travel that far afield. They could simply look in their own backyard. "Now we need another Hine to denounce the exploitation of children in late-twentieth-century America," says Newman. "How many people are aware that most of the fruit on our tables is gathered in California by unregistered child labour?"[4]

Hine spread his social message by means of lectures, exhibitions, and publishing. He might have met another lecturer of his day, had he been interested in the race to the South Pole: Roald Amundsen embarked on a lecture tour across America soon after his successful expedition, giving some 160 presentations. "I had no peace day or night. Like an old poster I was sent from one place to another . . . I was merely a cog in the great lecture machinery," he wrote. Amundsen wasn't giving his slide presentations merely out of passionate interest; he needed the income they generated, having exhausted his funds.[5] Second only to newspapers, such talks were a popular medium of bringing photographs to the attention of a wider public.

In 1908, competition for photography arrived on the scene at the movies: cinemas showed newsreels with the latest information on politics, culture, and sports, in moving images that were updated once or twice a week; after 1928, the pictures were accompanied by sound. In view of the newspaper boom in the 1920s it is safe to say that far from posing a serious threat to photography, these newsreels served to whet the public's appetite for current news. But the cinemas and newsreels did spell the end for lectures and slide presentations.

After the Second World War, the newsreels themselves were overtaken by yet another invention: television. Queen Elizabeth II's coronation in 1953 was the first in history to be televised internationally. As a medium, television was far more successful as competition for photography (p. 81) and the antagonism between still photography, distributed mostly in print, and moving images in television news continues to this day. During the second half of the twentieth century the journalistic photograph undoubtedly lost some of its uniqueness, but its suggestive power remains undiminished. Photography has been forced to rediscover its unique strengths. Among these is the fact that a photograph can zero in on *the* moment that is the culmination of a sequence of actions. The best photographs are those that hit the mark perfectly.

The Aesthetics of Horror

Let's not fool ourselves: many famous photographs from the arenas of war or disaster are also "beautiful," be it Verdun (p. 31), Lakehurst (p. 54), Korea (p. 77), or Tiananmen (p. 163). These examples are successful attempts at drawing a picturesque element out of the horror. From a plethora of photographs, these are the ones that have come to epitomize the events over time. At Lakehurst, there were thirty-six dead in the crash of the *Hindenburg*, but they were never photographed. From Tiananmen, there are photographs of protesters crushed by tanks, but those images tend to be found only in scholarly publications and research archives. My Lai is closely associated with the image of a screaming woman, but one would have to search far and wide

for photographs of the massacred villagers lying in their own blood.

Commonly held ideas about what is acceptable to the public—what constitutes good taste—have led to a kind of "aesthetic" censorship. Concerns about human dignity and the associated reluctance to photograph corpses may also have played a role, as has the Western habit of repressing anything that has to do with death. Thus the key photograph of the *Hindenburg* disaster shows impressive fireworks, and the Tiananmen massacre looks like a military-civic parade. The stageworthy assembly of Ku Klux Klan members in Wrightsville (p. 72) makes us shudder, although the photo gives us no clue that this is a criminal organization. Dorothea Lange's photograph from her ambitious campaign to document the misery of farmworkers in the southern states bears the mark of a Madonna image (p. 49). And even Robert Capa's *Death of a Spanish Militiaman* shows not a trace of blood. We've already mentioned our misgivings about the image that has come to symbolize the Gulf War. All these examples demonstrate that the visual reception of events is subject to an aestheticism, which can in part be attributed to the history of how photographs have been used. On the other end of the spectrum are relatively unvarnished images of historic events: the Armenian massacre (p. 28), Pearl Harbor (p. 54), the Crimean War (p. 57), the Warsaw Ghetto (p. 59), the Vietnam War (pp. 115, 134) and Rwanda (p. 173).

Luck, Staging, Manipulation

To be in the right place at the right time is the dream of every photojournalist. Sometimes there are signs that things are about to happen: demonstrations, for example, whose explosive character is evident, even before they begin. But "reading the signs" is not enough. Often it's a matter of pure chance whether someone is there with a camera, ready to release the shutter at just the right moment: Algiers (p. 95), Bratislava (p. 121), Paris (p. 117), Gdansk (p. 148), West Bank (p. 159), Beijing (p. 162). Moreover, developments in wartime are notoriously difficult to assess. Drastically restricted freedom of movement is perhaps the greatest obstacle for war correspondents. Taking a "good" picture under such conditions requires an enormous amount of patience and even more luck than usual, in addition to sound military experience and a great deal of talent. Among photographers, war correspondents are a species apart, and Robert Capa stands out as a remarkable figure among them. It has been said that he had more war experience than many a five-star general. The oft-quoted photograph from the Spanish Civil War is the incunabulum of twentieth-century war photography, establishing the maxim—"get as close as you can"—for all subsequent war photographers. But as Gisèle Freud has pointed out, Capa's advice would prove fatal for many a dedicated correspondent and indeed for Capa himself, whose life ended tragically when he stepped on a mine in his attempt to get "as close as possible" in Thai-Binh, Vietnam.

In the nineteenth century, when photography was still burdened with an excess of equipment in the days before the portable camera, photo-reportage was a cumbersome affair, a profession in its infancy. Still, some of the most famous early exponents of war photography date from that period. Roger Fenton was the first to create a visual record of war in the Crimea, where British, Turkish, and French soldiers fought against Tsarist troops from 1854 to 1855. With the technology at his disposal, Fenton—who travelled around in what he called his "photographic van"—couldn't take battle pictures. Instead, his photographs focus on portraits of generals, marshals, and other high-ranking military officials, on camp life and topography—all subjects at rest. Common soldiers are only seen in formation or as aides-de-camp; a scene with a wounded soldier becomes an unintentional allegory of compassion. This was an era when commanders still dined in style and drank champagne when the manoeuvres of the day were over. Battle scenes could be photographed only much later, during the course of the First World War. Lighter cameras, faster and more manageable "roll films," and faster shutter speeds made this possible. Alexander Gardner's and Timothy O'Sullivan's photographs of the dead on the battlefields of Antietam (1862) and Gettysburg (1863) impress with their high degree of realism. Soon after, they were shown at an exhibition in New York, where they confronted visitors with the gruesome reality of the Civil War. Photographs taken during the Paris Commune (1870–71) focussed on scenes during breaks between battles or once the fighting was over. In addition to group portraits of the fighters at the barricades, the photographs recorded many views of destroyed buildings and portraits of victims, both revolutionaries and government troops.[6]

In the twentieth century it became possible to photograph scenes of uprisings and demonstrations more directly and spontaneously; the examples collected in this volume are among the most outstanding works in the history of photojournalism. Rebellions were often followed by far-reaching changes in the political landscape, overthrowing governments or entire political systems. To the new leaders some visual record of their own beginnings was indispensable for their identity and self-image. As the former rebels became the new masters, they sought to bolster their claim to leadership, no matter how corrupt, by creating a "historic" frame around the heroic dawn of the party in an attempt at legitimization. If authentic visual records were available, all the better, and if not, one would simply commission some.

The storming of the Winter Palace in St. Petersburg is the perfect example of such artificial historicizing (p. 33). It is a well-known fact that capturing the seat of the Russian government was a fairly unexciting nocturnal exercise. There are no

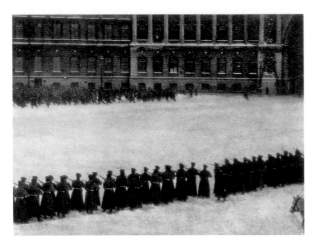

Suppression of a peaceful demonstration in front of the Winter Palace,
St. Petersburg, on January 9, 1905, known as Bloody Sunday.
Film still from *Ninth of January* by Vyacheslav Visorsky, 1925.

authentic visual records. To preserve the memory of this historic event—set off by the legendary cannon shot from the battleship *Aurora*—theatrical re-enactments were staged annually in the streets, and stills from the performance were made. The matching "photo document" is correspondingly theatrical. Although it was recast after the fact, the image is lodged so firmly in the collective memory of the twentieth century that it is widely accepted as the key image of the October Revolution. Even established stock houses sell it to this day as a photograph from 1917. Images from Bloody Sunday, January 9, 1905—when protesters marching peacefully to deliver a petition to Tsar Nicholas II were brutally mowed down in a hail of bullets—were also reconstructed. To create a visual record of this key pre-October Revolution event, Soviet "historians" used a still from Vyacheslav Viskorsky's 1925 film *Ninth of January* (*Deryatoye Yanvarya*).

On the other side of the Great Wall of China, the need for history was just as great after the revolution, during the early years of the new regime. To enhance the legend of the Long March (1934–36) with visual "proof," Mao Zedong, then ten years older, sat on a white horse and was surrounded by extras for a crowd effect. According to Harrison E. Salisbury, an expert on the Long March, no original photographs exist, only drawings.[7] The white horse seen in the staged photograph was later stuffed and is still on exhibit in a museum. Whether the person who created this *mise en scène* was conscious of "staging truth" is of no matter. The relationship between truth and tale in the Middle Kingdom is something very different than that in the rationally thinking West or in the "New World." Perhaps it was merely an attempt to create interesting visual material for the massive Peo-

ple's Education campaign, which the Communist Party was undertaking at the time.

Staged photographs, posed photographs, and retouched photographs: the lines between such definitions are blurred and often difficult to decipher. The photograph of Tibetan prisoners lined up for deportation (p. 87) is most likely posed. The Chinese would have had no trouble in rounding up survivors of the Lhasa massacre to create the scene. One of the most famous retouched photographs is that of Lenin's speech with Leon Trotsky standing beside the podium (p. 37). When Stalin decided to liquidate Trotsky—after having expelled him from the party in 1927—the former leader was quickly erased from the photograph and the blank space filled in with steps. By now, examples of Stalin's handiwork fills a whole book: "Just like their colleagues in Hollywood, the Soviet retouchers spent many hours 'improving' upon faces that were less than perfect and falsifying reality. Especially Stalin's pockmarked face required a high degree of retouching skill. But when he began to 'purge' the country in the late 1930s, a new kind of retouching occurred. After Stalin's henchmen had physically eliminated his political adversaries, [the retouchers] removed them from all visual records."[8]

Totalitarian governments have always been especially aware of the "power of the image," but photo manipulation is by no means restricted to such regimes. With software programs such as Photoshop, it has become quite common. The thin layer between fiction and non-fiction is porous and too easily overlooked. In an era besieged by mass media and cyberspace and consequently suffering from a latent loss of reality, the question about the authenticity of images has taken on new importance as the ethics of reportage and the reputation of the profession itself are at stake. How pressing and topical such questions are is confirmed by a April 1996 manifesto circulated by top newspaper and magazine professionals in Spain: "We want images that are new and imaginative, with virtuality not compromising the permanence of those that arise from reality, because by defending quality and credibility we are also defending the feasibility of the Press as a product. We believe in truth as the leading principle of our activity as journalists and therefore we consider that it is not correct to alter the content of a news image in a way that it might mislead the public or distort its author's intention." The copyright holder's claim is at stake.

History

History is a social construct of the past to which photography also makes a contribution. Our image of the twentieth century is often influenced by what journalists have captured on film. This applies equally to photojournalists, war correspondents, society photographers, and paparazzi, not to mention amateur photogra-

phers. But our image of the century is equally informed by that which has *not* been captured on film. Vast areas of the globe are a no man's land in photographic terms. Even in the case of important events in those areas, there's no guarantee that someone was ready with a camera. Moreover, many visual records have simply disappeared: chance plays a role in whether a photograph is preserved for posterity. It seems almost a miracle that the photograph of Scott and his team in front of Amundsen's tent at the South Pole has survived (p. 24). No such luck existed in the case of the sinking of the *Titanic*, where no camera was there to record the disaster. When editorial departments at newspapers around the world realized that no photographs existed, the disaster had to be reconstructed in drawings that gave the impression of news photography.

Just as visual records can elucidate, educate, and enrich our view of history, so they can become a curse when they misrepresent facts or fail to show events in their totality. Another danger lies in the fact that our "image" of an event is often entirely informed by a single photograph. Photos alone cannot give us the full picture; we need additional information to expand our knowledge. In his overview of the archival documentation of the pro-democracy movement in China, Richard Baum has addressed the same problem: "While the historical memory of the 'Beijing Spring' of 1989 has inevitably begun to fade with the passage of time, a few highly evocative, stereotyped images continue to provide a potent, if shadowy, reminder of what transpired. The solitary figure of a young Chinese civilian, captured on film calmly facing down a column of tanks, resonates powerfully today in annual U.S. congressional debates on the renewal of China's most favored nation status, in widening U.S. support for Tibetan independance, and in the appearance of an entirely new epithet in the English lexicon: 'The Butchers of Beijing.'"[9] Baum contends that the video still (p. 163) contributes to an inaccurate representation of the facts of the massacre in Beijing because, contrary to common belief, the victims were in the main average Chinese citizens and only relatively few students, and the worst carnage did not occur in Tiananmen Square but on Changan Boulevard to the west of the square.

Faced with the risk that events of this magnitude might be forgotten, we may have to resign ourselves to such inaccuracies, trusting that the potential for enlightenment is one of the enduring achievements of photography. Nevertheless, the problem remains that photographs often contribute to the simplification of an event, or promote prejudice and partial knowledge. Perhaps we should approach the "reading" of photographs in the manner recommended for reading biblical texts: that is, with the awareness that our understanding has been corrupted by religious artists over the centuries.

The Image in the Witness Box

We face a dilemma in working with the products of photojournalism. Photographs of high artistic quality are invariably appropriated by art history, the "science" of aesthetics. (Although—at least in Europe—art historians who make photography the topic of their study have often been relegated to the sidelines of their profession.) The visual products of pure reportage, those that document historic or political events, are considered the domain of historians. These professionals, in turn, are less experienced in reading an image, and while they are fully capable of providing the corresponding historic facts, aesthetic analysis and interpretation are another matter. Ideally, the interpretation of visual records should be a matter of both historic and art historic study: a challenge to establish a level of interdisciplinary co-operation that does not yet exist.

Art historians have been only too happy to study icons of photo-reportage: images such as *Migrant Mother* by Dorothea Lange, Robert Capa's *Death of a Spanish Militiaman,* or Joe Rosenthal's *Raising the Flag on Iwo Jima.* But history is not made up of "Sundays" alone. How do we approach everyday images from the arenas of politics and war: trench warfare at Verdun, independence celebrations in Africa, rebellions from Leipzig to East Timor, or daily life for blacks in South Africa? Many of these images are snapshots taken by photographers whose names are either not known or not yet researched, from areas of the world that the Eurocentric tradition of art history (or, to be more precise, its obsession with Italy) has trouble relating to.

Historians are always ready to use photographs to *illustrate* historic events. They interpet them with the help of text sources, using them as secondary sources, if at all. Photos are considered supplementary information to the "hard facts," and are seldom interpreted as primary sources. When we take a closer look—as this book literally invites us to do—we find that

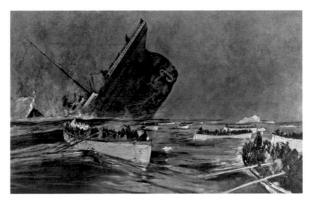

Sinking of the *Titanic*, 1912, gouache.

photos occupy a unique position vis-à-vis historic "fact." Rarely can they claim to be simply a mirror of events. Like eyewitness reports, images deliver an interpretation of an event from a specific perspective: subjective, sometimes partisan, sometimes manipulative. Anyone who believes that a photograph captures "reality" is naive. Why a picture was taken, who distributed it, what their intention was—these questions must be asked again and again. Photographs can speak to us only after we have mistrusted and challenged them.

Foreword

1 Ulrich Zuper, ed., *Wir bauen ihnen ein Denkmal: Dokumente, Materialien, Tonbandprotokolle. Lenin-Werft* (We are building a monument: Documents, materials, transcripts, from the Lenin Shipyards) (Stuttgart, 1982).

2 The accent was placed on photojournalistic work. But all areas of photography, traditional and modern, have produced deeply moving and consciousness-raising images. This applies equally to portrait, landscape, commercial, and industrial photography as to nature, underwater, and aerial photography, and to scientific, microscopic, X-ray, medical, and astrophotography.

"Photographs change nothing but spread their influence everywhere," Vicki Goldberg noted in her seminal work *The Power of Photography: How Photographs Changed Our Lives* (New York, 1991). She goes on to list the areas she studied to determine the impact of individual photographs: "The photographs have been divided into categories corresponding to the kinds of influence they exerted—revelation, proof, political persuasion, social reform... It may be that the influence of images cannot be proved to a scientist's satisfaction, yet we always seem to be living with the results...," p. 16*ff*.

Image and Power

1 Paul Watson, *Los Angeles Times* correspondent during the NATO attacks on Kosovo, is one of the most convincing critics of the allied information policy. His commentaries give a more complex view of many events, which the television stations treated with unfailing one-sidedness. As an eyewitness to ethnic cleansing and supposed liquidations, he rejects any hasty judgment and assessment as improper from a journalistic point of view. *Kosovo: The War and the Media*, a documentary film by Claude Vajda and Béatrice Pignède, France 2000. On the subject of manipulated media representation during the Gulf War, see Vicki Goldberg's *The Power of Photography: How Photographs Changed Our Lives* (New York, 1991), pp. 257*ff*.

2 UNDP, *Bericht über die menschliche Entwicklung 1994* (Bonn, 1994), p. 51, quoted from Walter Michler, *Afrika: Wege in die Zukunft* (Unkel/Rhein, 1995), p. 45.

3 In this context, Michler makes a remarkable proposal: "There is a lack of preventative new reporting about catastrophes and erroneous developments in the making. This kind of preventative information could ensure, in the case of conflicts, that attempts at negotiations are begun in time." Ibid., p. 42.

4 Marie-Monique Robin, *Cent photos du siècle* (Paris, 1999), no. 4.

5 Roland Huntford, ed., *Die Amundsen-Photographien: Expeditionen ins ewige Eis* (Braunschweig, 1998), p. 9.

6 *Roger Fenton: Photographer of the Crimean War* (London, 1954); Musée d'Orsay, *La Commune photographiée* (Paris, 2000).

7 There is only one photograph from 1936 with General Zhu De and Zhou Enlai. I am grateful to Eberhard Illner, Cologne, for his insight on the Long March.

8 David King, *The Commissar Vanishes: The Falsification of Photographs and Art in Stalin's Russia* (New York, 1997); see also *Bilder, die lügen*, published by Haus der Geschichte der Bundesrepublik Deutschland (Bonn, 1998).

9 Jian Ding, Elaine Yeeman Chan, and Leslie Evans, *The China Democracy Movement and Tiananmen Incident: Annotated Catalog of the UCLA Archives, 1989–1993* (Los Angeles, 1999).

THE PHOTOGRAPHS

San Francisco Earthquake 14

Child Labour in the United States 16

The Wright Brothers' Airplane 18

Discovery of Machu Picchu 20

Scott's Expedition Sights Amundsen's Tent 22

Mexican Revolution 25

Arrest of Archduke Ferdinand's Assassin 26

Armenian Genocide 29

The Siege of Verdun 30

Storming of the Winter Palace 32

Signing of the Treaty of Versailles 34

Lenin's Call to Arms 37

Opening Tutankhamun's Coffin 38

Lindbergh Lands in Paris 40

The Crash 42

Prohibition in the United States 44

Reichstag Fire 46

Migrant Mother 48

Death of a Spanish Militiaman 51

The *Hindenburg* Disaster 53

Bombing of Pearl Harbor 55

Searching for Dead Relatives 56

Deportation from the Warsaw Ghetto 58

Normandy Landings 60

Dresden Destroyed 62

Raising the Flag 64

Concentration Camp after Liberation 66

Bombing Hiroshima 68

Gandhi and the Spinning Wheel 70

The Burning Cross 73

Portrait of Einstein 74

Korean War 76

The Ascent of Everest 78

Coronation of Elizabeth II 80

Marilyn Monroe 82

Hungarian Uprising 84

Deportation of Tibetan Prisoners 86

Elvis Presley 88

Che Guevara 90

Celebrating Independence 92

Demands for Independence 94

Gagarin, First Man in Space 96

Escape to the West 98

Boy with Toy Hand Grenade 100

Cuban Missile Crisis 102

The Beatles 104

I Have a Dream 106

Assassination of John F. Kennedy 108

Muhammad Ali Knocks Out Sonny Liston 110

Louis Armstrong in Performance 112

Execution in Saigon 114

Student Uprising in Paris 116

War and Famine in Biafra 119

The End of the Prague Spring 120

Rescuing the Abu Simbel Temple Complex 122

First Man on the Moon 124

Woodstock 126

Tragedy at Kent State 128

Pelé Leads Brazil to Win the World Cup 130

Willy Brandt at the Warsaw Ghetto Memorial 132

Napalm Attack 135

Wounded Knee Takeover 136

Military Coup Against Salvador Allende 138

Portraits of the Condemned 140

Soweto Uprising 142

Camp David 144

Mothers and Grandmothers of the Plaza de Mayo 146

Strike at the Lenin Shipyards 149

The Royal Wedding 150

Destruction of the Yanomami Territory 152

Nuclear Disaster in Chernobyl 154

Workers in a Serra Pelada Gold Mine 156

The Intifada 158

Exxon Valdez Oil Spill 160

Massacre in Beijing 162

Fall of the Berlin Wall 164

Nelson Mandela's Release from Prison 166

The Gulf War 168

Albanian Refugees 171

Tutsi Genocide 172

Greenpeace Confronts Shell Oil 174

Muslim Expulsion 176

Mourning Yitzhak Rabin 179

Zapatista Uprising in Chiapas 180

AIDS Memorial Quilt 182

SAN FRANCISCO EARTHQUAKE

April 18, 1906 San Francisco, California

Photographer: Arnold Genthe

On April 18, 1906, at 5:12 a.m., two earthquakes shook northern California between Salinas and Fort Bragg, affecting an area that stretches some 65 kilometres (40 miles) across and 320 kilometres (200 miles) along the San Andreas fault. The first quake lasted for forty seconds and the second for twenty seconds, with a ten-second interval between them, and reached 8.4 on the Richter scale. Aftershocks continued throughout the day. Some 5,000 buildings, especially those built on soft or sandy ground, were destroyed. Roads and streetcar tracks were broken up, rendering them impassable. Subsequent fires caused extensive additional damage.

The photograph captures the drama of the moment: the photographer, Arnold Genthe, has chosen his position carefully, setting up the unwieldy equipment of the day—tripod and glass plates—in an elevated, central position. Together with hundreds of San Franciscans he looks down the hill at the centre of the city. Damaged buildings are clearly visible in the foreground. One facade has collapsed and rubble fills the street. But that's not what everyone is looking at. In fascination, they gaze at the huge columns of fire and smoke—a devastating panorama of destruction. Sporadic, smaller fires, fatally ignored by the authorities at first because no one believed they posed a serious threat, ignited burst gas mains. To make things worse, the wind picked up and soon firestorms were spreading throughout the city.

Only 585 firefighters and a mere fifty fire engines were available to serve the vast area affected by the quake. Desperate attempts by private citizens to put out the fires were doomed because the water mains that led from Crystal Springs Lake and from San Andreas Lake into the city had been broken. There were not enough experienced firefighters who to knew how to dynamite buildings and create firebreaks to stop the fires from spreading. The fires were finally brought under control when the wind changed direction and after the water system had been hastily repaired. The toll after seventy-four hours of raging fires: 450 dead, 28,000 buildings or approximately one-third of San Francisco destroyed, $350 million to $500 million in damage. Chinatown, San Francisco's financial district, was completely destroyed, as was the newly built city hall and its archives, the library, the art collection, and numerous churches and schools. The disaster ruined many businesses and prominent families lost their fortunes virtually overnight. Fire insurance companies chipped in with $229,000 in compensation, but others refused on the grounds that it was an "act of God." Even today, only 5 percent of Californians have earthquake insurance. The San Francisco Earthquake of 1906 remains one of the worst natural disasters in the history of earthquake-prone California.

E.I.

Warren A. Beck and David A. Williams. *California: A History of the Golden State*. Garden City, New York, 1972.

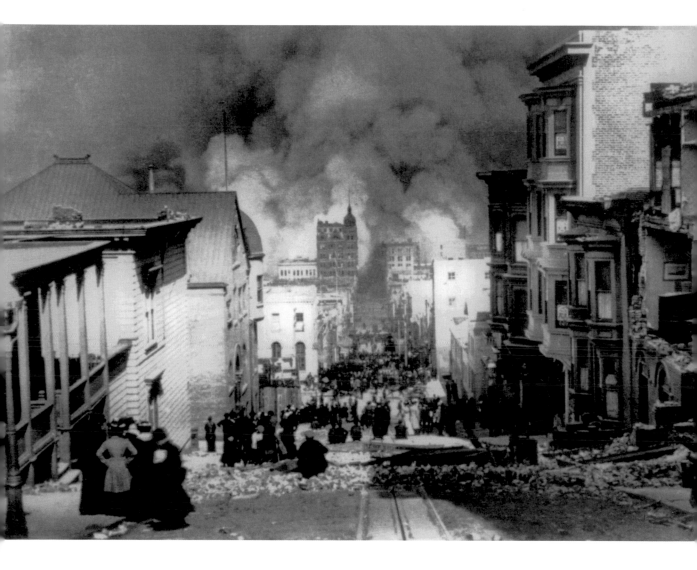

CHILD LABOUR IN THE UNITED STATES

November 30, 1908 Lancaster, South Carolina

Photographer: Lewis W. Hine

"Sadie Pfeifer, 48 inches high. Has worked half a year. One of the many small children at work in Lancaster Cotton Mills. Lancaster, S. C., Nov. 30, 1908." Thus read the brief notes jotted down by Lewis W. Hine, who photographed this girl in a cotton mill in South Carolina. The girl supervised an industrial spindle machine, watching for torn threads and changing spools.

We don't know how old the girl in the picture is, but her height gives us some idea. A twelve-year-old boy, whom Hine encountered in Columbia, South Carolina, had been working in a mill for four years. Of forty workers at a mill in Newton, Massachusetts, ten were still children. In textile mills in Dallas, Texas, and Tifton, Georgia, Hine found twenty or more child labourers, dozens in Lancaster—many clearly less than ten years old. Often barefoot, they worked as weavers, spindle changers, sweepers, or "back-ropers."

But that wasn't all. Things looked much the same in other areas. Hine photographed children in mines, glassworks, and canning factories. Children working as newspaper boys, shoeshine boys, cigar rollers, and . . . beggars. The army of children who worked in cottage industries at home—making doll dresses, lace, artificial flowers, or shelling nuts from dawn 'til dusk—was too large to count. After Jacob Riis, Hine became the pioneer of social documentary photography. His lens recorded the tough everyday life of the children without softening the edge. A far cry from the saccharine idyll of childhood seen in nineteenth-century photography, these images confront us with the underbelly of American prosperity: ragged clothes and large, sad eyes. Free from all sentimentality, his photographs sought to shake the public out of its complacency, to incite the delegates in Washington to toughen up child labour

legislation. Between 1906 and 1918, Hine undertook countless journeys by car and train on behalf of the National Child Labor Committee (NCLC), a humanitarian organization, travelling through the United States and taking some 5,000 photographs, each as good as circumstances would allow and labelled with brief notes for NCLC research: name, age or height, occupation, location, company name, and date. These notes proved that even those laws that did exist to protect children were often grossly ignored. They also demonstrated that new, farther-reaching legislation was required. It would take until 1938, however, before Congress passed the Fair Labor Standards Act, which permitted children fourteen and older to be employed only if such employment took place outside of school hours and not in factories or mines. The need for social reform that was the motivation for Hine's images pushed aesthetics into the background: the photographs aimed to shed light on poverty and maltreatment, America's dark side. Nevertheless, the photographs are clearly the work of great formal talent. In many of the individual or group portraits the psyche of these children is laid bare in a fascinating and often disturbing manner. P.S.

Vicki Goldberg. *Lewis W. Hine: Children at Work*. New York, 1999.

LEWIS W. HINE (1874–1940) was eighteen when his father died in an accident. He found employment in an upholstery factory, where he worked up to thirteen hours six days a week. After moving from job to job, he trained as a teacher and took up photography. Using this medium to educate the public became his central theme. In 1906 he began working for the National Child Labor Committee (NCLC), at first as a freelancer. In 1908 he resigned from teaching and devoted himself full time to photography. As an employee of the NCLC he took countless photographs of child labourers that were published in newspapers and other publications as part of the committee's public education campaign. From 1913–1914 Hine was responsible for the NCLC exhibitions; he also photographed child labourers and gave lectures on the topic. In 1918 he was commissioned by the Red Cross to document the effects of the First World War on civilians in the Balkans. In 1939 a retrospective of his work was exhibited in several U.S. cities.

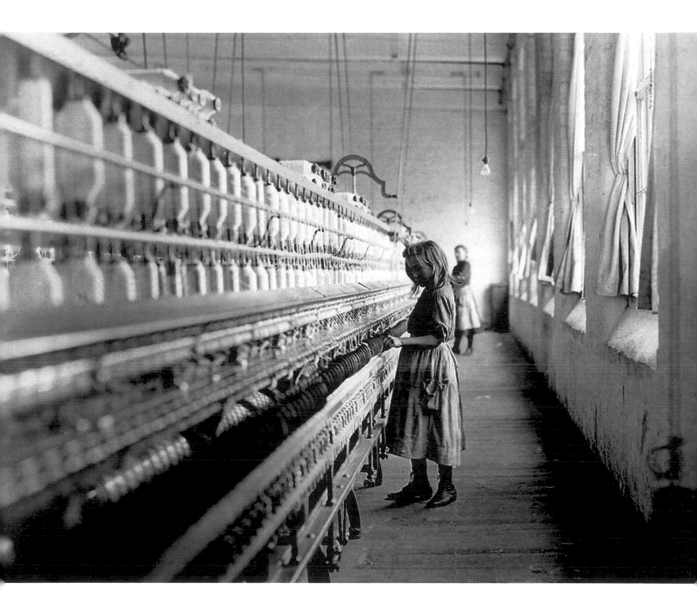

THE WRIGHT BROTHERS' AIRPLANE
August 1909

American pilot and aviation pioneer, Orville Wright, demonstrates his powered two-seater (type A) airplane, with improved engineering to meet military requirements, at the Tempelhof air show in Berlin in August 1909. The event was sponsored by the Scherl Press Agency.

Two photographs shape our image of the pioneers of powered flight: the first is the relatively nondescript shot documenting the first powered flight in the history of mankind on December 17, 1903, by Orville Wright, and the second, again of Orville Wright, captures his exhibition flight in a more advanced model in 1909. The image—shot from below in a carefully planned composition—is the more spectacular of the two: here a large crowd looks on as the plane rises much higher into the air. In contrast to the photograph from 1903—a snapshot taken by John T. Daniels, a coast guard employee, in which the plane glides at low altitude with the pilot in a prone position—the 1909 photograph was taken by a professional press photographer. It was used by the Scherl Press Agency for its sensational coverage of the aviation race that gripped Europe and the United States in the years before the First World War.

The breakthrough in powered flight based on the "heavier-than-air" principle was first achieved by the Wright brothers, Wilbur (1867–1912) and Orville (1871–1948). From Dayton, Ohio, the brothers were sons of a minister and ran a bicycle shop. Their path to success was surprisingly swift and direct; in a way, it was an early example of a typically American style of technical inventiveness. They began by studying the writings of Otto Lilienthal, Louis Pierre Moulliard, Octave Chanute, and Samuel Langley, which they borrowed through the Smithsonian Institution in Washington, D.C. Circa 1900 they undertook a series of experiments for the empirical study of gliding and steering in an engineless glider in the dunes at Kitty Hawk, North Carolina. During this phase they developed new principles of steering and increased the effectiveness of the propeller. Success followed quickly: On December 17, 1903, Orville Wright took off for the first steered powered flight in aviation history at Kitty Hawk. After four attempts at low altitudes he covered a distance of 255 metres (837 feet) in 59 seconds of flight time. The flights were deliberately secretive to avoid the risk of espionage. In 1907 the brothers Wright went to Europe. After exhibition flights at Le Mans and Paris in 1908, during which Wilbur Wright was accompanied by a passenger, Orville Wright arrived in Germany in the summer of 1909. Competition was fierce, for in July of the same year the Frenchman Louis Blériot had succeeded in flying across the Channel. Thus the Tempelhof air strip became another venue for the competition among the early aviation pioneers. E.I.

Peter L. Jakob and Tom D. Crouch. *Visions of a Flying Machine: The Wright Brothers and the Process of Invention*. Washington, D.C., 1997.

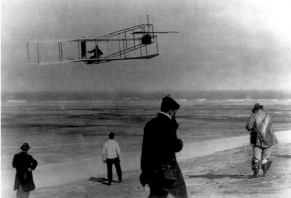

The first powered flight ever, December 17, 1903, steered by Orville Wright in Kitty Hawk, North Carolina. Photograph by John T. Daniels.

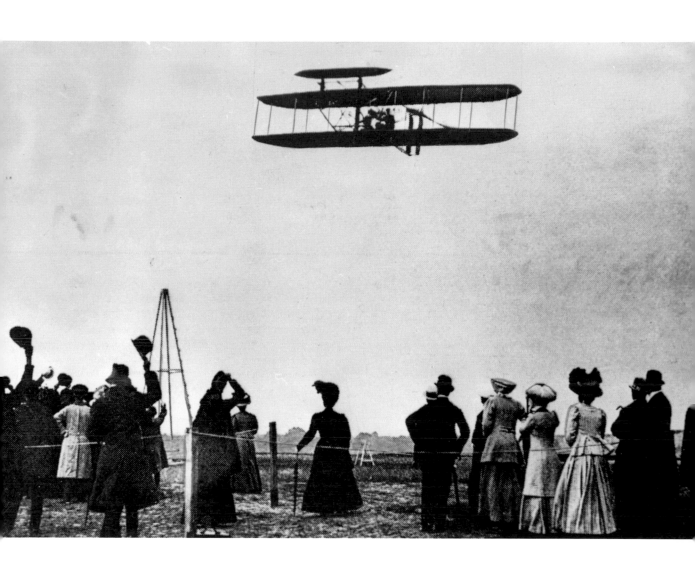

DISCOVERY OF MACHU PICCHU

1911 Urubamba Valley near Cuzco, Peru

Photographer: Martin Chambí (1925)

Despite their frenzied search for gold, the Spanish conquistadors under Pizarro never discovered this jewel on the edge of the Peruvian jungle. Not until the twentieth century did the West learn of the Incan city of Machu Picchu, possibly the first capital of the Incan empire and one of the most important architectural sites of a civilization destroyed by the Europeans.

Bathed in sunlight, it spreads out before our eyes: the acropolis of the Incas. "Tall city made of stony steps . . . High cliff of mankind's beginning. Lost shovel in the first sand" is Pablo Neruda's description of Machu Picchu in a poem dedicated to the city. Like an eagle's nest, it is perched high above two valleys on a narrow mountain ridge, flanked by two mountains, one of which—Huayana Picchu—is visible in the background of this photograph.

Martin Chambí (1891–1973), the great pictorial chronicler of the Altiplano, visited Machu Picchu before a train linked Cuzco and Aguas Calientes, the station later built at the foot of the mountain. He had to follow the rugged mule trail established in 1890 along the Rio Urubamba, weighed down with his heavy photographic equipment. The photograph was taken in 1925, more than a decade after the discovery of the city by Hiram Bingham, after most of the site had been excavated and the full splendour of the ruins was visible. But Chambí wasn't interested in archaeological documentation; instead, he wanted to capture the awe-inspiring landscape that surrounds the ancient city. From an ideal vantage point he waited for optimal light conditions in this region of fog and mist to achieve the marvellous balance of light and shade that characterizes this composition. The photograph harmonizes the richly modulated mountain silhouettes with the geometries of the walls, the opulence of nature with the logistical feats of human builders.

Capital, citadel, trade centre, or pilgrimage site for clerics and 'sun virgins'—the speculations about the original function of Machu Picchu are many. In Quechua, the Incan language, Machu Picchu means ancient mountain peak. The city housed palaces, temples, garrisons, and workshops, as well as terraced fields and irrigation systems for the fields and for bathhouses: a small Flo-rence in the Andes Mountains. The spiritual centre of the city may have been the *Intihuatana* ("the sun anchor"), a partially carved boulder around which the rites in honour of the sun deity Inti, or Inti's spiritual essence Viracocha, may have taken place.

Bingham, a professor of Latin American history at Yale University, reached the mountain on July 24, 1911, shortly after midday after a steep and difficult climb. The ridge was inhabited by Indios who had lived there for many generations. They offered cool water and roasted sweet potatoes to Hiram and his companions. "Leaving the huts, we climbed still farther up the ridge. Around a slight promontory the character of the stone faced *andenes* began to improve, and suddenly we found ourselves in the midst of a jungle-covered maze of small and large walls, the ruins of buildings made of blocks of white granite, most carefully cut and beautifully fitted together without cement. Surprise followed surprise until there came the realization that we were in the midst of as wonderful ruins as any ever found in Peru . . . From some rude scrawls on the stones of a temple we learned that it was visited in 1902 by one Lizarraga, a local muleteer." This was Augustin Lizarraga who had guided the Peruvian scientist and treasure hunter Luis Bejar Ugarte to the ruins as early as 1894. The hospitable Indios lived in dilapidated buildings and cultivated grain and vegetables among the ruins and on some of the terraces. Bingham observed that "a kind of gooseberry" grew wild next to potatoes, corn, sugar cane, beans, tomatoes, and pepper plants. In his search for the last capital of the Incan empire, Bingham may have found "the first capital." But what came as a surprise to Bingham was well known to the Indios. P. S.

Hiram Bingham. "The Discovery of Machu Picchu" in *Harper's* (April 1913).

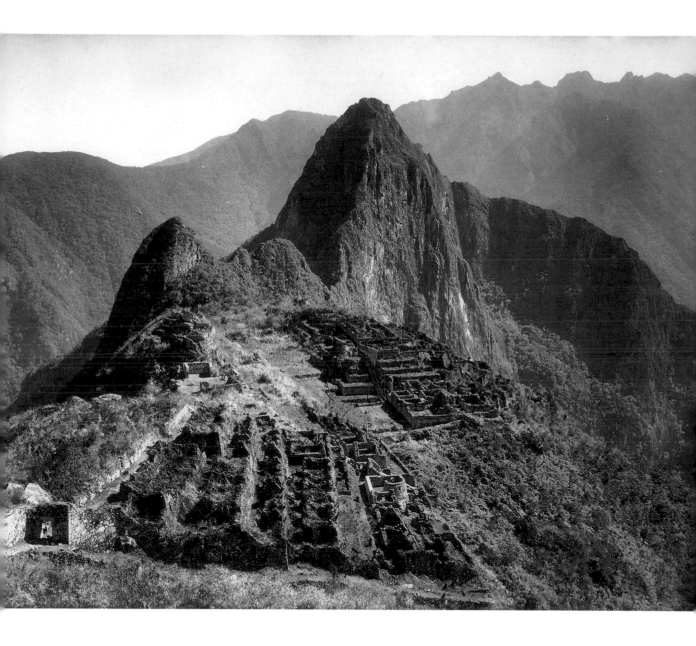

SCOTT'S EXPEDITION SIGHTS AMUNDSEN'S TENT

January 18, 1912 South Pole

Photographer: W.R. Bowers

On reaching the South Pole, the British expedition led by Captain Robert Falcon Scott discovered the tent of Roald Amundsen, their Norwegian competitor in the race to the Pole. Amundsen had reached the South Pole four weeks earlier. The British expedition never made it home alive: they were caught in violent storms and perished in Antarctica.

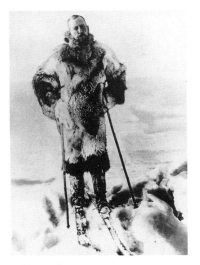

Roald Amundsen.

The news that the British South Pole expedition had perished in the ice of Antarctica reached Britain on February 12, 1913. The *Times* wrote: "One has to go a long way back in the history of British exploring to find any disaster of like magnitude."

This photo, one of the last to record the group around Captain Robert Scott alive, shows the disappointed men at the South Pole in front of the tent, which Roald Amundsen's expedition had left behind after they had reached the Pole on December 14, 1911. It is only after some reflection that this seemingly artless photograph reveals the tragedy behind it, the misery and hardship the British had endured in order to win the honour of deciding the race of nations for the last remaining discovery of the globe in their favour.

Around the turn of the century, the Royal Society, the Royal Geographical Society, and the British navy joined forces to chart Antarctica, the last unexplored continent on earth. Charged with leading the expedition and the scientific exploration was the naval officer Robert Scott. Between January 1902 and February 1904 he

took the research vessel *Discovery* out of McMurdo Sound and in his explorations eventually crossed the 80 degrees south latitude. The sensational success of this first expedition encouraged Scott to seek private financing and modern equipment such as motorized sleds and to prepare the ship *Terra Nova* for a new expedition. He left England in June 1910. Scott set up a base camp at Cape Evans (Ross Island). The sleds soon proved useless. Scott tried to use ponies and sled dogs, but the extreme cold and violent storms on the high plateau and the glaciers with their deep crevasses stressed the animals so much that the British team had to pull the sleds over long stretches themselves. Amundsen, by contrast, had extensive experience with his 120 sled dogs and covered the distance in good weather fairly quickly.

Tragedy struck the completely exhausted British team on their 1,480-kilometre (919-mile) return trek. After being caught in a fierce storm for days they missed a provision dump by 20 kilometres (12 miles) and froze to death in the extreme cold (−40°C/ −104°F). On November 12, 1912, a search party discovered the tent with the bodies of the five navy men and their equipment. With the help of the diary and the photographs, which included this picture by W.R. Bowers, the full tragedy of the endeavour could be minutely reconstructed. E.I.

Peter Brent. *Captain Scott and the Arctic Tragedy*. London, 1974.

ARCTIC FATE ALSO STRUCK Roald Amundsen. After he had finished the first crossing of the North Pole in the *Norge*, a zeppelin, on May 12, 1926, Amundsen was lost in June 1928 while on a flight to Spitzbergen, searching for the Italian flier Umberto Nobile.

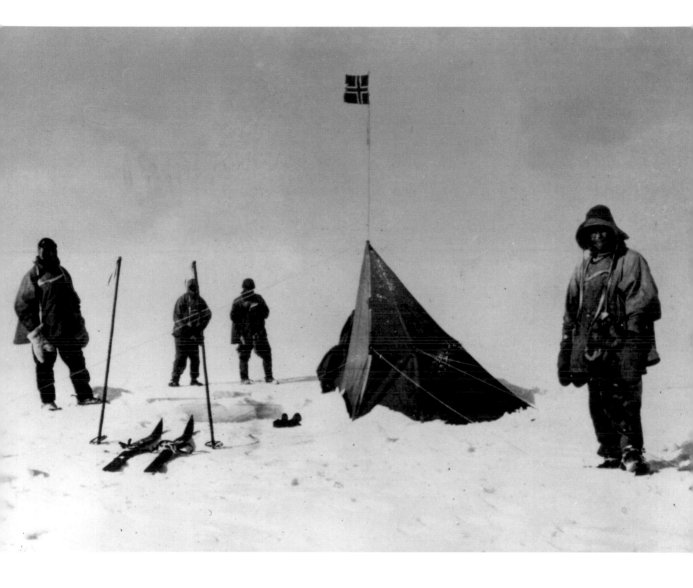

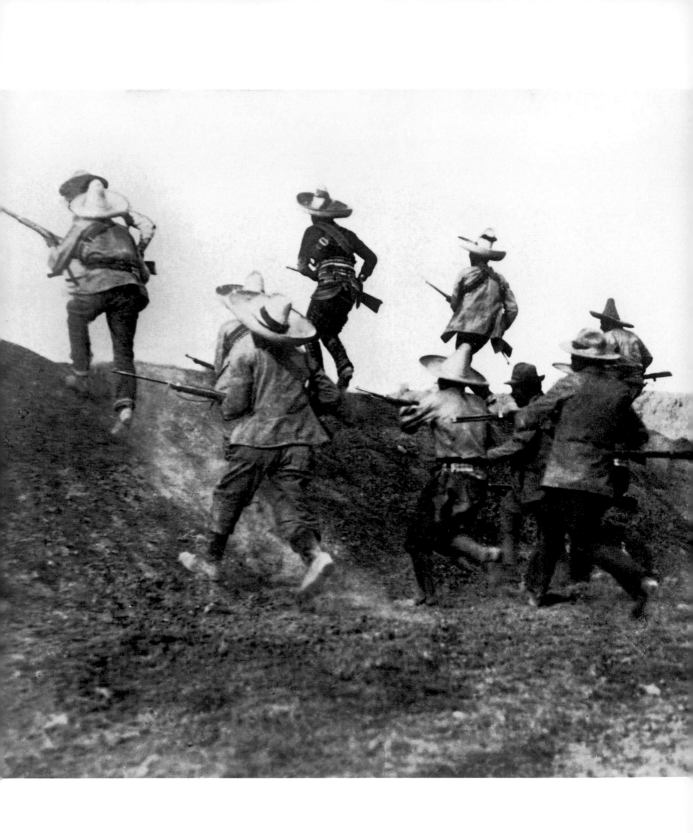

MEXICAN REVOLUTION
1913 Morelos, Mexico

Armed Zapatistas storm a stronghold of General Huerta's troops. In mid-April the rebels in the south began to move against Mexican federal troops. The government responded with mass arrests and deportations. Mexico was in the grip of a full-blown civil war.

The Mexican state of Morelos, where the Zapatista uprising originated, was one of the largest sugar-producing regions in the world. Prior to the revolution, the best land was divided into thirty-nine haciendas owned by eighteen families. For decades disputes erupted over the *ejidos*, the remaining pieces of land that belonged to the villages, and about access to water. The disputes were usually settled in favour of the powerful landowners, the *hacendados*. The farmers' uprising led by Emiliano Zapata in protest against the gradual erosion of their livelihood was one of several factors that forced dictator Profirio Díaz—in power since 1876—into exile in 1911. He was replaced by Francisco Madero, a *hacendado* himself, but one who aimed for a more liberal regime and was sympathetic to the needs of the rural population. In February 1913, Madero was ousted by a coup and succeeded by Victoriano Huerta, a brigadier general with blood on his hands.

Meanwhile, the Zapatistas began to implement their political goals in Morelos: the haciendas were required to pay weekly taxes. If they refused to do so, their sugar cane fields were set on fire. The federal government banned the payment of such "protection money," and the new dictator dispatched one of his most ruthless military leaders to Morelos. In March, Commander Juvenico Robles issued an order for summary executions. He was promoted to the rank of governor in April, and his men swept through Morelos, razing entire villages and executing the villagers. In late 1913, however, Emiliano Zapata was able to unify the rebels under his command, introducing a military-style hierarchy to prevent a dissipation of the rebellion. He captured the city of Jonacatepec in the same year: forty-seven officers and one general were taken prisoner—the latter defected to the guerrilla side.

A limited number of photographs remain of the different phases of the Mexican Revolution, documenting its frequent, sometimes daily, transformations. One of the most prominent images was a shot of Pancho Villa seated on a horse (also distributed on a "wanted" poster with a reward on his head). Another showed Villa next to Zapata seated on the president's chair after their victorious march into the capital. Others document scenes of battle, as does the one reproduced here. This photograph, especially impressive because of the immediacy with which it captures the drama, was taken in 1913. P. S.

Samuel Brunk. *Emiliano Zapata: Revolution and Betrayal in Mexico.* Albuquerque, 1995.

ARREST OF ARCHDUKE FERDINAND'S ASSASSIN

June 28, 1914 Sarajevo

On June 28, 1914, a young Serbian nationalist assassinated Archduke Franz Ferdinand, the heir to the Austrian throne. Gavrilo Princip killed the archduke with several well-aimed shots at point-blank range. He was immediately arrested, narrowly escaping an enraged crowd.

Archduke Franz Ferdinand and his wife, the duchess of Hohenberg, had survived an attempted assassination earlier the same day when a bomb was thrown at their carriage. After a reception hosted by representatives of the city, they continued their tour through Sarajevo. Archduke Franz Ferdinand had travelled to the area to observe military manoeuvres in Bosnia, ignoring repeated warnings. The failed bomb attack should have alerted him to the seriousness of the situation.

In the photograph, Austrian police lead the resisting assassin into an administration building in Sarajevo. Enraged Bosnians, dressed in national costume, struggle to grab the attacker. The vivid movement in the image expresses the dynamics of the event and anticipates the historic consequences that would follow within days. The image is therefore a document of an event that triggered a war, although—as the Greek historian Thucydides once taught—a trigger should not be confused with the actual cause of war.

What was the background to this event? June 28, 1914, the day of the assassination, was a national holiday for the Serbs, commemorating the 525th anniversary of the battle on the Field of the Blackbirds, which they had lost against the Turks. After two successful campaigns in the Balkans, the Serbs were now left with one major enemy, the Austro-Hungarian monarchy, which opposed any plans for Serbia expanding into Albania, Croatia and Slovenia. The passionate nationalist movement in Serbia could count on diplomatic support from Russia, however.

The assassins were young Bosnian Serbs who held Austrian citizenship, but investigations revealed numerous links to politicians and military officials who had organized a secret society in Belgrade called "Unification or Death." The weapons came from a Serb arsenal and the Russian military attaché had been advised that assassination attempts would be made. The political background was soon all too clear: the Serbs had feared that the archduke might succeed in bringing about a reconciliation between the Croats and the monarchy, thus obstructing their plans for a Greater Serbia.

In response to the assassination, Austria issued an ultimatum to Serbia, which in turn answered by mobilizing its troops. Austria then declared war on Serbia. Russia, too, now felt threatened because of its close ties to Serbia and Tsar Nicholas II ordered the mobilization of the army. The system of treaties and alliances of the day (Russia, France, England and Italy versus Austria-Hungary and Germany) unleashed an automatic response leading to the outbreak of the First World War within a few short days. E.I.

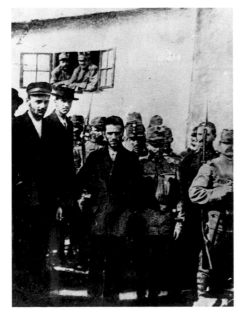

Assassin Gavrilo Princip after the attack.

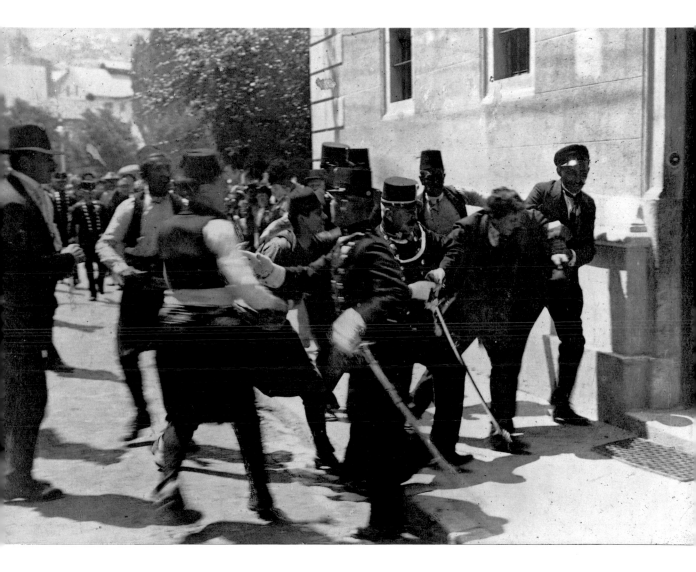

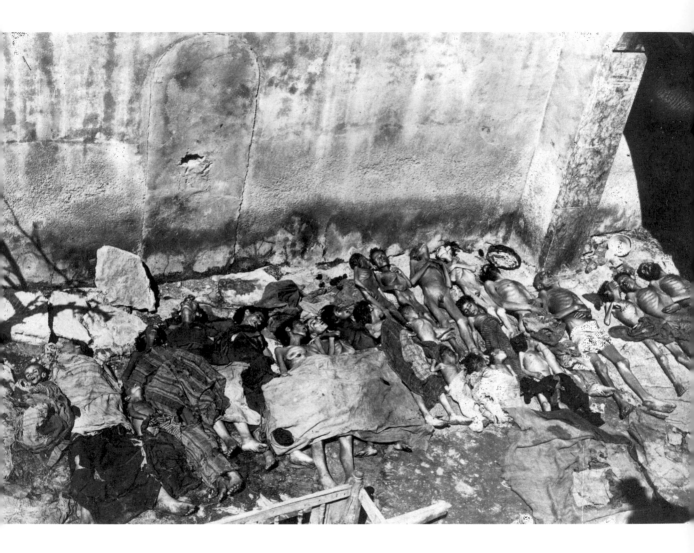

ARMENIAN GENOCIDE
1915 Ottoman Empire

LONDON, Oct. 6. Viscount Bryce, former British Ambassador to the United States, in the House of Lords today said that such information as had reached him from many quarters showed that the figure of 800,000 Armenians destroyed since May was quite a possible number. Virtually the whole nation had been wiped out, he declared, and he did not suppose there was any case in history of a crime "so hideous and on so large a scale."

The New York Times, October 7, 1915

Walter Benjamin characterized photography as a document of "the scene of the crime"; this photograph witnesses crime on a monstrous scale. In 1915 the decaying Ottoman Empire launched a pogrom against eastern Turkey's Armenian population, falsely accusing them of supporting a Russian invasion. Tens of thousands of men were shot and hundreds of thousands of women and children driven out of their homes and on forced marches towards Syria and Iraq. Shootings, deliberate starvation, mass burnings and drownings meant few survived. The death toll is estimated to have been a million people.

This photograph is still controversial; to this day, Turkish scholars dispute what happened to the Armenians. Turkey's persistent denial of the Armenian genocide worked on many: "Who speaks today of the Armenian massacres?" asked Adolf Hitler in 1939. This is an anonymous photograph, but there are other, signed and documented photographs of the atrocities and corroborating witness accounts.

A photograph such as this one is a precious and fragile testimony. The bodies are displayed full frame—an abject, grotesque spectacle—yet in this glimpse of circa thirty victims we picture hun-

dreds more. Death here is casual, repetitive, and the primary cause of death, hunger, all too visible. In its frank description of what genocide means—the mass production of murder—this picture anticipates photographs that were to follow, from bodies piled high during the Second World War to stacks of skulls in the Killing Fields of 1970s Cambodia.

Another series of photographs of Armenians dying and dead in eastern Turkey and Asia Minor in 1915 was taken by Armin T. Wegner, a German military officer stationed with the 6th Ottoman Army. Wegner's notes, letters and photographs of the massacre are crucial testimony and include images of people shot, starved and abandoned in open graves. International outcry at the massacres continued during and after the First World War. When an Armenian survivor assassinated Talaat Pasha, prime instigator of the massacre, in Berlin in broad daylight in 1921, a court acquitted him.

J.J.

Richard G. Hovanissian, ed. *Remembrance and Denial: The Case of the Armenian Genocide.* Detroit, 1998.

THE SIEGE OF VERDUN
1916 Verdun, France

On February 21, 1916, German forces launched a massive attack on French fortresses defending the city of Verdun. The battle continued for months. Despite huge casualties on both sides—2,200 German dead and wounded in a single day—and the use of gas and flame-throwers, the last fortress never fell.

This picture captures the moment not just of one man's death, but the death of a way of thinking about war, courage and human agency. It shows a French officer being machine-gunned as he leads his men in a counterattack on German positions. Taken from film footage, it is an image of front-line action during the First World War, in contrast to the more familiar pictures of the dead and wounded, the trenches and desolate battlefields.

Action is the heart of this image, and its irony. The massive fatalities and appalling suffering on the Western Front during the First World War occurred precisely because generals on both sides believed the war could be won by decisive action. This picture shows such action: men running at a machine gun. The mechanical efficiency of defence with machine guns, fortifications, barbed wire and artillery was much greater than the resources of attack. These soldiers have nothing to protect them but tin helmets. The first man dies before our eyes; in a moment the others will die too.

"What passing bell for these who die as cattle?" asked the British war poet Wilfred Owen. Attacks like this were not unique to the French, or to Verdun. Each army took it in turns to emerge from trenches in doomed rushes across no man's land at Ypres, on the Somme. In this photograph nineteenth-century notions of courage collide with modern reality. It records the end of an illusion.

The futile heroism of this photograph anticipates post-war images of the complete destruction of the individual. In the art of Georg Grosz and Otto Dix in Germany, or Jacob Epstein's *The Rock Drill* in Britain, the men who throw themselves at the enemy become dehumanized, mechanical monsters. The absurdity glimpsed in this photograph was recreated in Stanley Kubrick's film *Paths of Glory* (1958) about a French attack on a position called the Anthill. J.J.

Alistair Horne. *The Price of Glory: Verdun 1916*. London, 1993.

THE GERMAN EXPRESSIONIST painter Franz Marc was killed at Verdun.
His animistic paintings of horses and sensual vision of nature exemplify the early
modernist energy, passion and appetite for existence snuffed out by the war.
"For days," he wrote from Verdun two days before he died, "I have seen nothing
but the most terrible things that could be imagined by the human mind." C.B.

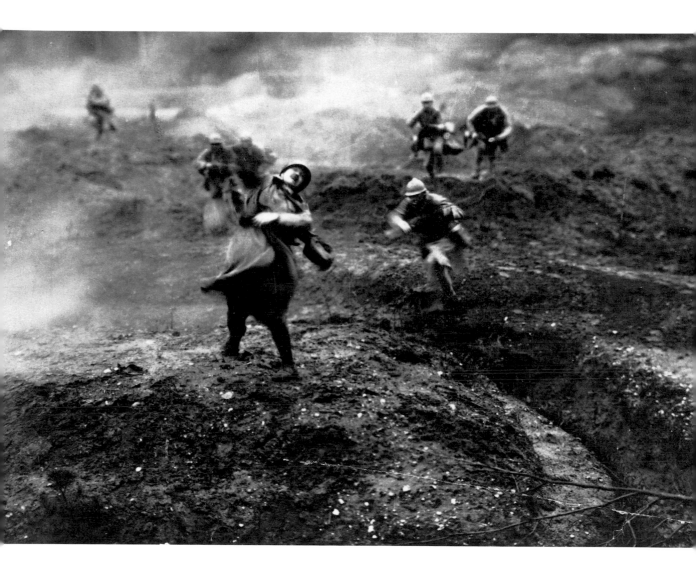

STORMING OF THE WINTER PALACE
October 25–26, 1917 Petrograd

Bolshevik units storm the Winter Palace, the seat of Kerensky's provisional government. This photograph is in fact a still from Sergei Eisenstein's film *October*, which the Soviet film pioneer made for the occasion of the tenth anniversary of the Russian Revolution in 1927.

The film was intended as an epic glorification of the Russian people and a mythic treatment of the revolution and the fall of the Tsar. That was why Eisenstein concentrated the entire action around the Winter Palace and not the Smolnyj, the seat of the revolutionary headquarters. Dramaturgical considerations required the "Storming of the Winter Palace." The still from the film "documented" the heroic beginnings of the October Revolution, because no one had, nor for technical reasons could have, organized an authentic photo shoot for the events of that dark night. The film, however, celebrated the legendary participation of the masses.

Let's stay with the facts. After the Tsar had abdicated and fled at the beginning of March 1917, Petrograd had two competing political factions: the provisional government under Kerensky supported by the middle-class deputies of the Duma, who wanted to continue the war and who pursued a course of moderate reform. They were opposed by the Soviet of the workers and soldiers, who wanted to end the war immediately and who pressed for fundamental change. At the beginning of October, the military situation in Petrograd had reached a crisis point and the government under

Kerensky proved incapable of action. That's when the Bolsheviks, who were still a minority in the All-Russian Congress of Soviets, staged a putsch. The central committee of the Bolsheviks had already taken the decision to act on October 10. It had been published in the newspapers, but it did not particularly disturb the Kerensky government, which assumed that the moment of surprise had been lost. Even when small groups of Soviet soldiers occupied strategic positions in the city on October 25, the government undertook no counter-measures. Trotsky called a meeting of the Soviets in the afternoon and declared that the government "had ceased to exist," claiming that "vast masses," for which history had no precedents, had accomplished this. But during Trotsky's speech there were no masses anywhere in the city. Even the Winter Palace, the seat of the provisional government, was guarded by only a small unit of military cadets, who offered no resistance worth mentioning to the revolutionary battle groups—about 300 to 400 soldiers—who occupied the 1,500 rooms of the palace.

Memoirs, films, and paintings later embellished this episode in vivid colours. In reality, however, the soldiers simply crossed the square and entered the palace by a side entrance. When just before two o'clock in the morning they entered the malachite hall, the ministers of the Kerensky cabinet were willing to surrender. The action was over at ten past three a.m. and the Bolsheviks took power. Compared to the intensity of the later battles of the civil war, this action was quite unspectacular. E.I.

Harrison Salisbury. *Russia in Revolution 1900–1930*. New York, 1978.

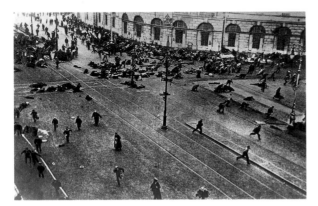

July 4–17, 1917, in Petrograd: the Bolsheviks attempt their first coup. Cossacks and nobility loyal to the government move in from the left and begin shooting in the middle of the street. The demonstrators flee or throw themselves to the ground; others are fatally shot.

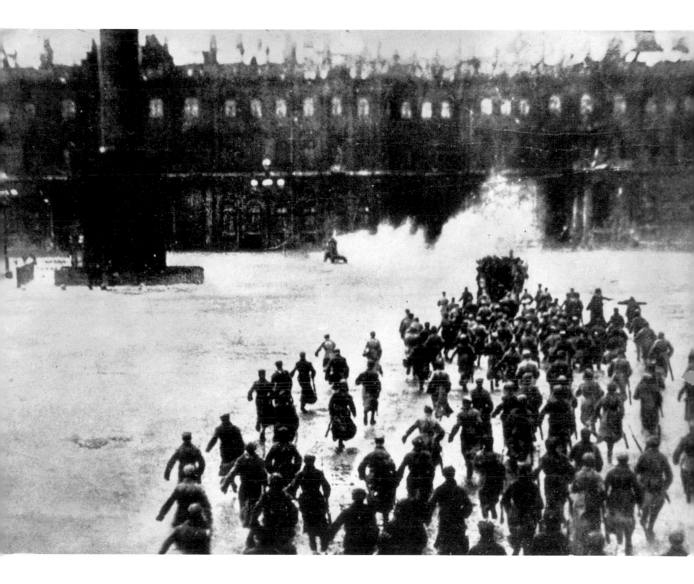

SIGNING OF THE TREATY OF VERSAILLES
June 28, 1919 Versailles (near Paris)

The diplomatic representatives of the Allies and associate countries and the representatives of Germany came together in the Hall of Mirrors of the Palace of Versailles to sign a peace treaty ending the Great War. The Treaty of Versailles set the terms of reparations for Germany, agreed to a charter for the League of Nations, and dealt with other international problems.

At first glance, this photograph is rather unremarkable. But if one recalls how the peace of Versailles came about, it is all the more impressive. It is as if the photographer had sensed the atmosphere of those days and provided the *mise en scène*. After all, it is rather uncommon to look at such proceedings from the back row, across the heads of other observers in order to focus on a group of officials. Minutes before the actual signing, they are still engaged in private conversations as if they were rather disinterested in the actual purpose of the gathering. They are sitting or standing behind a long table, which has been positioned in front of the wall of mirrors in the Baroque hall. The photographer was obviously intrigued by the diplomatic business and the lack of ceremony. In fact, however, he did not merely capture the moments before the signing but caught the essential nature of the political-diplomatic situation in Europe at the end of the Great War.

What were the coordinates of this situation? U.S. president Woodrow Wilson was interested in establishing a League of Nations and thus providing for a European security system based on the Fourteen Points he had proposed in January 1918. French president Georges Clemenceau, on the other hand, wanted to secure the safety of France with a border at the Rhine. He also wanted a declaration that Germany bore sole responsibility for the war, and he wanted immediate reparation payments for all war damages. The British, led by Lloyd George, wanted to establish a balance of powers in central and eastern Europe aimed primarily at containing a revolutionary Russia but also to stabilize trade and British colonial power.

The treaty determined, in eight parts with more than 400 separate articles, the ceding of territories and temporary occupation, the demobilization of the German forces, the level of reparations, and many other provisions. Faced with the possibility of a full occupation by Allied troops, the German representatives had no power to seek any concessions. On June 28, 1919, the German representatives, Foreign Minister Müller and Transport Minister Bell, and the delegates of the Allies signed the treaty in the room where in 1871 the German Reich had been founded.

The final level of reparations was determined in the London Ultimatum of 1921 but remained, along with the occupation of the Rhineland, under constant negotiation during the following years. The revision of the Treaty of Versailles remained a priority in German foreign policy into the 1930s and provided material for Nazi propaganda. The treaty thus contained within it the seeds for new problems in the internal politics of Germany; it also complicated Germany's foreign and economic policies. The peace of Versailles lasted for only twenty years.

E. I.

William Laird Kleine-Ahlbrandt. *The Burden of Victory: France, Britain, and the Enforcement of the Versailles Peace, 1919–1925*. Lanham, 1995.

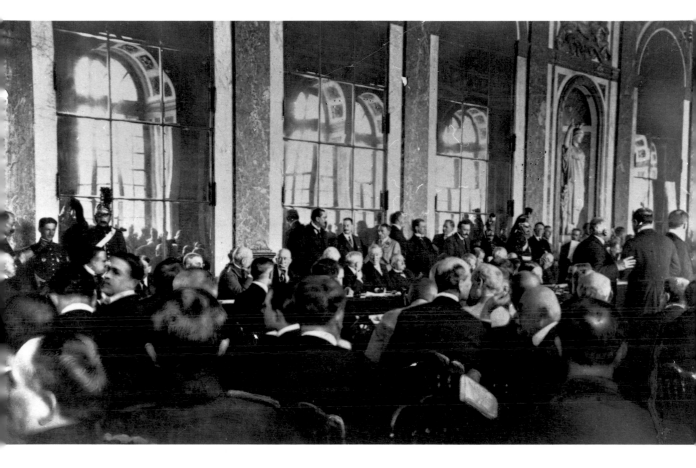

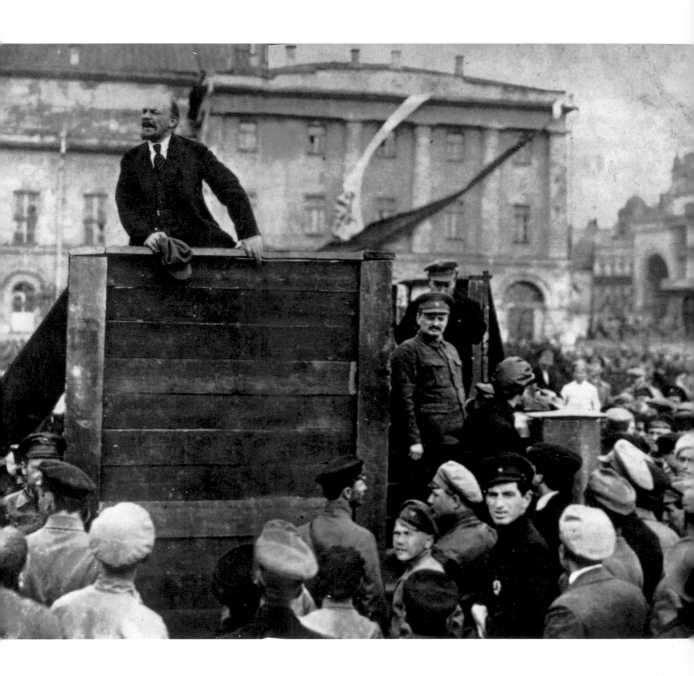

LENIN'S CALL TO ARMS

May 5, 1920 Moscow

Photographer: G.P. Goldstein

Ten days after Poland's invasion of the Ukraine, Lenin rallies units of the Red Army and volunteers on the city's Sverdlov Square "to fight the white guard gangs of the Polish bourgeoisie." This photograph by G.P. Goldstein shows Vladimir Ilyich Lenin in his famous oratory pose on an improvised stage. He is accompanied by Leon Trotsky and Lev Kamenev, who stand on the stairs to the right of the platform.

This photo found wide distribution and became an icon of the Russian Revolution because it showed Lenin as the orator who knew how to galvanize the people, and it documented as well his close relationship with Trotsky. A few seconds after this picture was taken, an unknown photographer shot from the same angle a nearly identical photo. It is ever so slightly different: Trotsky and Kamenev have turned and are now visible only in profile. The photograph was published as a postcard in 1927 for the tenth anniversary of the Russian Revolution. Thereafter, the image was available only in a retouched version with Trotsky and Kamenev replaced by wooden steps.

What led to this falsification? Trotsky had been instrumental in planning the Bolshevik takeover of October 25 to November 7, 1917. As chairman of the Council of People's Commissars, Lenin was threatened from within by the Mensheviks and from without by the Allies and the war against Poland. The people's commissars and the top cadres of the Politburo, which had been set up in 1919, worked untiringly to protect the new state. Trotsky was a great public speaker, and he had contributed his considerable organizational skills in building the Red Army. As the person responsible for the military arm of the revolution, Trotsky was present at the rally on May 5, 1920.

After Lenin's death in January 1924, Stalin moved more and more into the foreground. By contrast, Leon Trotsky fell into disfavour. He was dismissed from the Central Committee of the Communist Party in 1927. In 1929, he was expelled from the Soviet Union and assassinated in exile in Mexico on Stalin's orders in 1940. Stalin systematically diminished the historical significance of Rykov, Sinovyev, and Tomski, who were Lenin's comrades and members of the Politburo. Historical documents that underscored their collaboration with Lenin were published only in excerpts, and they were removed from well-known photographs such as this one. As this practice became common, gaps formed in the collective memory of the Russians. Trotsky had pointed publicly at the Stalinist methods of falsifying history. He therefore had to be eliminated. "Erased memory," as the story behind this photograph shows, is inherent to all totalitarian systems of government. E.I.

David King. *The Commissar Vanishes: The Falsification of Photographs and Art in Stalin's Russia*. New York, 1997.

OPENING TUTANKHAMUN'S COFFIN
November 26, 1922 Luxor, Egypt

After three years excavating the tomb of Pharaoh Tutankhamun in the Valley of the Kings, Howard Carter finally reached the inner shrine. Even thieves had failed to find what lay here, and what was revealed had not been seen since the tomb was sealed in 1323 BC. Nested within three outer coffins lay a solid gold coffin containing the body of the boy king Tutankhamun.

On November 4, 1922, the Egyptologist Howard Carter discovered the tomb of Pharaoh Tutankhamun on the brink of giving up after years of excavations in the Valley of the Kings, Luxor. Workmen discovered a step carved out of the rock of the valley floor which led to the doorway of the sealed tomb. For over a decade Carter unearthed treasures that captured the imagination of the world. Fascination with the pharaohs ran so high that even images of Lenin were drawn depicting him as an Egyptian king.

During his reign, Tutankhamun was regarded as an unimportant puppet king. At the time of his death, he was between fifteen and eighteen years old. The pharaoh was seen as a semi-divine being at the top of the hierarchy of Egyptian society, forming a bridge between the gods and humankind. It was believed that riches and accoutrements were necessary for safe passage into the afterlife, and mummies were buried surrounded by treasures and foodstuffs needed for the journey. Many of the burial sites had

been plundered repeatedly by thieves, years before study of ancient Egyptian civilizations became a pastime of English gentlemen.

In a sealed room surrounding the main burial chamber, Carter found the pharaoh's mummified remains. Inside three outer coffins, an inner coffin made of pure gold was discovered untouched since the day of burial. In this image we can see Carter carefully scraping away a hardened black resinous pitch that had been poured onto the innermost coffin. The body's arms were crossed, holding a crook and flail, and the mummy wore a gold death mask. Inlaid with blue faience, glass, carnelian and lapis lazuli, the mask was detailed with life-like eyes made from quartz and obsidian. The back of this incredible mask was inscribed with a series of texts from the *Book of the Dead*. L.L.F

Nicholas Reeves. *The Complete Tutankhamun*. London, 1990.

Gold death mask of Tutankhamun.
Egyptian Museum, Cairo.

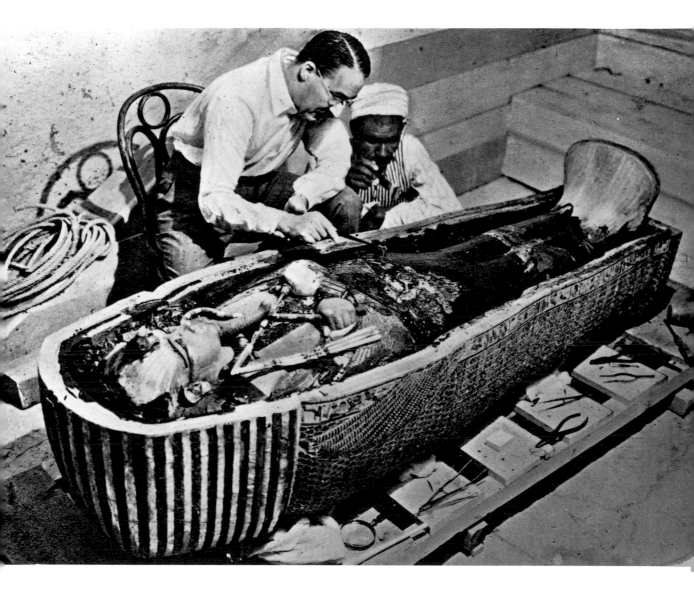

LINDBERGH LANDS IN PARIS

May 21, 1927 Le Bourget airfield, near Paris

An exuberant throng surrounded Charles A. Lindbergh's airplane after it landed at Le Bourget air-field on May 21, 1927, at the conclusion of the first solo non-stop flight from New York to Paris. The American pilot's 33.5-hour flight in a single-engine plane made aviation history.

After his arrival, members of the cheering crowd of 150,000 carried Lindbergh from the plane, but he was soon taken to the American Embassy on the Avenue d'Iena in Paris. The next day Lindbergh, still stunned to have attracted so much attention, stood beside the American Ambassador, Myron T. Herrick, greeting Parisians from the embassy's balcony, as the second photograph illustrates. Lindbergh's flight (just twenty-four years after the Wright Brothers' first flight) made banner headlines and captured

Lindbergh with the American Ambassador Myron T. Herrick
on the balcony of the American Embassy in Paris.

the imagination of the world. By flying alone, Lindbergh minimized the plane's weight, enabling him to carry enough fuel to cover over 5,600 kilometres (3,500 miles). His plane was named in honour of the St. Louis businessmen who had financed its purchase for about $10,000. An offer of a $25,000 prize for the first non-stop flight between New York and Paris was only part of the lure for Lindbergh. After dropping out of college in order to fly, Lindbergh had trained as an army pilot, had flown mail routes during treacherous weather in the midwestern United States, and had barnstormed there. He believed in aviation's future, and his

transatlantic journey was meant to demonstrate the possibilities of flight.

Lindbergh's photogenic lean good looks, in addition to his bravery and modesty, made him an instant hero. He was shown in some of the earliest talking newsreels. For years after his first transatlantic flight, photographers and reporters hounded him relentlessly. He must be considered the first media superstar. The *Spirit of St. Louis* is on permanent exhibit at the National Air and Space Museum, Smithsonian Institution, Washington, D.C.

The plane's name, the *Spirit of St. Louis*, painted on the nose of the plane, is difficult to see in this photograph, but its licence number, N-X 211, is legible. (The letter N was the international designation for the United States, the X meant that the plane—a Ryan monoplane—was experimental.) B.L.M.

A. Scott Berg. *Lindbergh*. New York, 1998.

LINDBERGH WAS TO PAY a heavy price for his fame and wealth. In 1929 Lindbergh married Anne Morrow, the daughter of a prominent financier and diplomat. She was to become a well-known writer. The apparently charmed lives of this attractive couple were shattered by the kidnapping of their twenty-two-month-old son from their home near Princeton, New Jersey, on March 1, 1932. Although they paid a $50,000 ransom, the child was not returned to them. Bruno Richard Hauptmann was arrested in September 1934 after trying to spend marked ransom money. Maintaining his innocence, he was executed in 1936 for kidnapping and murder in what has been called the "crime of the century." As a result of the case, kidnapping was made a federal crime.

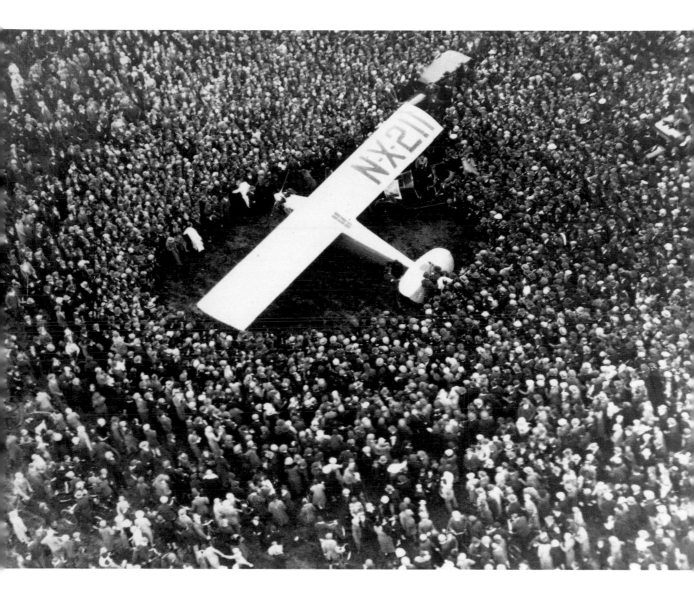

THE CRASH

October 24, 1929 New York City

On the morning of "Black Thursday," October 24, 1929, crowds gathered in the vicinity of the New York Stock Exchange on Wall Street in New York City as stock prices fell sharply in record trading of nearly 13 million shares.

This photograph shows the shocked and anxious crowd that flowed onto steps of the United States Sub-Treasury Building (now the Federal Hall National Memorial) across Wall Street from the Stock Exchange on the day that marked the beginning of the Great Depression.

Stock market speculation had been among the excesses of the Roaring Twenties, and when the market began to fall, there was no stopping it. The panic was temporarily halted on "Black Thursday," when major banks and investment companies purchased huge blocks of stock, but the downslide resumed on "Black Monday." On "Black Tuesday," October 29, the Dow Jones Industrial Average collapsed completely, plummeting more than 23 percent from its closing level the preceding week, in record sales of more than 16 million shares. Stock prices continued to fall until 1932, resulting in bank failures, declining industrial output and widespread unemployment. Americans elected President Franklin D. Roosevelt in 1932. His New Deal programs included economic reforms to insure against future financial instability and public works projects that increased employment and improved the nation's infrastructure.

The stock market collapse and depression in the United States precipitated an economic slump throughout Europe and other industrialized nations. Germany was particularly hard hit; its economic woes were a factor in Adolf Hitler's rise to power. The Great Depression, which lasted for about ten years, was the longest and severest economic depression ever experienced by the Western world.

B.L.M

John Kenneth Galbraith. *The Great Crash, 1929.* Boston, 1997.

THE FEDERAL HALL NATIONAL MEMORIAL at 28 Wall Street is rich in history. Completed in 1842 after a design by American architects Ithiel Town and A.J. Davis, it is one of the best examples of Greek Revival architecture in New York City. Originally built as the U.S. Custom House, the building became the Sub-Treasury in 1862. In 1789, George Washington stood in front of this building's predecessor, called Federal Hall, to be sworn in as the first President of the United States. The statue of George Washington by J.Q.A. Ward (1883), visible in this photograph, commemorates that event.

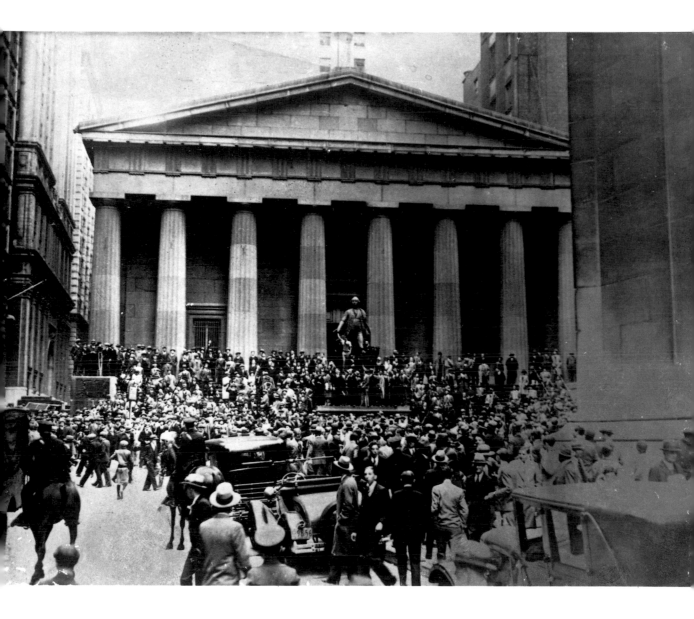

PROHIBITION IN THE UNITED STATES
1930s

Between January 1920 and December 1933, the manufacture, transport, and sale of alcoholic beverages was prohibited in the United States.

In this posed photograph, federal agents dump barrels of bootleg liquor. This image from the early 1930s is typical of photos made during Prohibition to publicize the enforcement of the law by "dry agents," as they were known. In fact, enforcement of Prohibition was spotty, as there were not enough federal agents—3,000 at most—to cover all forty-eight states, and corruption was rampant among the agents. State and local police were often too poorly financed to add anti-liquor laws to their concerns. In large cities like New York, which had opposed Prohibition, speakeasies—small clubs that sold liquor illegally—became popular. By 1922 more than 5,000 speakeasies existed in New York; several years later there were between 30,000 and 100,000. Fewer legal drinking spots had existed before Prohibition.

Enactment of Prohibition had occurred after much lobbying by temperance groups during the late nineteenth and early twentieth centuries. In particular, Carry Nation, who had been married to an alcoholic, became famous for using a hatchet to destroy barrooms in Kansas. Organized reformers, including the Women's Christian Temperance Union and the Anti-Saloon League, wielded political clout in convincing state legislatures to approve resolutions that ultimately became the Eighteenth Amendment to the United States Constitution.

The reformers, whose stronghold was in rural areas, promoted abstinence because they believed that alcoholism caused moral degradation, ill health, poverty, and crime. Ironically, crime and health risks became more widespread under Prohibition. Illegal production of alcoholic beverages was common, and drinkers were sometimes poisoned by wood alcohol. Bootlegging—the illegal production, smuggling, and distribution of liquor—became a gold mine for organized crime, involving famous gangsters like Al Capone in Chicago and "Legs" Diamond in New York. The violence and graft that became associated with Prohibition were key factors in its repeal by the Twenty-first Amendment in 1933.

B. L. M

John Kobler. *Ardent Spirits: The Rise and Fall of Prohibition.* New York, 1993.

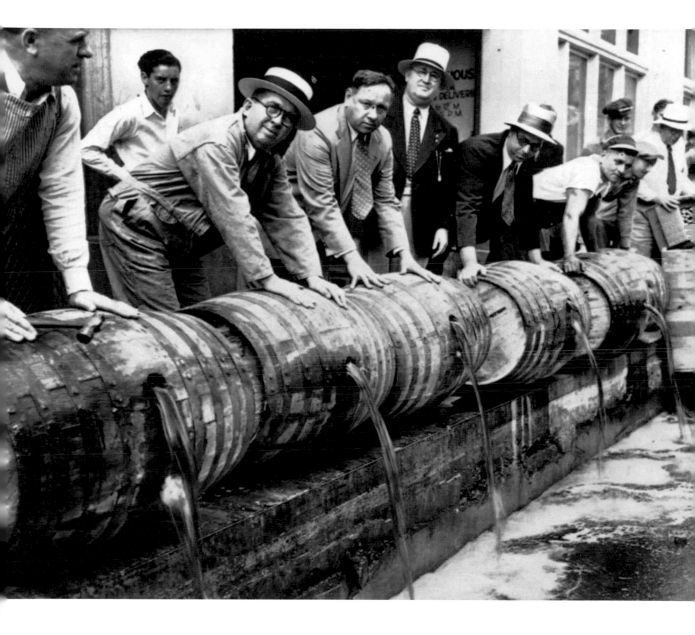

REICHSTAG FIRE
February 27–28, 1933 Berlin

Adolf Hitler was appointed chancellor on January 30, 1933. Four weeks later, during the night of February 27 and only a few days before new parliamentary elections, the Reichstag, which dated from 1894, was destroyed by fire.

News of the Reichstag fire hit the already hot election campaign like a bomb. Police arrested the twenty-four-year-old Dutch bricklayer Marinus van der Lubbe at the site. They found a Communist pamphlet on him, which allowed Hermann Göring, who at the time was the Prussian minister of the interior, to announce that the fire had been started by the Communists. That same night he ordered the arrest of the deputies and ranking party officials of the KPD, the Communist Party. The next day, the Reich cabinet announced the decree "For the Protection of People and State," which introduced the death penalty in cases of high treason and arson.

This photograph of the burning Reichstag is not only a historical document marking Germany's turbulent development towards a stable parliamentary democracy. It is also a news photo that was used for propaganda purposes by the enemies of democracy. The National Socialists (the Nazi Party) claimed the fire was proof of an often predicted insurrection by the Communists, the fight against whom Hitler had declared a top priority of his "government of national awakening." The "Reichstag Fire Decree" was used until 1945 to repress any incipient resistance. It provided the Nazi Party with an official pretext to legitimize its dictatorial governance. In March and April 1933, it was used to arrest about 25,000 political opponents in Prussia alone.

The trial of van der Lubbe was also manipulated. To be sure, he was found guilty and condemned to death. But the other Communists who had been put on trial with him were found not guilty. No proof was ever found of any Communist conspiracy. Still, the Nazis benefitted greatly from using the Reichstag fire in their propaganda in the national elections, which were held shortly after the fire. They received 43.9 percent of the popular vote. The Reichstag fire also figured in the lead-up to the liquidation of the leaders of the Brownshirts by the SS and the Nazi Party leadership during the so-called Röhm putsch in June 1934.

This photograph has acquired a rather multilayered iconic character. The true cause of the fire remained undetermined; in fact, historians have continued to argue over this event. Thus the image points to the different views and interpretations that characterize the general discussion around the causes of the Nazi march to power. Unearthing the entire background of the event has become one of the most intractable problems in the history of National Socialism. Behind the question, which is no longer answerable, of whether there was just one arsonist or whether it was a deliberately provocative act by the Communists, or for that matter even on the part of the Nazis, there stands the more fundamental question of whether accidental evolution or careful planning characterized the consolidation of the Nazi dictatorship. Some historians view the Reichstag fire as the "politically most significant case of arson in modern history" (Walter Hofer) and attribute to it foreshadowings of all future Nazi crimes. As early as June 1931, Hitler had openly stated his anti-parliamentary position when he said: "The sooner someone burns down this babble palace, the sooner the German people will be free of foreign influences."

And yet much evidence exists that the Reichstag fire was not perpetrated by the Nazis. The historical controversy in the 1980s circled around the authenticity of the "Breitling Papers." What originally had been a matter of clearly limited factual inquiry metamorphosed into the fundamental question concerning the totalitarian nature of National Socialism and Hitler's role in it. However one answers that question, the Reichstag fire undoubtedly cleared the way towards a Nazi dictatorship. E.I.

William L. Shirer. *Rise and Fall of the Third Reich: A History of Nazi Germany.* New York, 1990.

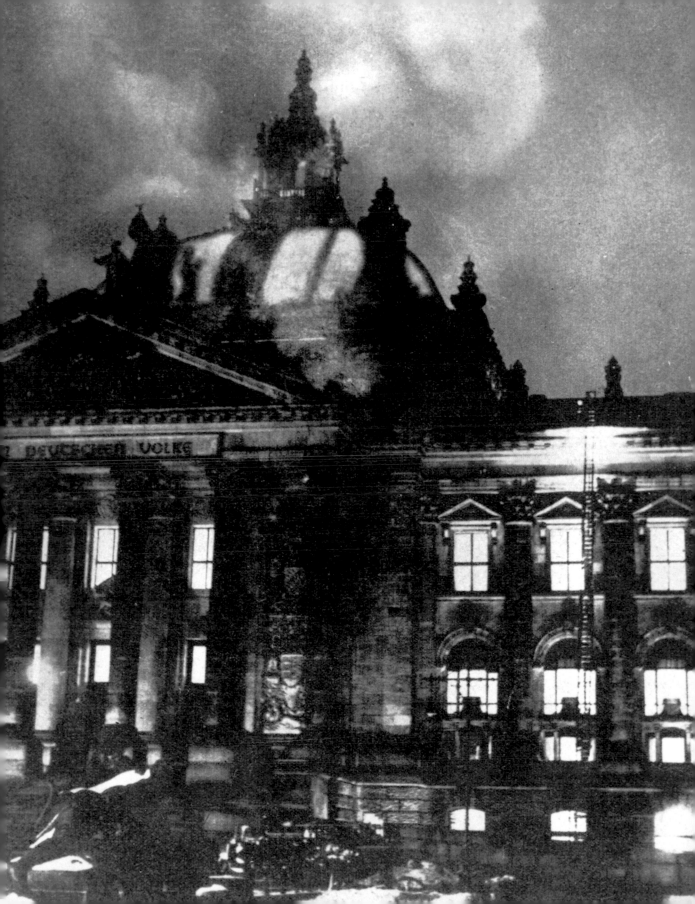

MIGRANT MOTHER

March 1936 Nipomo, California
Photographer: Dorothea Lange

Dorothea Lange took this photograph to portray the plight of migrant agricultural workers in the western United States during the Depression. The woman and her children were living in a tent at a California pea-pickers' camp.

The woman was unemployed and penniless because the pea crop had frozen. She and her children had been subsisting on frozen vegetables from the surrounding fields and birds the children had killed. In desperation, the mother had just sold the tires from her car to buy food. Lange drew attention to the camp of hungry laborers by publishing some of her pictures of the pea-pickers' camp in a local newspaper.

Although the Madonna-like "Migrant Mother" has since become famous as a quintessential picture of human suffering, it is best understood in the context of its time. American farmers had already begun to suffer from falling prices in the decade before the 1929 stock market crash. Droughts, soil erosion, increasing mechanization, and further price drops during the 1930s forced farmers—especially tenant farmers who leased, rather than owned the land they worked—to move west, seeking employment. Lange's "Migrant Mother" is one of her many photographs documenting the lives of such people. The series culminated in the book, *An American Exodus: A Record of Human Erosion* (1939), written with her husband, Paul Shuster Taylor.

In the 1920s, Lange had run a portrait studio in San Francisco where she took flattering, soft-focus photographs of her clients. But when the Great Depression struck she felt the need to document its tragic consequences in the lives of the poor. Lange's compassion for the difficulties of others may have derived in part from her childhood bout with polio, which left her with a permanent limp. As a photographer she possessed a unique ability to communicate emotion through significant gestures, as shown here in the way the infant and two children huddle against their sad but stalwart mother.

B. L. M.

Milton Meltzer. *Dorothea Lange: A Photographer's Life*. New York, 1978.

LIKE MOST OF LANGE'S DEPRESSION-ERA PHOTOGRAPHS, "Migrant Mother" was made for the United States government agency that would become known as the Farm Security Administration (FSA). Other photographers to participate in the program included Walker Evans, Ben Shahn, Russell Lee, Carl Mydans, and Marian Post Wolcott. Roy Stryker, the director of the FSA photography project, understood that photographs were important tools in convincing legislators to aid poverty-stricken Americans. He gave each FSA photographer guidelines about what to photograph. For instance, Lange's "Migrant Mother" was taken during a six-week field trip through California, New Mexico, and Arizona. She was assigned to illustrate urban and rural slums, migrant workers, and soil erosion, to show that poverty existed in the West, as well as the East and South where other FSA photographers were working.

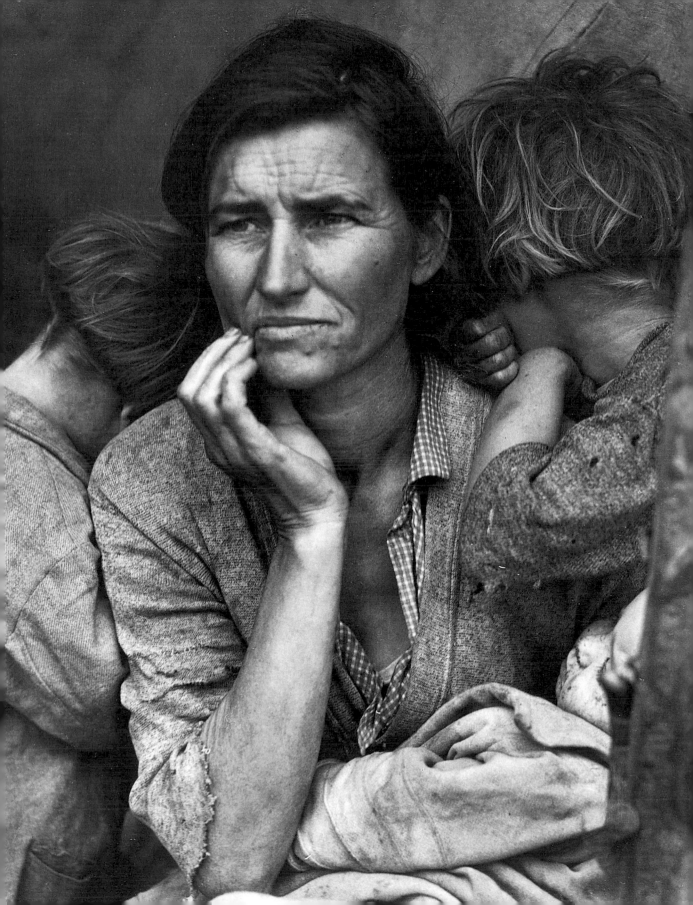

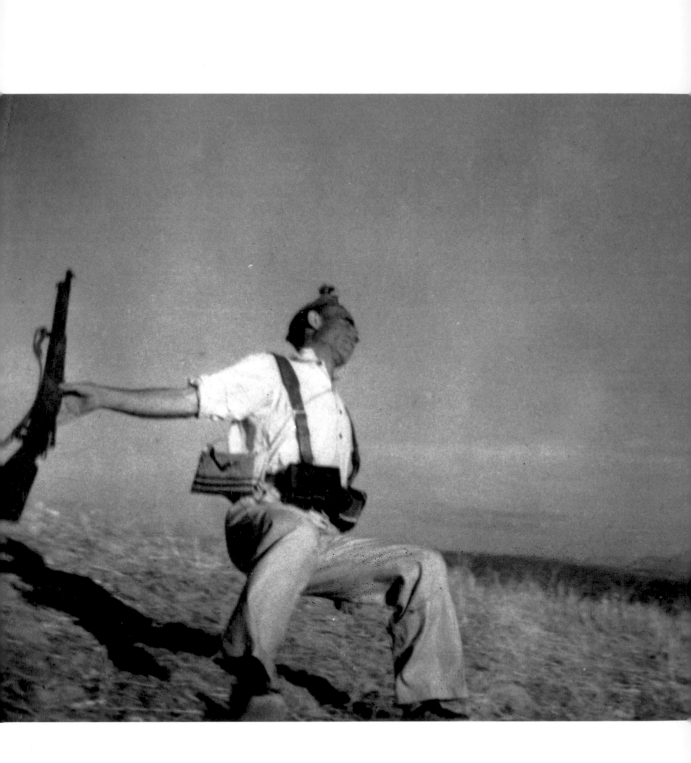

DEATH OF A SPANISH MILITIAMAN
September 5, 1936 Cerro Muriano, Spain
Photographer: Robert Capa

The victory of the Popular Front in the Spanish general elections of February 1936, a coalition including communists, anarchists and social democrats, led to a pronunciamento or attempted coup by the army, the beginning of Spain's bloody civil war.

This is one of the most famous, influential and controversial photographs of the twentieth century. Robert Capa's photograph of a republican soldier at the moment of his death at Cerro Muriano, outside the fascist stronghold of Cordoba, was a new kind of war photograph: a close-up action image taken by a photographer risking his life alongside the soldiers he celebrated. The man in the photograph, dressed in white, spreads his arms out like Christ as a fascist bullet hits him. This is an image of martyrdom reminiscent of Picasso's *Guernica*. In Europe on the brink of world war, Spain was a chance for the Left and fascist Right to square up, and Capa's partisan image had an instant impact on world support for the republican cause.

Perhaps it is not surprising that Capa's veracity should have been questioned. The soldier's death is almost unbelievably iconic, and skeptics suggested that Capa staged it. This would make it a brilliant propaganda image but not the document it claimed to be. Capa's evocation of the suffering of republican Spain does seem to be factual, however. The soldier's widow has come forward to identify him as Federico Borell Garcia, and her testimony is corroborated by military records.

Even if it were a "fake," Capa's photograph changed history; it defined the war for everyone who saw it. Spain was the last great romantic war, a place for young men and women from across Europe to act on their idealism. This picture depicts a noble, necessary death, the kind of death volunteers in the International Brigades accepted might be their lot. Even with his last breath, the militiaman seems to embody freedom.

J.J.

Robert Capa et al. *Heart of Spain: Robert Capa's Photographs of the Spanish Civil War*, New York, 1998; Richard Whelan, *Robert Capa: a biography*, New York 1985.

ROBERT CAPA was born André Friedmann in Budapest in 1913 and left after being involved in the Hungarian Revolution. Capa was originally a fictional person invented by Friedman and his lover Gerda Taro to sell his work. Spain made Capa the world's first famous war photographer and his later shots of the D-Day landings confirmed his preeminence (see quote on p. 60). He was one of the founders of the Magnum agency. Robert Capa was killed when he stepped on a mine in Indochina in 1954.

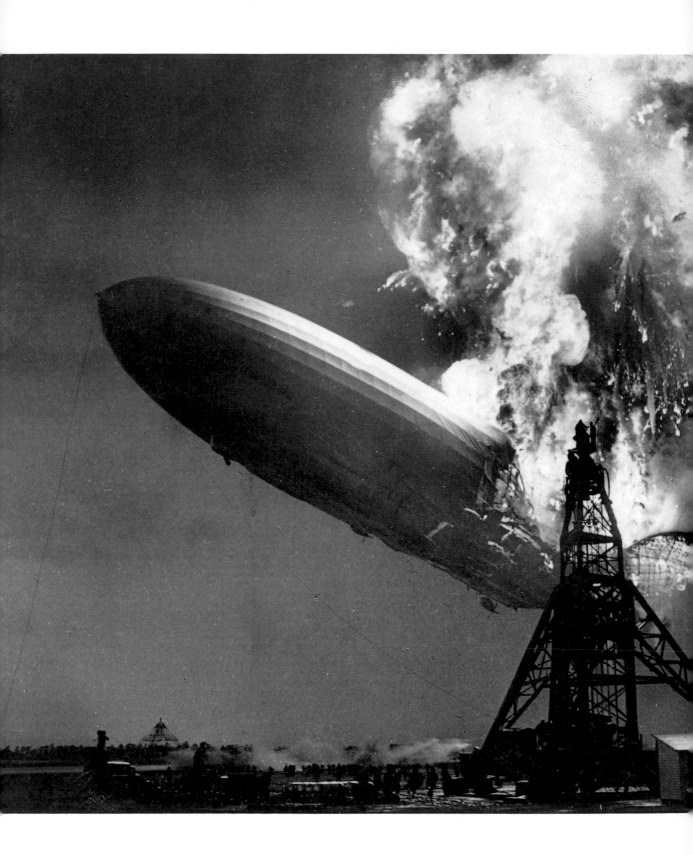

THE *HINDENBURG* DISASTER
May 6, 1937 Lakehurst, New Jersey
Photographer: Sam Shere

On May 6, 1937, the *Hindenburg*, a German dirigible, exploded as it approached its mooring at Lakehurst, New Jersey. The 245-metre (804-foot) airship had just completed its eleventh transatlantic crossing. Without warning, a small explosion and fire occurred at 7:21 p.m., followed by a second stunning explosion. Flames burst through the rear of the airship. In less than a minute the entire ship collapsed to the ground, engulfed in flames.

The conflagration quickly reduced the dirigible to its bare aluminum frame. Thirty-six of the ninety-seven people aboard were killed. The accident was long believed to have been caused by static electricity igniting the highly inflammable hydrogen gas that kept the airship aloft. However, recent research by a retired NASA scientist in the U.S. as well as archival records of the Zeppelin company in Germany have shown that the flammability of the coating of the *Hindenburg's* outer skin (not known to be flammable at the time of the flight) was the reason that a spark turned into a conflagration.

This photograph and others taken at the same time mark a new era in photojournalism. Never before had a disaster been so thoroughly documented. Twenty-two photographers and some newsreel cameramen had gathered in Lakehurst for what we would now call a routine photo opportunity. Instead, as survivors jumped from the airship and screams issued from the wreckage, they recorded the event, instant by instant. One photographer, fearing that he might make a double exposure, threw each filmholder to the ground after taking only one of the two negatives. Emotional, on-the-scene radio accounts and newsreels, as well as the photographs that appeared on the front pages of newspapers around the world, made people feel they had witnessed the event themselves.

For several years, Zeppelins like the *Hindenburg* had seemed to be the transportation of the future. Their commodious cigar-shaped bodies travelled faster and more smoothly than ocean liners and were less cramped than airplanes. The *Hindenburg* had contained individual sleeping quarters similar to those on trains, a full dining room, and an elegantly appointed lounge. But with the *Hindenburg* disaster, the public was alerted to the dangers of travelling in such highly combustible vehicles. Paid passenger flights on dirigibles were discontinued soon afterward. B.L.M

Harold G. Dick and Douglas H. Robinson (contributor). *Golden Age of the Great Passenger Airships*. Washington, D.C., 1992.

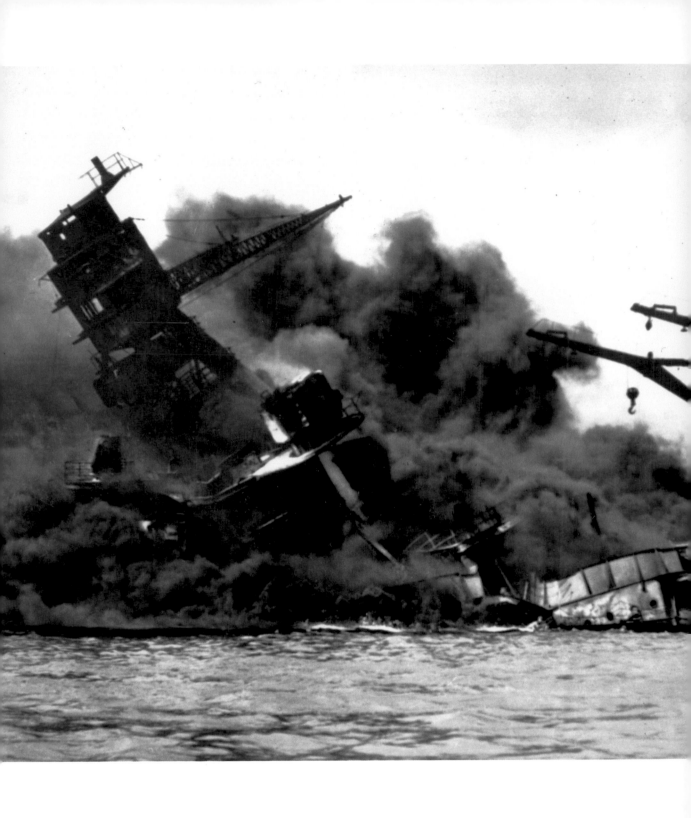

BOMBING OF PEARL HARBOR
December 7, 1941 Oahu, Hawaii
Photograph: U.S. Navy

Without warning, just before 8 a.m. on December 7, 1941, Japanese planes attacked the bulk of the U.S. Pacific fleet at the naval base on the Hawaiian island of Oahu, forcing the United States into the Second World War. The sinking USS *Arizona* is shown here, its bridge in flames. It had suffered a direct hit, and the violent explosion blasted the ship out of the water before it sank with the loss of nearly a thousand lives. It was one of nineteen naval vessels that were destroyed or severely damaged at the time. The *Oklahoma, Nevada,* and *West Virginia* also sank. More than 180 aircraft were destroyed.

Americans listening to the radio on a quiet Sunday afternoon were shocked to learn of the attack. Until that date, the United States had officially remained neutral in the growing world conflict, despite its increasingly strained relations with Germany and Japan. On December 8, the U.S. Congress declared war on Japan. Addressing the Congress, President Franklin Delano Roosevelt called the date of the Pearl Harbor attack "a date which will live in infamy." Within a few days Germany and Italy declared war on the United States. Because of its repercussions, the attack on Pearl Harbor must be viewed as a turning point in the Second World War, and thus a significant moment in world history.

This photograph is typical of photographs published in the United States during the Second World War: although it shows a spectacularly horrifying event and staggering property damage, it avoids depicting the suffering or death of troops. Wartime military censorship and self-censorship meant that pictures that might aid the enemy or harm domestic morale were not released. Pearl Harbor is now a U.S. national historic landmark. A memorial has been built over the sunken hull of the USS *Arizona*. B.L.M.

Gordon William Prange, with a new afterword by Daniel M. Goldstein and Katherine V. Dillon. *At Dawn We Slept: The Untold Story of Pearl Harbor.* New York, 1991.

SEARCHING FOR DEAD RELATIVES
February 1942 Crimea, USSR
Photographer: Dimitri Baltermants

In the spring of 1942 after the snow had melted, revealing the dead fallen in battle, inhabitants of the city of Kerch on the Crimea searched among the bodies for family members. The photographer Dimitri Baltermants immortalized this heart-rending scene when he passed through the embattled Crimean peninsula. This image captures the suffering of the Russian civilian population victimized by the brutality of the war.

What was the military background to the scene in the image? Following the rapid advance of the German Wehrmacht in the summer of 1941, the Crimean peninsula offered a natural refuge for the retreating Russian forces. By land it could only be reached by a narrow isthmus, and the surrounding waters were controlled by the Soviet Black Sea fleet. But at the end of October 1941, after extremely bloody fighting, access to the Crimea fell into the hands of the Germans. They occupied the cities of Simferopol, Fedosiy, and Kerch. On January 10, 1942, Stalin ordered counterattacks on German positions at Leningrad and in the region of Kerch. But these offensives failed, and the Russian troops were left weakened and without supplies. The fighting resulted in tens of thousands dead, with many civilians among the victims. Numerous brutalities were committed against the populations of entire villages. The German forces justified their actions by referring to the "Jurisdiction Decree Barbarossa" and the "Commissar Decree."

When Baltermants developed his film in Moscow some time later, he encountered problems. First of all, his negatives were damaged. This photograph, for instance, had two holes at the top and poor contrast in the upper half of the image. He compensated by montage with another take. He inserted a cloud-covered sky and actually achieved a dramatic enhancement of the scene. But he knew also that the photo with its deeply human and moral dimension would not pass the censors. His assignment had been to document the heroic deeds of the Red Army and to strengthen the morale of the civilian population.

The photograph remained unpublished until twenty years after the war, when, in 1965 Baltermants sent this picture, entitled "Suffering," from his Kerch series to be part of the Hamburg exhibition "Was ist der Mensch" (What is man). In the following five years, as the exhibition travelled to many countries, the photograph became famous. Illustrated magazines such as *Life, Stern,* and *Paris Match* as well as hundreds of photographic publications reprinted the photo. Today, the photo stands as a pictorial icon for the infinite suffering of any civilian population in war. It has gained universal meaning.

E.I.

Peter Young and Peter Jeser. *The Media and the Military: From Crimea to Desert Strike*. New York, 1997.

DIMITRI BALTERMANTS (1912–1990) was a photographer for *Izvestia* and the army paper *Na razgrom vraga*. He reported in the Second World War on the battles at Moscow, Sevastopol, Stalingrad, and on the Soviet advance through Poland. After the war, he worked for the magazine *Ogonyok* and edited several photographic books. Baltermants became famous for his journalistic experience and his ability to capture the essential drama of events in his images.

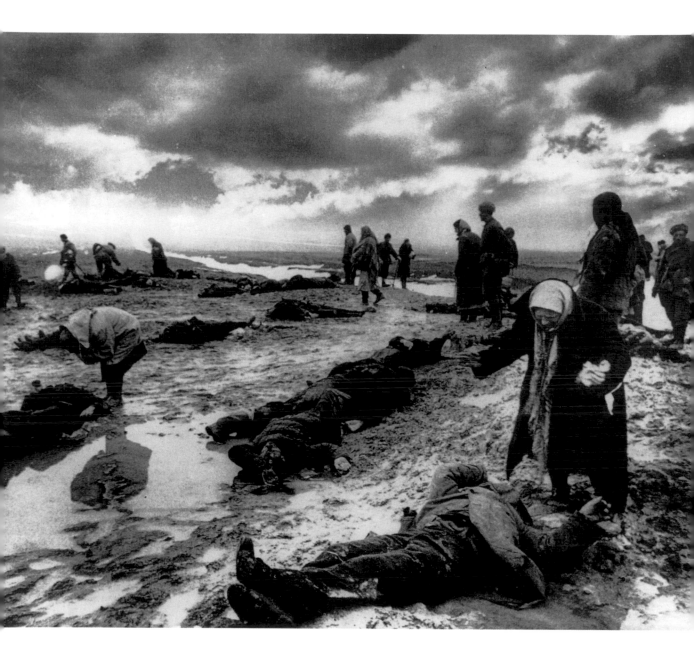

DEPORTATION FROM THE WARSAW GHETTO
April 1943 Warsaw, Poland

On January 18, 1943, German guards and SS troops deported five thousand
Jews from the Warsaw Ghetto in Poland. Most of the prisoners were transported
to Treblinka concentration camp, where it is believed they were executed.

The Ghetto was established by the Nazis in 1940. By the winter of
1941, starvation was endemic and many died from the combined
effects of hunger and cold. An uprising by a group of Jews living
in the Ghetto in April 1943 led to further reprisals and deportation
by the Nazis.

This photograph, now part of the Yad Vashem collection in
Israel, documents one of the many deportations that took place in
the Warsaw Ghetto during 1943. The deportation shown in the
photograph was probably one of the reprisals by the SS after the
uprising of April 1943. At the centre of the photograph, a small
boy holds up his hands in a gesture of surrender. Although there
are many photographs that convey the horror and pathos of the
Holocaust, this image has come to represent, perhaps more than
any other, the suffering of those who lived in the Warsaw Ghetto.
The child is clearly terrified of what lies before him, while the

soldier who guards the fleeing women and children is nonchalant,
pleased to be photographed.

The movement in the photograph is frenetic: people signal to
friends and relatives, children peer out from behind their parents
as all are herded towards the place of deportation. The scene is full
of tension and pressure; only the soldiers are calm and collected.

Photographs like this one, recovered by the Allied troops after
the liberation, were invaluable testimony of crimes against humani-
ty, and many were used as evidence during the Nuremberg trials.
Despite being published and included in the displays of Holocaust
museums around the world, these photographs have an enduring
power that does not diminish over time. V. W.

Martin Gilbert. *The Holocaust*. London, 1987.
Chana Byers Abells. *The Children We Remember: Photographs from the Archives
of Yad Vashem*. London, 1983.

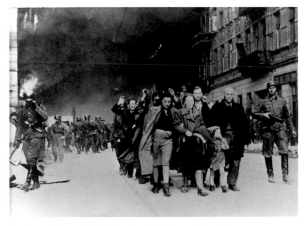

Survivors of the uprising being deported, Warsaw, May 1943.

A LARGE NUMBER OF PHOTOGRAPHS documenting aspects of the Holo-
caust, from mass executions to convivial drinking parties, were taken by
German soldiers as mementos of the war, and were often sent home to
family and friends in other parts of Germany. Kurt Franz, the last com-
mandant of Treblinka, had a carefully arranged personal photograph album
that documented life at the camp. German soldiers who took photographs
of executions were frequently reprimanded by their superiors. The author
of this photograph is anonymous, but it is likely that it was made either
by an official army photographer or by a German soldier keen to capture
the action of the moment.

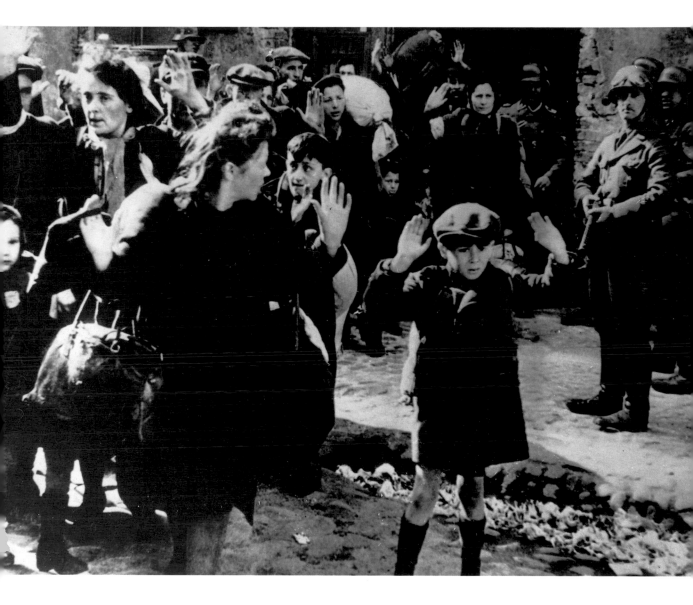

NORMANDY LANDINGS
June 9, 1944 Normandy, France

On June 6, 1944, the long-planned invasion of Normandy by American, British and Canadian forces began the drive to defeat Hitler. D-Day saw 150,000 men land across five beaches between Caen and Valognes; by the end of the day, they had begun to push into France.

This photograph was taken three days after the Normandy beachhead was established, on June 9, 1944, and shows the colossal scale of the operation to transport men and material for the liberation of Europe. Landing craft disgorge personnel carriers loaded with U.S. troops while supply ships lie docked offshore and barrage balloons guard against air attack. The landings even had their own portable docks, nicknamed Mulberry harbours, huge concrete blocks that were sailed across the English Channel and beached.

The image of total organization this photograph conveys is slightly deceptive. Three days into the invasion of Normandy the Allies already look at home in France, unloading apparently limitless troops and equipment with reassuring efficiency, but D-Day had its moments of desperation and terror, particularly for Americans who landed at Omaha Beach and whose horrific casualties were recorded by the photojournalist Robert Capa.

Yet this picture tells a truth about the Normandy landings and the last phase of the Second World War. Once the Allies were in France, with German forces fighting on two fronts as the Soviet Union fought westward, defeat for Hitler was a matter of time. This photograph captures the optimism of that moment; it conveys not the heroism of individual soldiers on the ground but the vast military machine that backed them up. It is a picture of the collective effort that won the war. "The history of war does not show any such undertaking so broad in concept, so grandiose in scale, so masterly in execution," Joseph Stalin congratulated Winston Churchill. J. J.

Max Hastings. *Overlord: D-day and the Battle for Normandy 1944*. New York, 1999.

THE MEN AROUND ME LAY MOTIONLESS. Only the dead on the waterline rolled with the waves. An LCT braved the fire and medics with red crosses painted on their helmets poured from it. I didn't think and didn't decide it. I just stood up and ran for the boat. . . . As I reached the deck I felt a shock, and suddenly was covered in feathers. . . . I saw that the superstructure had been blown away and that the feathers were the stuffing from the kapok jackets of the men who had been blown up. The skipper was crying. His assistant had been blown up all over him and he was a mess.
—Robert Capa, recalling June 6, 1944, on Omaha Beach

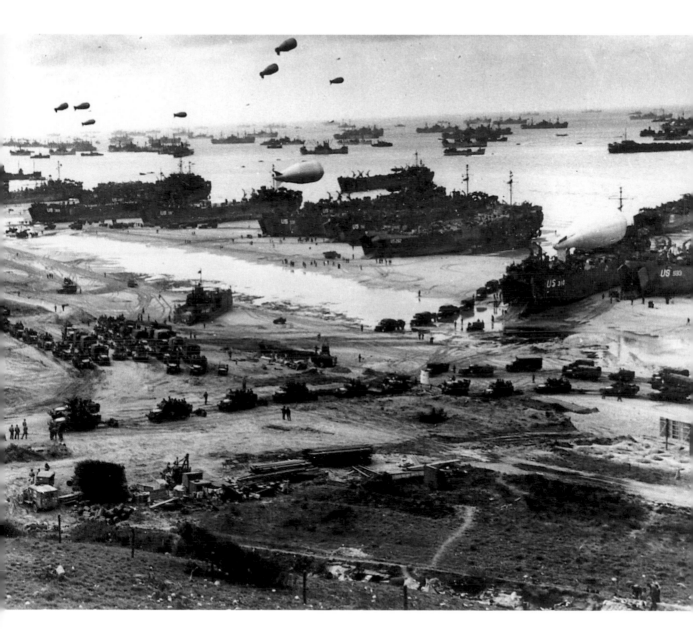

DRESDEN DESTROYED

February 1945 Dresden, Germany

Photographer: Walter Hahn

During the night of February 13–14, 1945, Dresden became the target of the most horrific bombing of the Second World War in Europe. The bombs and the resulting firestorms killed more than 25,000 people, among them refugees in transit from the East. Within a few hours, the historic core of the city with its irreplaceable art treasures was reduced to rubble.

The photographer contrasted the devastation of Dresden with a statue at the city hall tower—not an angel, but a personification of Kindness —that had somehow survived the bombardment of February 1945. It once looked out over the glorious panorama of the Saxon capital, which had its cultural origins in the seventeenth and eighteenth centuries. Now, before it lies a sea of ruins, void of human life. The statue's extended arms stir the emotions.

Let us consider the historic background. With the start of the Soviet offensive in January, hundreds of thousands of people, mostly from Upper and Lower Silesia, fled by train, by horse-drawn carts, or on foot towards the West. Dresden was their first stop, a city practically untouched by the war. The population in the east had until then had no experience with air raids. It was only with the advances on the southern and western fronts that targets in central Germany could be reached by the Allied bombers. The narrow, crooked streets of the city did not frighten the refugees; they looked to them for shelter and assistance. Approximately 200,000 refugees were in the city at the time of the attack in addition to the 700,000 residents. Dresden was completely unprepared for aerial attacks; no bomb shelters had been built.

British and American formations of 1,250 planes flew four major assaults between February 12 and 15, officially against supply lines despite the fact that there was no war industry in Dresden. After the first wave, the air raid sirens failed and subsequent attacks caught people in the streets and at the railway station without warning. The centre of Dresden became a sea of flames after the second attack.

From a military perspective, this most severe conventional bombing attack in the European theatre had no direct military value as the supply lines were interrupted very briefly. Only the final attack had a tactical purpose since it immediately preceded the occupation of the city by Soviet troops. E.I.

Alexander McKee. *Dresden 1945: The Devil's Tinderbox*. New York, 1984.

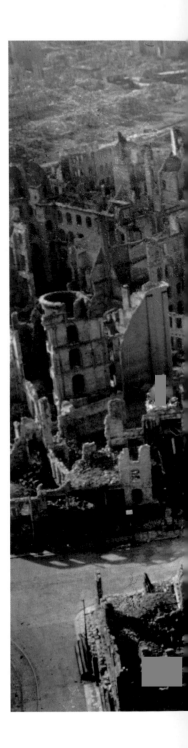

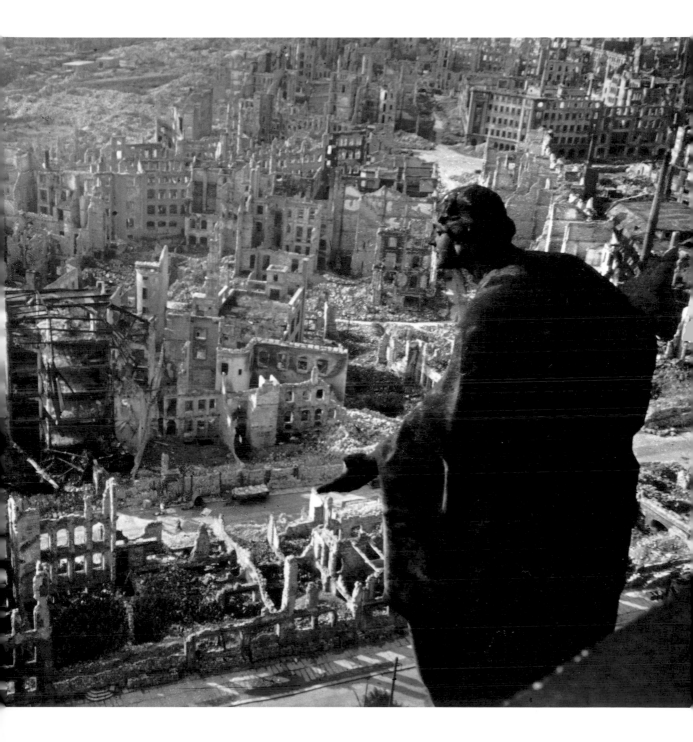

RAISING THE FLAG

February 23, 1945 Iwo Jima, Japan

Photographer: Joe Rosenthal

Iwo Jima, the site of a Japanese air base some six hundred miles off the coast of Japan, was a strategically critical spot during early 1945. Allied forces wanted to seize the island as a staging ground to bomb Japan, but Japanese troops had created a stronghold of tunnels in the island's volcanic rock. In some of the fiercest battles towards the end of the Second World War the death count was more than 20,000 Japanese and nearly 7,000 Americans.

The Associated Press photographer Joe Rosenthal took this Pulitzer Prize-winning picture of American soldiers raising their country's flag over Iwo Jima on February 23, 1945. Before the fighting ended, American marines captured the island's 166-metre (546-foot) Mount Suribachi, an extinct volcano. Rosenthal climbed to the top just as five marines and a navy hospital corpsman were getting ready to raise a flag large enough to be seen from ships off shore as well as from any spot on the entire island.

This picture was not posed. A misunderstanding led some people to think that it was. In fact, Rosenthal had to work so quickly that he was unsure whether his two unposed shots had succeeded. So, he made a final version of marines posed around the flagpole, and sent the film off the island to be processed. When his flag-raising picture (which he had not seen) was praised and he was asked whether it was posed, at first he said "yes," assuming that the last picture was the successful one, but that statement was soon corrected.

The picture's composition and patriotic energy do seem perfect. As in Eugene Delacroix's painting, *Liberty Leading the People,* an unfurled national flag, upraised hands, and strong diagonal lines arouse patriotic emotions. But while Delacroix had the luxury of working in an atelier in 1830, Rosenthal's picture was taken on a battle-torn Pacific island. It has been reproduced countless times, from a poster for war bonds to a postage stamp; it was also reenacted for the film *Sands of Iwo Jima.*

The teamwork of the picture's faceless subjects and the victory symbolized by raising the Stars and Stripes served as a visual morale-booster to Americans during the last difficult months of the war.

B.L.M.

Vicki Goldberg. *The Power of Photography: How Photographs Changed Our Lives.* New York, 1991.
James Bradley, with Ron Powers. *Flags of Our Fathers.* New York, 2000.

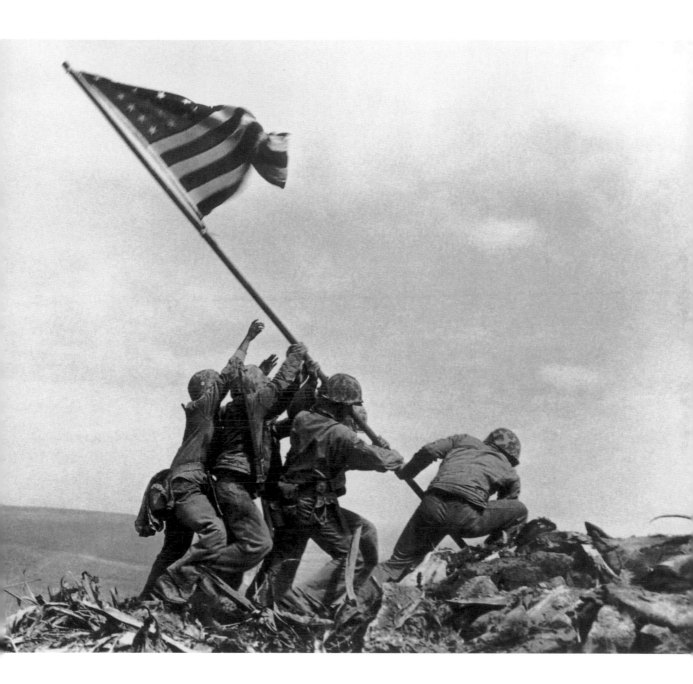

CONCENTRATION CAMP AFTER LIBERATION
April 11, 1945 Buchenwald, Germany

Buchenwald concentration camp, located in the suburbs of Weimar, was liberated by the U.S. Army. But by the time troops reached the camp, most of the surviving Jewish prisoners had been forced to take part in death marches as the Nazis fled. The prisoners who remained were too weak and sick to walk.

Buchenwald was established in 1938. Prisoners were used as slave labour in the neighbouring V-bomb plant. Many distinguished members of the Viennese intelligentsia ended up at Buchenwald as prisoners of the Nazi regime. General George Patton was so enraged by what he saw at Buchenwald that he ordered a round-up of the citizens of Weimar and forced them to walk through the camp to witness the appalling conditions there. All denied knowledge of what had happened at the camp.

Although this photograph is not credited, it is likely that it was taken either by *Life* photographer Margaret Bourke-White, who entered Buchenwald with the American 3rd Army on April 11, 1945, or by an official U.S. Army photographer accompanying her. The photograph was taken in one of Buchenwald's barracks, where prisoners who had escaped the forced marches awaited the coming of the Allies.

This image was one of the many that presented evidence of the Nazi atrocities to an incredulous world. Bourke-White and other *Life* photographers (including George Rodger and David Seymour) reported on the liberation of the camps across Europe. The photographs published in *Life* magazine informed a mass American audience about the grim facts of the Holocaust.

Several photographs similar to this one appeared in Bourke-White's 1946 book *Dear Fatherland Rest Quietly,* a description of her journey across Europe with the U.S. Army in 1945. The claustrophobia of the crowded bunks, the lack of light, and the questioning gazes of the prisoners are clearly documented in this photograph, which has become one of the classic images of the liberation. V. W.

Margaret Bourke-White. *Dear Fatherland Rest Quietly.* New York, 1946.
Susan D. Moeller. *Shooting War.* New York, 1989.

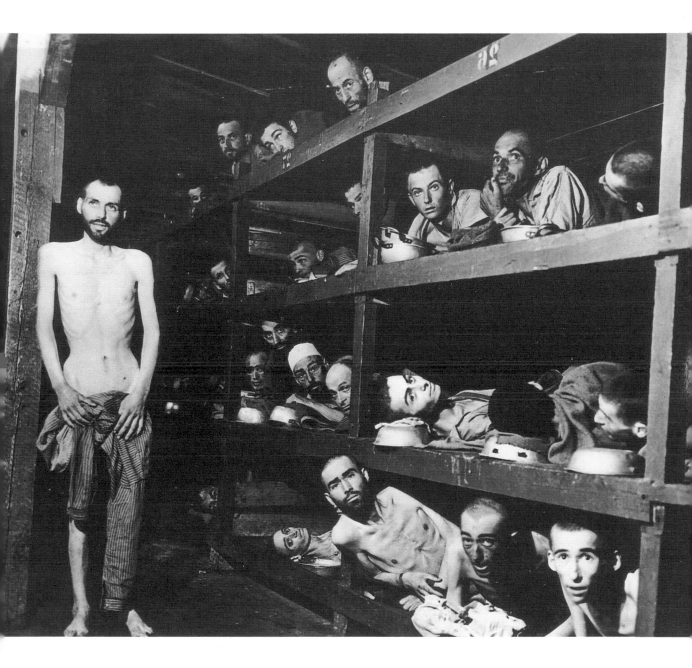

BOMBING HIROSHIMA
August 6, 1945 Hiroshima, Japan
Photographer: George R. Caron

At 8:15 a.m. on August 6, 1945, an atomic bomb exploded over the city of Hiroshima in Japan. Lifted upward by strong air currents, the pillar of radiation-laden smoke reached the bottom of the stratosphere, forming a mushroom cloud.

The atomic bomb brought a sudden end to the Second World War. Previously untouched by the war, the city of Hiroshima was reduced to rubble in a fraction of a second. Destruction on this scale had previously only been imagined, and the capability of this new warfare made the world seem a more dangerous place. As a symbol of our potential for self-extinction, this image of a cloud over the city is imprinted on all our memories.

The atomic bomb was developed by the Allied forces led by the scientist Robert Oppenheimer under the code name "The Manhattan Project." Lieutenant Colonel Tibbets, pilot of the B-29 *Enola Gay* that dropped the bomb, recalled: "A bright light filled the plane. We turned back to look at Hiroshima. The city was hidden by that awful cloud . . . boiling up, mushrooming." It is this moment that we can see in the photograph. Ten times brighter at ignition than the sun, the devastating effects of this weapon were produced by the splitting of atomic nuclei at the centre of the

bomb. Out of a population of 350,000 it was estimated that 45,000 died in Hiroshima on the first day and a further 19,000 during the subsequent four months. A total of 200,000 people died from radiation-related illnesses in the ensuing years.

This photograph illustrates the destructive power of the newly developed weapons. In the context of the burgeoning Cold War, the image served as a warning to the Soviet powers of the strength of America and her allies. The viewpoint is from the bomber itself; otherwise, this image of the mushroom cloud would be impossible to see, yet here it is in a photograph that appeared in newspapers around the world. The photograph thus gave concrete reality to the atomic bomb, which until the destruction of Hiroshima had existed only in the imagination. L.L.F

Michael Hogan, ed. *Hiroshima in History and Memory.* Cambridge, 1996.
Vincent Leo. "The Mushroom Cloud Photograph: From Fact to Symbol," in *Afterimage* 13, Summer 1985, pp. 6–12.

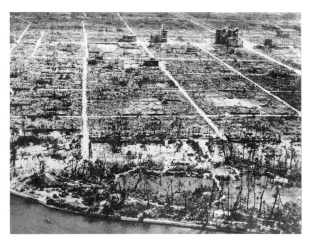

Hiroshima destroyed, 1945.

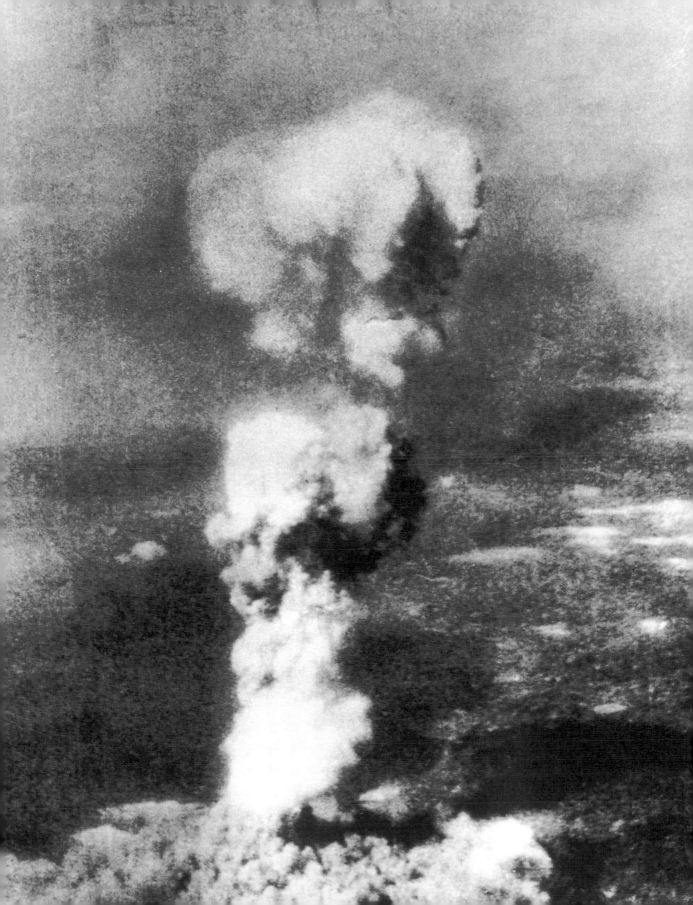

GANDHI AND THE SPINNING WHEEL

1946 New Delhi, India

Withdrawn and ascetic, Mahatma Gandhi lived to see his life's ambition ful-filled, the independence of India. His non-violent political struggle over many decades made him a living legend. He used his public stature to exert influence over hundreds of millions of Indians with symbolic acts—such as working on the spinning wheel.

The son of a chief minister, Mohandas Karamchand Gandhi (1869–1948) studied law in London and practised for twenty years in South Africa. His first campaign of civil disobedience was prompted by the massacre at Amritsar perpetrated by British soldiers. Through *Asahayoga* (non-participation) in civil institu-tions he developed an effective and simple strategy for a mass protest movement. His premise was that the complicity of the Indian population enabled the British to rule such a large country with only 1,000 civil servants. A traditionalist, he instigated a boycott of British companies and goods and promoted ancient production methods such spinning as a means of overcoming economic dependence.

American photojournalist Margaret Bourke-White, who met Gandhi on several occasions, later wrote about the significance of the spinning wheel: "For millions of Indians it was the symbol of their struggle for freedom. Gandhi was very astute in his assess-ment of the economic and spiritual power this would have. If mil-lions of Indians could be persuaded to spin fabric for their own clothing instead of buying textiles made in the factories of the British colonial power, the boycott would have a huge impact on the British textile industry. The spinning wheel was therefore the key to victory. Non-violence was Gandhi's motto and the spinning wheel was his strongest weapon."

Similar motives had prompted him in 1930 to lead hundreds of thousands to the ocean to collect salt in a protest against the punitive salt taxes and virtual salt monopoly of the Raj. When the British needed India's support during the Second World War, Gandhi immediately demanded his country's independence. Gandhi did not hold an office in government at the time, yet he was consulted with regard to every important question during the independence negotiations with the British Cabinet Mission. When violent dissent broke out between Hindu and Muslim communities in the wake of the division of India into two nations with the foun-dation of Pakistan (August 1947) and the subsequent conflict over Kashmir, the seventy-eight-year-old staged a fast to bring an end to the atrocities. His fasting had great symbolic meaning in India: it awakened a feeling of urgency and demonstrated the necessity to abandon old ways of thinking and the need for new solutions. Shortly after this action on behalf of non-violence and tolerance, on his way to a prayer meeting on January 30, 1948, Gandhi was assassinated by a Hindu fanatic from the Brahmin caste. The death of this simple yet complex man, who embodied all the contradic-tions of Indian society, marked the end of India as a traditional, colonial nation. E.I.

Margaret Bourke-White. *Portrait of Myself.* Boston, 1985.

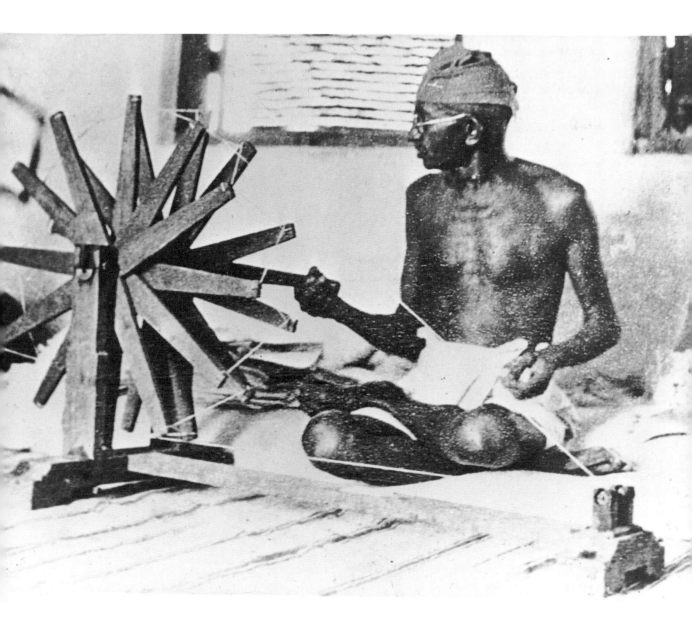

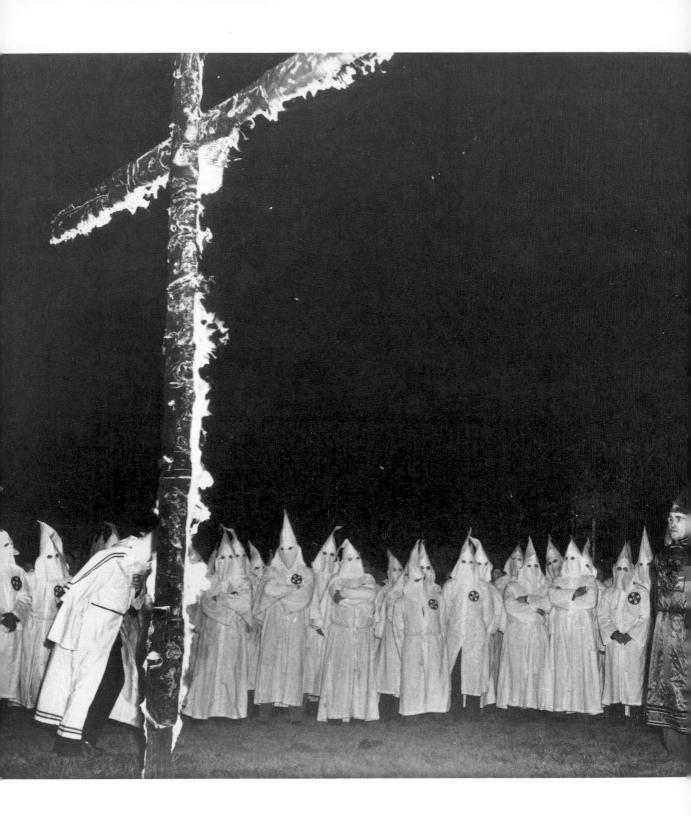

THE BURNING CROSS

March 2, 1948 Wrightsville, Georgia

Dr. Samuel Green, the grand dragon or leader of the Ku Klux Klan in Georgia (standing unmasked on the right side of the photograph), and about three hundred white-robed and hooded members of the racist organization, burned a 4.5 metre (15 foot) cross on the courthouse lawn in Wrightsville, Georgia. The event was staged to protest President Harry S. Truman's efforts towards racial integration but was specifically aimed (and succeeded) at preventing a few hundred registered black voters from participating in a Democratic Party primary election the following day.

Dr. Green (who was an obstetrician) led a revival of the Ku Klux Klan after the Second World War. The Klan, which has always been most active in the southern United States, was formed in Tennessee in 1866 and thrived in the years following the Civil War, using terror, whippings, and lynchings to oppose the federal government's equal rights policies and to keep black voters from the polls. The Klan's ghostlike costumes—designed to look like spirits of Confederate troops—were meant to frighten superstitious blacks; masks were used to prevent identification by occupying federal troops. By the early 1880s the Klan had almost disappeared, because its aim—the restoration of white supremacy in the South—had been achieved.

In 1915, the Klan was revived in Georgia as an even more bigoted and widespread organization; it had an estimated national membership of over 4 million during the 1920s. The new Klan was hostile to blacks, Roman Catholics, Jews, foreigners, and organized labour. Marches, parades, and night-time cross burnings throughout the United States were typical of their tactics. Federal and state laws against masked demonstrations, corruption within the Klan, and the economic hardships of the Great Depression cut the membership until the Klan disbanded temporarily in 1944.

Dr. Green's efforts to revive the Klan ultimately failed, as the organization splintered and states banned it entirely. Violence against civil rights workers in the South during the 1960s was evidently the work of Klan members. However, the denunciation of the Klan by President Lyndon B. Johnson, himself a Southerner, helped to reinforce a new racial tolerance in the South. Membership in the Klan during the late twentieth century is said to have declined to a few thousand, some of whom in recent years have taken their messages of hate to cyberspace. B. L. M.

David M. Chalmers. *Hooded Americanism: The History of the Ku Klux Klan*. Durham, 1987.
Wyn Craig Wade. *The Fiery Cross: The Ku Klux Klan in America*. New York, 1998.

PORTRAIT OF EINSTEIN
1948 Princeton, New Jersey
Photographer: Yousuf Karsh

Albert Einstein (1879–1955) was Professor Emeritus at the Institute for Advanced Study, Princeton University, when this picture was taken by Yousuf Karsh, the great portrait photographer. It has become the iconic portrait of the physicist and Nobel Prize winner (1921), indeed of the socially engaged intellectual of the twentieth century.

"I am a decided, but not absolute pacifist, that is to say that I oppose the use of force under any circumstances, except when I am confronted by an enemy whose declared aim is the destruction of life. I have always condemned using the atomic bomb against Japan." After 1945 Einstein spoke out publicly concerning the threat of nuclear annihilation. In 1952, he was offered the presidency of the state of Israel but declined.

Yousuf Karsh's portrait shows the face of a man marked by profound experience. Einstein is seated, his head tilted forward ever so slightly. His eyes are mildly melancholy yet attentive. His hands are held as if in prayer, suggesting the thoughtfulness of a man of conscience. The impression of a certain intimacy can be attributed to the impression that he is moving towards the viewer. Dramatic lighting sets off Einstein's head against a neutral background. The delicate balance between light and shadow, form and negative space, gives the image a structure and rich texture, conveyed most clearly through the clothing and lined face of the subject. Karsh's work falls into the tradition of portraiture that dates back to the Renaissance, when carefully constructed portraits were used to preserve the images of public leaders for posterity.

In 1905, Einstein published his quantum theory of light and introduced the special theory of relativity. When he fled Nazi Germany in 1933, emigrating from Berlin to the United States, he was already world famous. For more than a decade he taught at Princeton University. He became Professor Emeritus in 1945, but continued his research at the Institute for Advanced Study. The famous scientist was shy and lived a somewhat secluded life in a small house. "You are surprised, aren't you, at the contrast between my renown in the world, the gossip about me in the newspapers, and the isolation and quiet in which I live. I have longed for this peace all my life, and found it here in Princeton."

I.L.S.

Albrecht Fölsing. *Albert Einstein*. New York, 1999.
Icons of the Twentieth Century: Portraits by Yousuf Karsh. Albany, 1999.

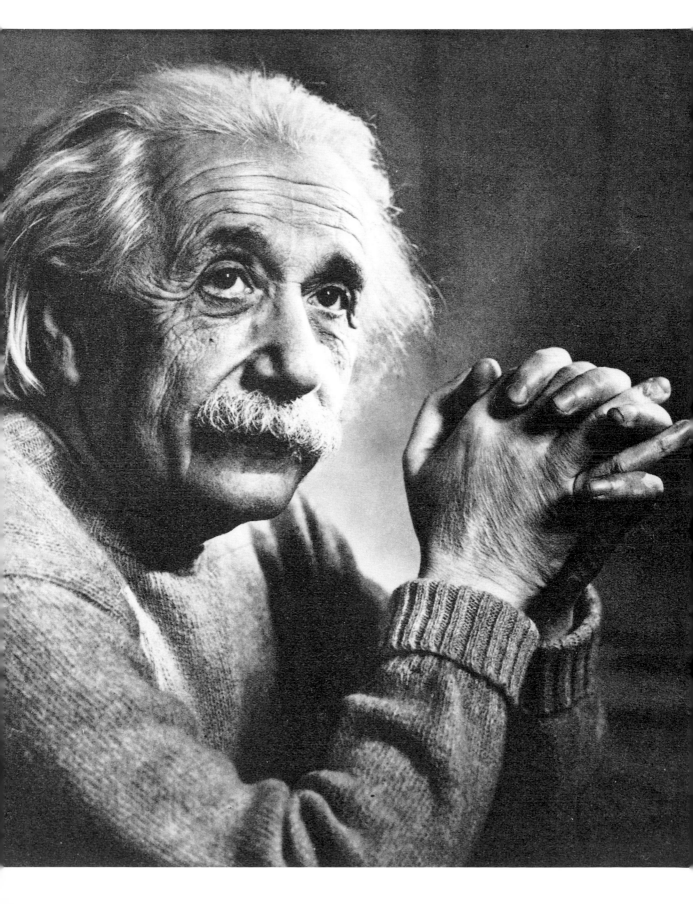

KOREAN WAR
February 1951 Korea
Photograph: U.S. Air Force

As the war against Communist forces in Korea escalated, U.S. bombers attacked targets in the countryside. The American public still supported the war effort, but there was growing criticism of what was seen as the government's inability to supply fully trained troops or adequate resources, together with doubts about American involvement in foreign political conflicts that claimed American lives.

This photograph, probably taken by a U.S. military photographer, shows the ferocity of the American offensive in predominantly rural Korea. The United States intervened in Asian politics during the Cold War, first in Korea with UN forces and later in Vietnam. American military strategy grew to rely on the indiscriminate bombing of primarily rural, peasant populations. In this image, hundreds of bombs rain onto a landscape of mountains and rivers, with no traditional military target in sight. Such is the stillness and silence of the scene that it is almost impossible to imagine the death and destruction below.

The Korean War was incomprehensible to the ordinary American, even though anti-Communist propaganda had succeeded in convincing the public that the conflict was inevitable. The presence of press correspondents and photographers in Korea was greater than it had been during the Second World War. Photographs and newspaper reports revealed individual human suffering and reported on the use of napalm, leading to the beginning of animosities between the press and the U.S. military authorities.

V. W.

Margaret Bourke-White. *Portrait of Myself*. Boston, 1985.
David Douglas Duncan. *This is War!* New York, 1951.
Susan D. Moeller. *Shooting War: Photography and the American Experience of Conflict*. New York, 1989.
"Korea: Carl Mydans." *US Camera Annual*. New York, 1951.

THE KOREAN WAR ATTRACTED an enormous number of reporters and photojournalists. *Life* magazine fielded its star photographers Margaret Bourke-White, Carl Mydans, and David Douglas Duncan. Many of the photojournalists working in Korea had also accompanied the Allied armies as Europe was liberated after the defeat of Germany in the Second World War. The U.S. forces also trained large numbers of photographers and cameramen, producing photographs for use in military strategy. In Korea, David Douglas Duncan was particularly critical of U.S. involvement, and his photographs of young, exhausted, and bewildered Marines have become symbols of this humiliating chapter in American history.

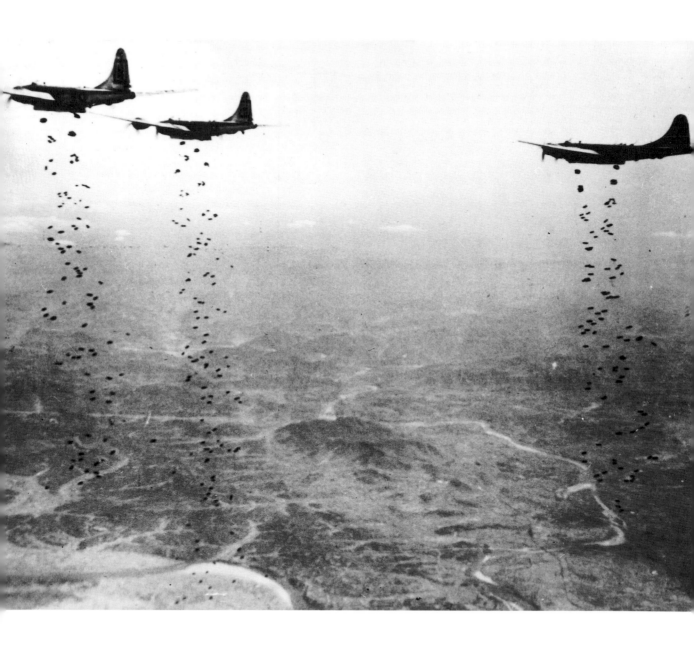

THE ASCENT OF EVEREST
May 1953 Foot of Mount Everest, Nepal

Sir Edmund Hillary and Sherpa Tenzing Norgay set off on their attempt to climb Mount Everest. If successful, the two climbers would be the first to reach the 8,848-metre (29,028-foot) summit of the mountain, which lies in Nepal near the border of China. Hillary, a New Zealander, was part of the reconnaissance party to Everest in 1951. Tenzing Norgay is a renowned Nepalese mountaineer.

This simple snapshot perhaps conveys more than the most skilful mountaineering photograph. Posing together before making their attempt on the summit, Hillary and Tenzing Norgay seem both proud and anxious. They hold food and drink, and appear to be embracing the realities of everyday life in the knowledge that they are about to risk their lives. The photograph tells a very simple, yet highly evocative story. Two men, whose bodies and psyches are to be pitted against a treacherous combination of high altitude, extreme weather conditions and uncharted territory, enjoy their last moments in the relative normalcy of the base camp. The photograph emphasizes their physical vulnerability as well as their pride in being chosen to attempt this dangerous mission.

This is not a heroic portrait, emphasizing masculinity, strength and skill; but in its lack of glamour and photojournalistic thrust, it perhaps emphasizes the achievement of these two men even more powerfully. Hillary and Norgay became world heroes in the early 1950s, but in the photograph there are no signs of the public adulation that would come their way. Instead, the portrait stresses the bond between them, their closeness and companionship. It shows a private moment which would become an iconic image of achievement and tenacity.

The ascent of Everest heralded an enormous interest in exploration and adventure during the 1950s and '60s. Once conquered, Everest became a mecca for mountaineers from all over the world. Hillary went on to join the Transantarctic Expedition of 1957, and became the first person since Amundsen and then Scott (see p. 22) to reach the South Pole overland over forty years later.

The photographer who made this picture is unknown, but it is likely that it was taken by a member of the expedition team. Expedition photography has a long and intriguing history, and notable practitioners include Herbert Ponting, who accompanied Scott's doomed journey to the South Pole, and the Bisson brothers, who photographed in the Alps. V.W.

Sir Edmund Hillary. *View from the Summit*. New York, 2000.

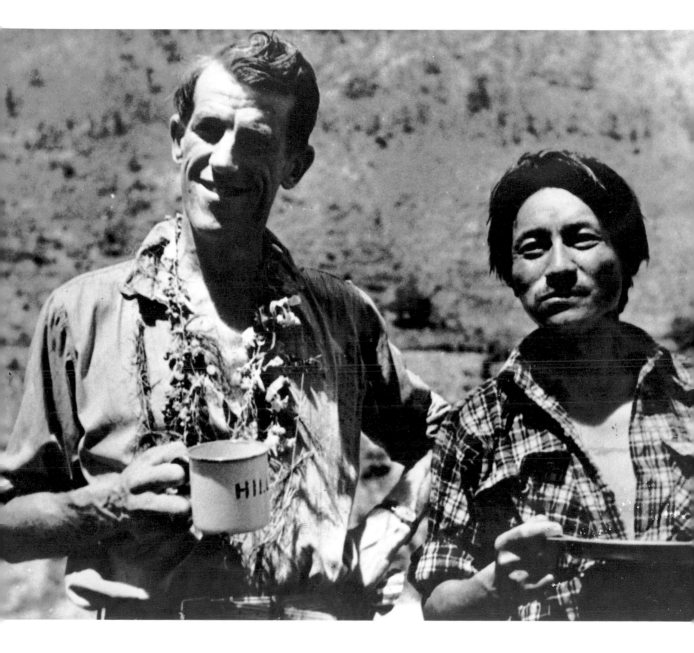

CORONATION OF ELIZABETH II

June 2, 1953 London

Queen Elizabeth II was crowned in Westminster Abbey, London, on June 2, 1953. Accompanied by two bishops, she is proceeding through the nave towards the west door of the Abbey after the coronation ceremony. The Queen wears a jewelled crown and holds the orb and the sceptre, symbols of monarchy. Six maids of honour carry her fur-edged, purple velvet train. Prime Minister Winston Churchill and four-and-a-half-year-old Prince Charles were among those who observed the ceremony. The 7,500 guests who filled the church also included dignitaries from the Commonwealth and members of European royalty.

The coronation service has remained essentially the same for over a thousand years: the Queen was consecrated to the service of God and the service of her people. She was anointed while seated in the Coronation Chair, made in the early fourteenth century and used for every coronation since that of Edward II in 1308. Yet elements of Elizabeth II's coronation were strictly mid-twentieth century. Post-war optimism filled Britain, as wartime controls diminished and prosperity returned. Heavy rain and wind scarcely dampened the spirits of the half-million people who, a day before the coronation, lined the route of the royal procession through central London, hoping to glimpse the smiling Queen as she rode by in a golden coach drawn by eight horses.

The most comprehensive view of the coronation was enjoyed by the estimated 27 million people in Britain who watched the events live on black-and-white television for at least half the day, not to mention many more who viewed it in western Europe and North America. (Films were flown across the Atlantic.) The televising of this event was revolutionary in two ways. Never before had the world been able to view a coronation; on the other hand, the broadcast constituted a break in the wall of privacy that had surrounded the royal family for generations—a wall that would continue to crumble until the present.

Among those who saw the coronation on television was the Duke of Windsor, who lived in Paris. The former King Edward VIII, whose abdication and marriage to the divorced American, Wallis Simpson, had caused much consternation in Britain, had not been invited. The abdication had put his brother on the throne as George VI, and immediately following George's death on February 6, 1952, his elder daughter, Elizabeth, became Queen.

B.L.M.

Ben Pimlott. *The Queen: A Biography of Elizabeth II*. London, 1997.

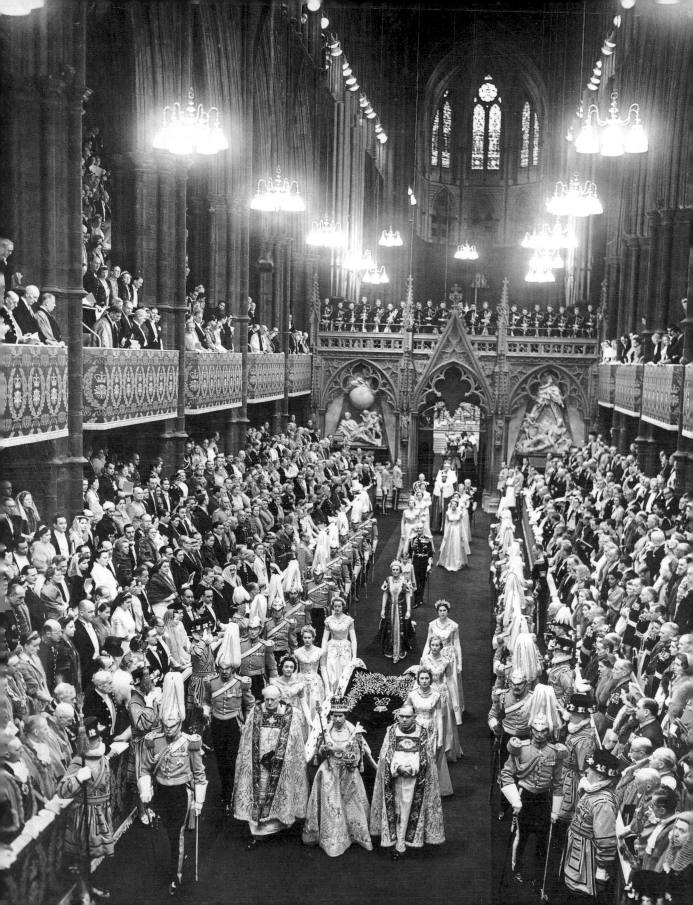

MARILYN MONROE

September 9, 1954 New York City

Photographer: Matthew Zimmermann

During a publicity shot for *The Seven Year Itch*, Marilyn Monroe stepped onto a
New York subway grille. The undulating skirt, floating around the figure, emphasizes
the dual seduction of movie star and spectator: Marilyn is seduced by the camera, and
in the same moment the photographer and spectators are seduced by her beauty.

Like Venus rising from the ocean waves in Botticelli's *Spring* in the
Uffizi Galleries in Florence, Marilyn's pose is both virginal and
seductive. The dress is a prop as well as a symbol. Light as a but-
terfly's wings, it expresses a lightness of being that was tragically
absent in the drama of her personal life. Our knowledge of the con-
trast between appearance and reality behind the iconic image
makes it all the more powerful and poignant.

The photograph introduced a new type of image. The publicity
shot for the film shows the star and the PR director side by side.
Marilyn Monroe, born Norma Jean Mortenson in 1926, was the
greatest sex symbol and female film icon of the twentieth century:
her charm combines eroticism, sensuality, sensitivity, and child-
like innocence. Her portraits in photographs and in film communi-
cate the carefree magic that drew so many people to her. Her pas-

sion and her intense relationship with the camera transformed the
starlet into the first female superstar, forever changing the percep-
tion of women in this industry dominated by men.

After a difficult and only moderately successful life in Holly-
wood she attended the Actors' Studio in New York in 1954 and
founded the Marilyn Monroe production company in 1955. In
1956 she married American playwright Arthur Miller, her third
marriage, and returned to Hollywood to film *Some Like It Hot*.
After many personal crises, her suicide in 1962 was nonetheless
unexpected and shocking. It contributed to the mythic status that
has surrounded the actress ever since. I. L. S.

Barbara Leaming. *Marilyn Monroe*. New York, 1998.

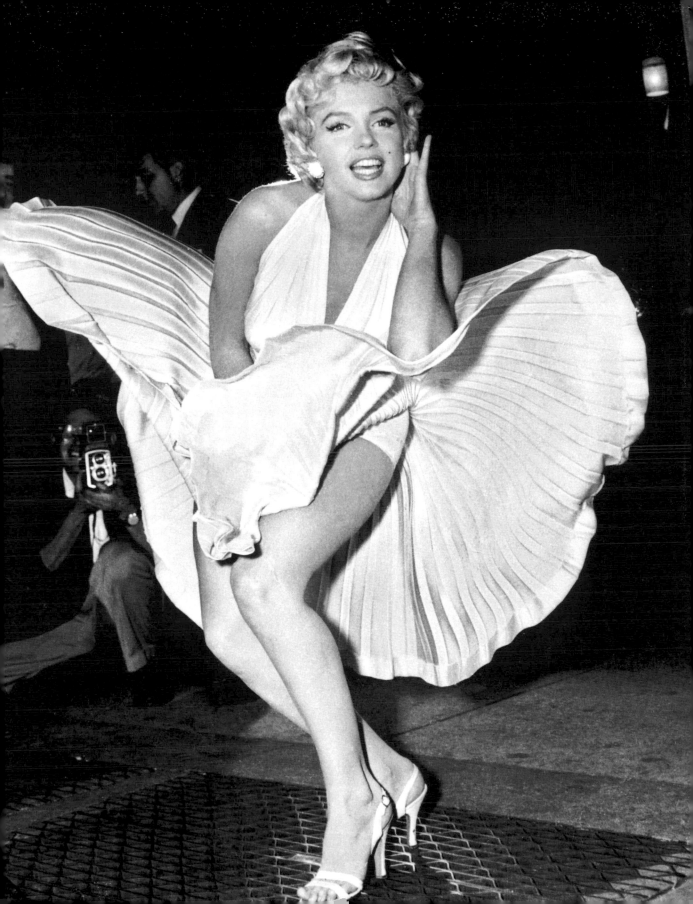

HUNGARIAN UPRISING
October 23, 1956 Budapest

On October 23, 1956, Hungarian students marched to present a petition to the Soviet power expressing the nation's discontent. Among other demands, they asked that the statue of Stalin in Budapest be destroyed. The crowd marched to Parliament and tore down the statue. Stalin's legs held fast, but the head toppled to the ground: this moment marked the beginning of the uprising.

Against a background of political subjugation and economic hardship, a group of students drew up a petition stating a number of popular demands: these included a call for political freedom, fundamental economic reform, return to the rule of law and the development of a more equitable relationship between the USSR and Hungary. Aside from these standard demands the petition requested that Imre Nagy be made premier, Soviet troops be withdrawn, the hated statue of Stalin be removed, and a gesture of solidarity be made to Poland by placing a wreath at the foot of the statue of the celebrated General Bem.

The laying of the wreath was planned for October 23, 1956, and was accompanied by an uneventful march. The crowd then split, with some making their way to the statue of Stalin. Erected on the site of a bombed-out church and made of bronze that had been melted down from statues of Hungarian royalty, the statue was a symbol of Soviet control. In the first act of violence of the uprising, the crowd pulled down the statue. Here we see the crowds moving past the toppled head of Stalin, marking the sense of freedom that the citizens of Hungary felt as they opposed Soviet domination. This photograph communicates in a single moment the surge of a revolutionary movement.

The formal qualities of this photograph further accentuate the symbolism of this image—we can see individuals in the street casually glancing at the toppled head. In the background an angled pole seems to bisect Stalin's head. The space around the head gives the impression that individuals are cautiously approaching this fallen symbol of an age now past. This action was firmly linked to Eastern European cultural and political uprisings—starting with Eisenstein's portrayal in the film *October* of people toppling a statue of the Tsar. The depiction of toppled statues in Eastern Europe has become firmly established as a starting point in revolution. L.L.F

Nigel Swain. *Hungary: The Rise and Fall of Feasible Socialism*. London, 1992.

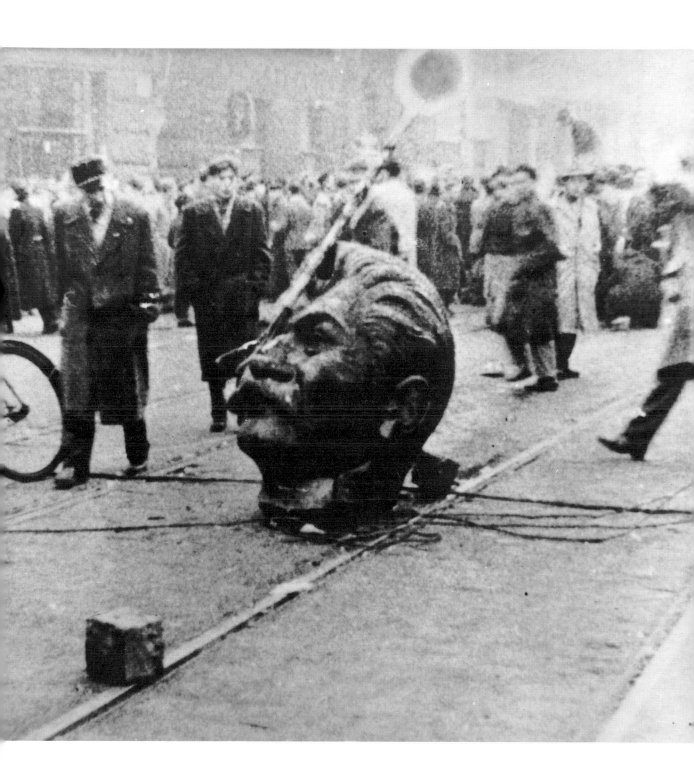

DEPORTATION OF TIBETAN PRISONERS

March 1959 Lhasa, Tibet

The darkest hour of Tibet's history is played out against the backdrop of the Potala as the Chinese crush the Tibetan uprising. A stream of refugees had been growing for several weeks as many fled from the east and northeast of Tibet where a partisan war had broken out. In Lhasa, the situation was increasingly desperate as more refugees crowded into an already overcrowded city. Fearing for the safety of the Dalai Lama—amid rumours that the Chinese planned to kidnap him—thousands gathered around Norbulingka Palace to protect their political and spiritual leader. On March 17, the Dalai Lama fled to India. A massacre ensued during which 15,000 Tibetan rebels were killed in Lhasa alone.

By sending the People's Liberation Army into Tibet's Amdo and Kham regions, Mao Zedong's name joined the list of infamy: Hitler, Stalin, Pol Pot—and Mao—perpetrators of genocide and terror. Since 1949 the annexation of Tibet has claimed over a million victims; 100,000 have been tortured to death. In eastern Tibet —approximately two-thirds of the country, which was seized as Chinese "provinces"—and in the remaining third, which was named the "Autonomous Region of Tibet" in 1965 but which was in truth ruled by Beijing, the population suffered under a barbarous dictatorship. Massacres, executions infamous for their savagery, forced abortions and sterilization, deportations and the "re-education" of children were the order of the day. Tens of thousands of villages and monasteries were razed.

Only a handful of images document the Chinese war against the Tibetans. Given the fact that the occupation has continued for decades, with dramatic events, clashes, and acts of aggression occurring daily, the lack of photographs is particularly shocking. Chinese military archives, where such documents might be found, are not accessible. Moreover, Beijing persistently enforced media blackouts or manipulated what little news coverage of the events it did allow. Every now and again, bits of information about the conditions in the hermetically sealed country would trickle out, but without photographs to provide the corresponding visual docu-

mentation. Fearing Chinese reprisals, Indian prime minister Nehru also imposed a news blackout, after having granted the Dalai Lama political asylum in 1959. "Out of gratitude to Nehru, the Dalai Lama kept silent for two months," reports Mary Craig in her book *Tears of Blood*. He didn't give a press conference until June, when the full extent of the horror and the massacres was made public.

This photograph is thus extremely rare. There is no clear information as to how it was taken and by whom. The deportation of the prisoners appears organized and orderly. The column is led by a man bearing a pole to which white scarves are tied as a symbol of surrender and one red flag; to the right stands a Chinese. The photograph creates the impression of a peaceful, carefully planned operation with Lhasa's main attraction in the background, as if this were a postcard. However, the "harmless" impression conveyed by the photograph contradicts all other reports of the massacre in Lhasa in March of 1959, after which there were "piles and piles of bodies reaching up to the branches of the trees." No corpses, no wounded, no signs of violence—the photograph shows none of the atrocities that accompanied these deportations and, in all likelihood, what we see here is a Chinese propaganda photograph. P.S.

Mary Craig. *Tears of Blood*. London, 1992.
Tibetan Young Buddhist Association. *Tibet: The Facts*. Dharamsala, 1990.

AFTER THE FAILURE OF THE UPRISING and the closing of its borders, Tibet was reduced to a Chinese gulag. In 1961, as a result of forced collectivisation and the attempt to grow crops unsuited to the climate, a famine broke out that would last three years. Beijing's insidious goal became to outnumber the Tibetans by means of a massive settlement of Han Chinese in the region: four Chinese to each Tibetan. An apartheid system ruled supreme in the land, whose harsh racism surpassed conditions in South Africa. Nonetheless, uprisings broke out in 1987, 1988, and 1989. Second-class citizens in their own land, the BBC reports that 70 percent of Tibetans are unemployed; access to good jobs is restricted to the Chinese. Massive deforestation has destroyed the land's ecological balance, and the culture and religion of the Tibetans have been annihilated.

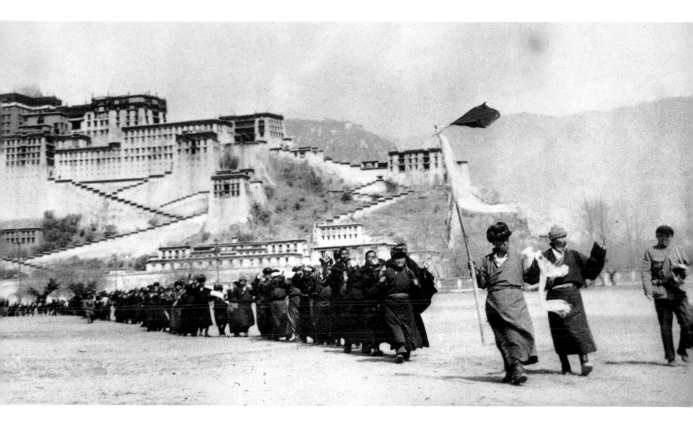

ELVIS PRESLEY

1960

Photographer: Bert Reisfeld

**Press photograph of rock singer Elvis Aaron Presley holding his guitar
and demonstrating the famous pelvic twist. This full portrait of the King
of Rock 'n' Roll (1935–1977) resembles a trademark image.**

"Elvis the Pelvis" is instantly recognizable by his posture alone.
He created the famous twist by turning his left leg inward and
slightly lifting the heel of the right foot, which gave his silhouette
the unique X-shape. Against a white background, he stands out
like a smooth, chiselled sculpture. The singer has raised his arms
in the classic gesture of triumph; his flawless, gleaming smile
signals sex appeal.

In the 1960s, Elvis Presley was the star of rock 'n' roll. The suc-
cessful superstar personified the American dream: he was good-
looking and charming. He had strummed his way from truck driv-
er to multimillionaire and incited teenagers to hysterics with his
music. With his velvety voice he sang his way into the hearts of
millions of listeners and beat all records—both in terms of fan
numbers and of profits. His provocative, suggestive moves and the
famous pelvic twist became his trademark on stage. He angered
many conservative Americans but did no damage to his success.
His concerts in the United States and in Europe in the mid-1950s
became milestones of rock 'n' roll thanks to a clever marketing
strategy. From March 1958 onward he was stationed in Germany as
a soldier for seventeen months. In 1956 he shot the first of thirty-
four feature films, *Love Me Tender*. Hits such as *Girls, Girls, Girls*
were catchy tunes that are still familiar to any music buff. I.L.S.

Pat H. Broeske and Peter Harry Brown. *Down at the End of Lonely Street: The
Life and Death of Elvis Presley.* New York, 1998.

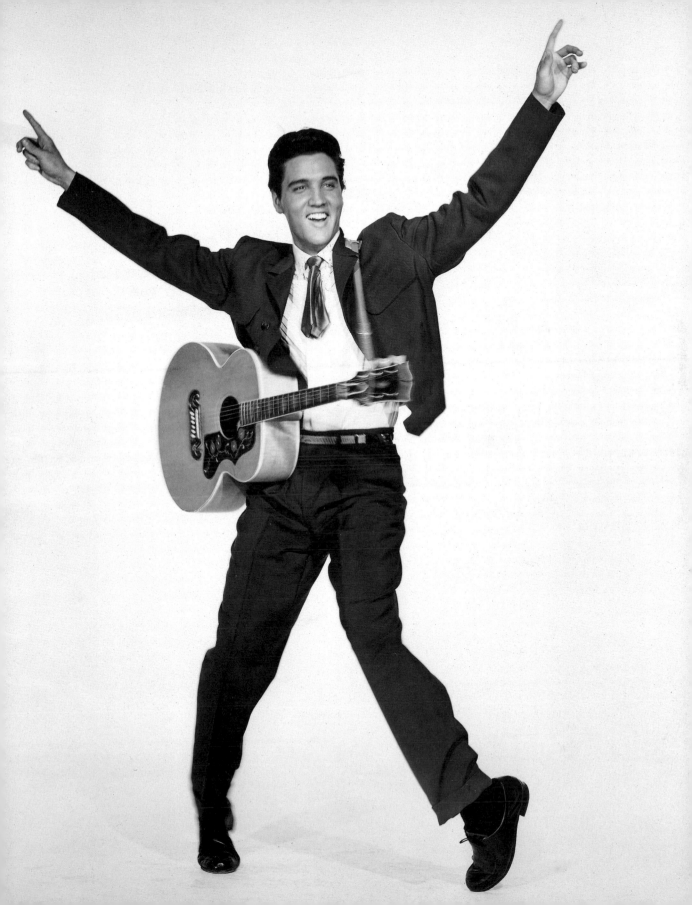

CHE GUEVARA

March 6, 1960 Havana, Cuba

Photographer: Alberto Korda

Fidel Castro speaks to the assembled crowd at a memorial service in Havana. Members of the Cuban leadership are gathered on the podium, among them the president of the national bank and future minister of industry, Che Guevara. Alberto Korda is there to photograph the event for the *Revolución* newspaper. By chance, he takes one of the most widely published political portraits of the twentieth century.

Argentine-born Ernesto Guevara de la Serna, known as Che Guevara (1928–1967), did not seek out flashlights and publicity. Even at official events he would sometimes ask photographers to put away their cameras. As Alberto Korda later recalled, this photo was pure chance.

Just days before this photo was taken, eighty people had been killed when a French cargo ship loaded with guns for Cuba was blown up. The burial service turned into a mass demonstration for the new government of Cuba, which had been formed only one year earlier under the leadership of Fidel Castro. Korda stood some eight metres (25 feet) from the podium, taking pictures as Castro delivered his speech. The Cuban leader was surrounded by his ministers and other dignitaries; Jean-Paul Sartre and Simone de Beauvoir were also in attendance. Guevara stood in the background. Suddenly, he stepped forward and looked out over the crowd. Korda recalled being "fascinated by the intensity in his eyes." Before Guevara stepped back again, Korda had time to take two pictures: one in landscape and one in portrait format.

Spontaneous and natural, the portrait is a snapshot of the revolutionary as observer, unaware that he is being observed himself. The angle is slightly from below, with Guevara's eyes directed upward and into the distance. In keeping with the occasion, the commandante wears a formal military jacket; his face is framed by the star-adorned beret, his tousled hair, and full beard. Sensitivity and gentleness, determination and will power, dignity and a profound gravity emanate from Guevara's youthful figure in the portrait. The composition is reminiscent of images of saints with a "heavenward" gaze; perhaps its worldwide appeal is explained by this accidental reference to Catholic visual propaganda that has served the Church for centuries. Milan publisher Gian Giacomo Feltrinelli knocked on Korda's door in search of a Guevara portrait four months before Che's death and came away with two prints at no cost—he must have suspected the photograph's great visual potential. Feltrinelli selected the image cropped by Korda to show only Guevara's face and printed it as a poster in vast numbers. As Korda said: "And the photo exploded all around the world." As a picture of a new messiah, it became the icon of the leftist protest against capitalism and the establishment. P.S.

CHE GUEVARA WAS BORN into the Argentine upper class and trained as a doctor. From 1955 onwards he was in touch with Fidel Castro. Guevara was one of the commanders of the guerrilleros in the Sierra Maestra. At first, Guevara was the president of the national bank, later Cuba's minister of industry. In July 1965 he travelled to the newly independent Congo to fight in the cause of that country's first premier, Patrice Lumumba, who had been assassinated. True to his conviction that the world "would have to see several Vietnams" he went on, after his failed efforts in the Congo, to help overthrow the Barrientos regime in Bolivia. Without support from the chairman of the local Communist party, Mario Monje, and misunderstood by the peasants in the Selva, the Bolivian campaign became another failure for the *guerrillero*. With U.S. aid, Bolivian soldiers were able to capture Guevara. He was held captive in a school and executed the following day. The photographs of Guevara's dead body were front-page news around the world. In Cuba, the news of Guevara's execution was met with disbelief and even Guevara's brother questioned the authenticity of the photographs. Castro, seen holding the photographs during a television broadcast on October 10, 1967, announced that they were being used as a diversionary tactic. Thrown into an unmarked grave in Bolivia after his execution, Che Guevara's remains were finally returned to Cuba thirty-eight years later. They were interred in a mausoleum next to the graves of other partisans with public mourning.

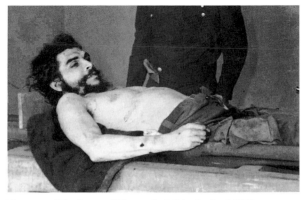

The corpse of Che Guevara, Valleygrande, Bolivia, October 9, 1967.

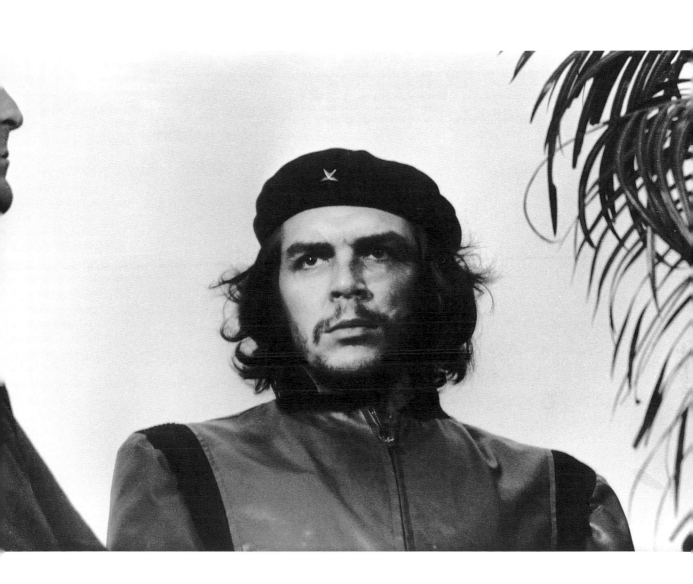

CELEBRATING INDEPENDENCE
December 1, 1960 Nouakchott, Mauritania

On November 28, 1960, Mauritania bid farewell to French rule and gained full independence. Drums beat day and night, and for four days the capital of Nouakchott was filled with dancing and singing.

In Mauritania—a country largely forgotten in the West—the colonial era was relatively short. While the neighbouring states to the south were already integrated into French West Africa, Moors and Berbers continued to offer fierce resistance north of Senegal after 1905 and northern Mauritania refused to bow to Paris for decades. In 1920 Mauritania was formally declared a French colony—a country in which black Africans lived side by side with dark-skinned Moors and a majority of light-skinned Mauritanians. A mere thirty-six years later, in 1956, Mauritania was able to claim far-reaching autonomy without bloodshed and was declared an autonomous republic two years later after a national referendum.

The typical West African ethnic mix, which also impresses any visitor to Senegal, Mali, or Nigeria, is evident in this photograph, which shows members of different ethnic groups playing music and dancing. The four men have pulled shirts over their traditional dress, the *boubou*. The shirts bear the slogan of the day: *République Islamique de Mauritanie* and an image of the new green national flag with a crescent moon beneath the star. In contrast to many field photographs by ethnologists, which tend to present half-naked Africans as if on a platter for the perusal of curious European eyes, this group is focussed on itself in a circle. The dancer on the left turns his back to us while the Mauritanian to the right triumphantly raises a scarf. The message is clear: henceforth, Europeans are the outsiders. P. S.

Leon Clark. *Through African Eyes, Vol. 1. The Past: The Road to Independence.* London, 1997.

Independence celebrations after sixty-eight years of British rule in Nairobi, Kenya. Jomo Kenyatta raises the independence declaration up high and waves to the crowd gathered at Uhuru stadium. Prince Philip stands next to him as the representative of the British crown.

THE AVALANCHE WAS SET OFF by Ghana: it gained independence in 1957 under Kwame Nkrumah. Soon after, the French colonies—whose status as overseas territories tied them more closely to Paris—followed the example of the former Gold Coast and British Togoland. Within the francophone zone, Guinea took the lead in 1958. Preoccupied by the Algerian war, Charles de Gaulle responded to their demand for independence by withdrawing all French nationals and leaving the country to deal with its own infrastructure virtually overnight. Undeterred by the resulting difficulties, the remaining French colonies and thus most of Africa including Mauritania gained their independence in 1960.

DEMANDS FOR INDEPENDENCE
December 1960 Algiers

Algerian students engaged in a street battle with armoured units of the French army, demanding independence from France. After negotiations began between France and the liberation movement, the conflict moved into a phase of political clarification. In Algeria the process was accompanied by mass demonstrations against the supporters of French Algeria.

On November 1, 1954, the *gouvernement général*—France's highest authority in Algeria—announced in Algiers that the National Liberation Front of Algeria (FLN, or *Front de libération nationale*) under Ben Bella had engaged in armed insurrection. Few realized that this marked the beginning of a ten-year war that would be noted for its brutality. Algeria symbolized France's status as a colonial power owing to its strategic location and its population of 1 million French citizens, which constituted a dominant minority. When oil was discovered in the Sahara on June 22, 1956, a race began for control of the valuable resource, and this added yet another edge to the conflict. French Algerians and influential groups in metropolitan France were determined that Algeria remain part of the French state.

On the side of the Algerian movement of national liberation, a different, no less explosive dynamic soon emerged: on the one hand there was the goal of national independence and on the other, a revolutionary component that unified the rural and urban proletariat and prompted them to enter into a pact with the Muslim population. After 1956 the conflicts increased and in August 1958 they spilled over into France itself. French militia and the army responded with repression, arrests, and torture. Both sides were responsible for the viciousness and brutality of the conflict—the national liberation army (ALN, or *Armée de libération nationale*), which fought with guerrilla tactics, and the French Foreign Legion, which counted many former Waffen SS among its numbers and was determined to repair its battered reputation after the defeat at Dien Bien Phu (1954).

The ferocity and duration of the war, into which even regular units of conscripted Frenchmen were eventually drawn, led to internal conflict in France. It brought about the end of the Fourth Republic in 1958 and the seizure of power through General Charles de Gaulle. When de Gaulle undertook negotiations in the interest of his nation's foreign policy, French citizens in Algiers mounted the Barricade Rebellion in February 1960, which was followed by a revolt of army officers. A full-scale coup was narrowly averted, but assassinations by the secret army organization (OAS, or *Organisation armée secrète*) in Algeria and France marred the period preceding the Evian Treaty (March 1962), which finally ended the war. The Algerian War marked a turning point in France's foreign policy. E.I.

Raymond F. Betts. *France and Decolonization. 1990–1960*. New York, 1991.

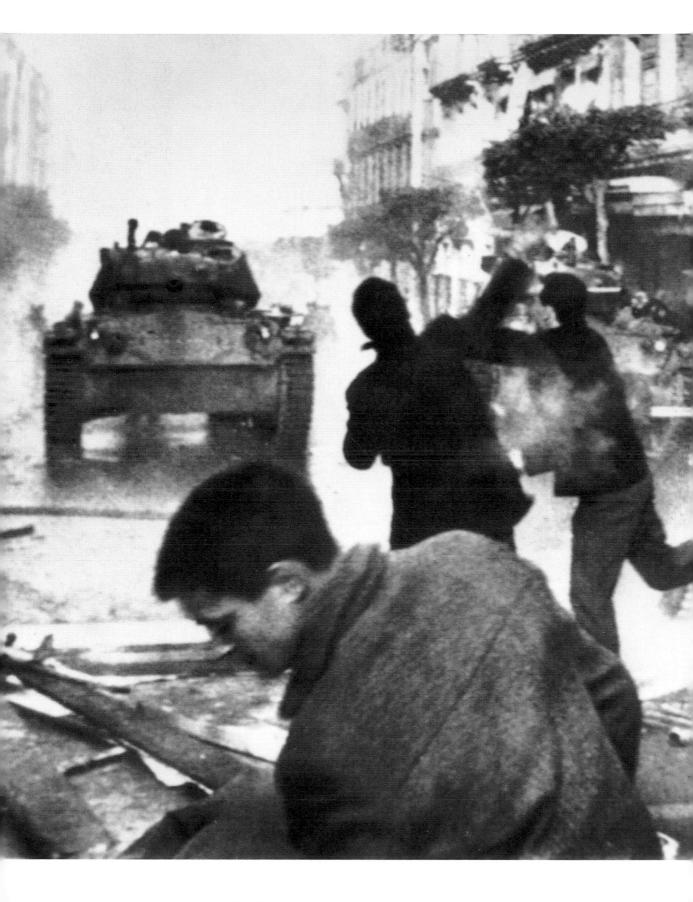

GAGARIN, FIRST MAN IN SPACE
April 12, 1961 USSR

The Soviet cosmonaut Yuri Gagarin is shown here in a picture said to have been taken on April 12, 1961, shortly before he became the first person to orbit the Earth. During his 108-minute flight he travelled 25,400 miles in *Vostok I*, the world's first manned spacecraft. The flight, which blasted off at 9:07 a.m. Moscow time, was launched from and returned to the Soviet Union.

Gagarin's successful flight marked a new stage in the Space Age, an era that had begun in 1957 when the Soviets orbited the first unmanned satellite, *Sputnik I*. His trip proved that space flight was possible for humans, and the Soviet Union appeared to be at the forefront of the space race. What this picture does not show is as significant as what it does. It was characteristic of Soviet secrecy that no pictures were released of the space capsule itself, of its designers and engineers, or of Gagarin in flight. The image of Yuri Gagarin in a bulbous space helmet is a prelude to the hundreds of colour photographs from space that at first looked like science fiction but are now almost commonplace.

The choice of twenty-seven-year-old Gagarin as the first spaceman fulfilled Soviet propaganda requirements: his humble proletarian background as the son of a Russian collective farmer was as important in promoting him as a national hero as his training as a

fighter pilot in the Red Army. Although he took no more space flights, he did help to train other cosmonauts. Ironically, Gagarin died in a plane crash in 1968, during what was described as a routine training flight.

By then the United States had gained the upper hand in space, after years of aeronautic rivalry between the Cold War adversaries. About six weeks after Gagarin orbited the earth, President John F. Kennedy addressed a joint session of Congress to say that "this nation should commit itself to achieving the goal, before this decade is out, of landing a man on the moon and returning him safely to Earth." That goal was reached in July 1969, with the flight of *Apollo 11* (see page 124). B.L.M

William E. Burrows. *This New Ocean: The Story of the First Space Age*. New York, 1998.

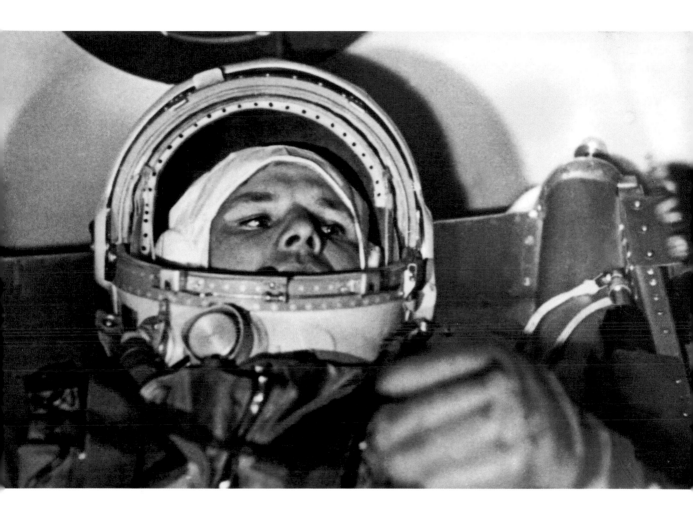

ESCAPE TO THE WEST

August 13, 1961 Berlin

Photographer: Peter Leibing

On the night of August 13, 1961, after months of rumour as young, skilled workers continued to leave the German Democratic Republic for the West, soldiers, policemen and the Workers' Militia set up an "anti-fascist protection barrier" across Berlin. In the first few days of the Berlin Wall, gaps in construction allowed a few people, including border guards, to escape.

This picture of a young East German border guard seizing his opportunity to escape in the first days of the Berlin Wall became an iconic image in the West, though not in the East where guidebooks to Berlin right up to the dismantling of the Wall continued to ignore its existence.

Konrad Schumann was nineteen when he was sent to guard the border. On the morning of August 13 he was stationed on Bernauer Strasse in the Wedding district of Berlin where, as can be seen in the picture, the "wall" was as yet just a barbed-wire barrier. Western photojournalists shooting the wall got the picture of a lifetime when Schumann, in his black boots, helmet and smart DDR uniform and carrying a rifle, plucked up the courage to leap across the barrier. Film footage shows how this soldier thrust his weapon from him in mid-leap.

The picture became a classic because it captures the contrast between freedom and constraint; like all the greatest, most influential journalistic photographs, it is artful by coincidence. There could not be a more poetic or articulate image of the wall. Here is a young man flying through the air, suspended for a moment in limbo between East and West. The dilapidated building to his right is a reminder of Berlin's wartime scars. Behind him a small crowd watches, but they don't look like they will follow.

This is a perversely joyous image. It suggests not the coming years of division but the final futility of the wall. In the 1960s, images like this made Berlin an implausibly glamorous place in the West, and gesture politics like John F. Kennedy's "Ich bin ein Berliner" speech in the city in 1963 were accompanied by photo opportunities on a platform overlooking the wall. So while the wall was officially invisible in the East, it became a romantic backdrop for the West, from films like *Funeral in Berlin* to records like Lou Reed's *Berlin*. This picture helped to define the wall in the eyes of the West, but it was not until popular protest in the DDR itself became irresistible that Konrad Schumann's act enjoyed its final sequel.

J.J.

Ann Tusa. *The Last Division: Berlin and the Wall 1945–89*. London, 1996.

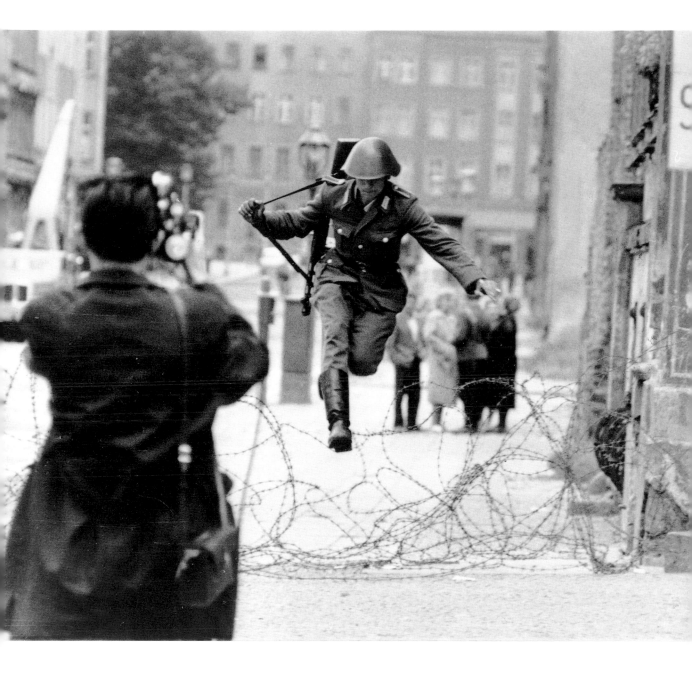

BOY WITH TOY HAND GRENADE

1962 Central Park, New York City

A native New Yorker, Diane Arbus photographed the inhabitants of the city, seeking out those at the edges of society. Her work reflects daily life, but with a gaze that emphasizes the abnormality of the commonplace. The boy with the hand grenade in Central Park seems no different from other children; his exasperation communicates a frustration beyond the specific image. One of her best-known images, it forces us to take note of the disturbances underlying everyday experience.

The work of Diane Arbus has profoundly affected photography, both documentary work and artistic practice. Her images project a sense of both subject and photographer analyzing what they see, a self-consciousness that reveals her subjects' relationship to their environment and the isolation they experience from each other. Describing her concern with image-making, Arbus stated: "A photograph has to be specific. I remember a long time ago when I first began to photograph I thought there were an awful lot of people in the world and it's going to be terribly hard to photograph all of them, so if I photograph some kind of generalized human being, everybody'll recognize it. It'll be like what they used to call the common man or something . . . but the more specific you are the more general it will be."

Arbus's photographs communicate the interactions between photographer and subject and through their intensity articulate a wealth of information about both individuals. In this image we are given a clear sense of the frustration the boy is feeling. It is this close link to familiar sights and activities that makes Arbus's photographs so profoundly articulate. Deeply influenced by Weegee and by Lisette Model, her teacher, Diane Arbus created images that cut across American culture, calling into question what is usually regarded as normal and giving insight into the psychology of a nation.

L.L.F.

Diane Arbus: An Aperture Monograph. New York, 1997.

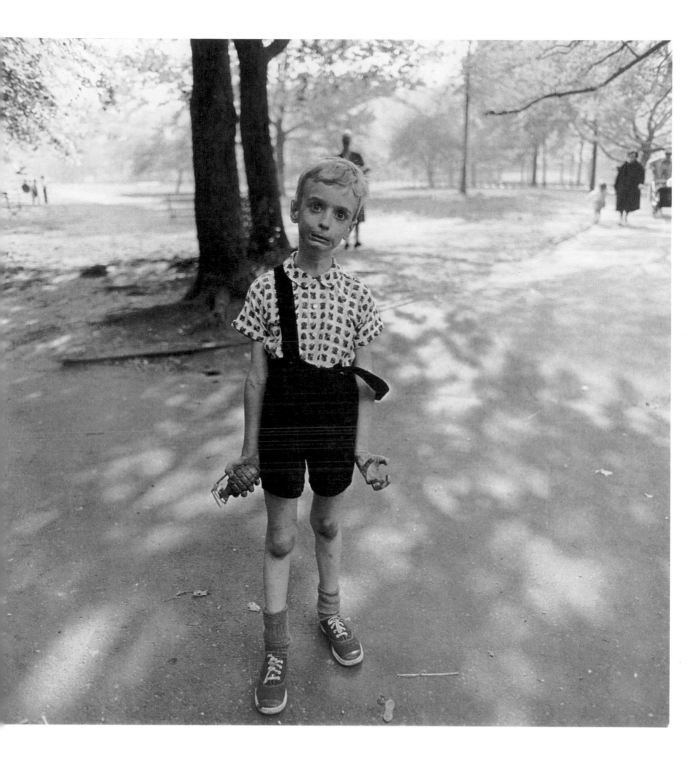

CUBAN MISSILE CRISIS

October 15, 1962 Cuba

Photograph: U.S. Air Force

Photographs taken from a U2 reconnaissance plane show Russian medium-range SS-4 missiles stationed in western Cuba on October 14, 1962. When more missiles are spotted on Russian freighters in the Caribbean, U.S. president John F. Kennedy imposes a blockade and issues Soviet premier Nikita Khrushchev an ultimatum to withdraw the missiles. The world is on the brink of nuclear war.

In 1962 the confrontation between the Cold War superpowers, the United States and the Soviet Union, reached its most dangerous peak with the Cuban Missile Crisis. Democrat John F. Kennedy had moved into the White House in 1961, bringing with him consultants from the Rand Corporation and Harvard. It was the beginning of a new political philosophy. Its proponents understood Soviet-American relations as a military rivalry, an arms race both in nuclear and in conventional weapons, but also as a political and ideological race that had an impact on U.S. internal politics. In terms of nuclear strategy, the Americans moved towards what they called a "flexible response." Khrushchev had observed Kennedy's restraint during the failed invasion in the Bay of Pigs (April 16–17, 1961) and the building of the Berlin Wall (August 12–13, 1961). In the summer of 1962 he began stationing medium-range missiles on

Cuba in an attempt to compensate for the U.S. superiority in long-range missiles. U.S. reconnaissance cameras discovered the installation only after some time, on October 15. By October 16, the CIA had analyzed the photos and laid them on Kennedy's desk. The first idea—to carry out an air raid on the missile installations—was abandoned after it became clear that no one knew whether an air raid could guarantee that the installation would be fully destroyed or whether nuclear warheads had already arrived in Cuba.

On October 22, 1962, Kennedy imposed a blockade. In front of the United Nations Security Council, American Ambassador Stevenson displayed the photographs to force his Soviet counterpart, Zorin, into an admission of their presence and danger. According to former CIA photographic analyst Dino Brugioni: "The photos made a considerable impact. They proved the Russians were lying. Thanks to those photos, Kennedy could command unconditional national and international support. But the photos also had a long-term impact. They were proof positive that reconnaissance could offer tactical advantages and this was the beginning of deterrence politics." Indeed, Khrushchev was impressed by the seriousness of the American response and withdrew the missiles. In turn, Kennedy assured the sovereignty of Cuba and withdrew American missiles from Turkey. As a consequence of these events, a crisis management program ("Hot Wire") was formed. Ultimately the crisis led to the signing of treaties on disarmament and the nonproliferation of nuclear weapons. E.I.

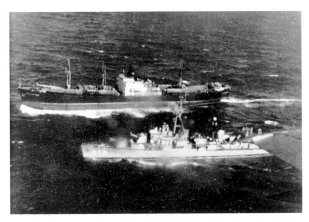

Soviet freighter *Ivan Polzunov* faces off with a U.S. warship, November 1962.

Jerome Kahan and Anne Long. "The Cuban Missile Crisis: A Study of Its Strategic Context" in *Political Science Quarterly* 4 (1972).

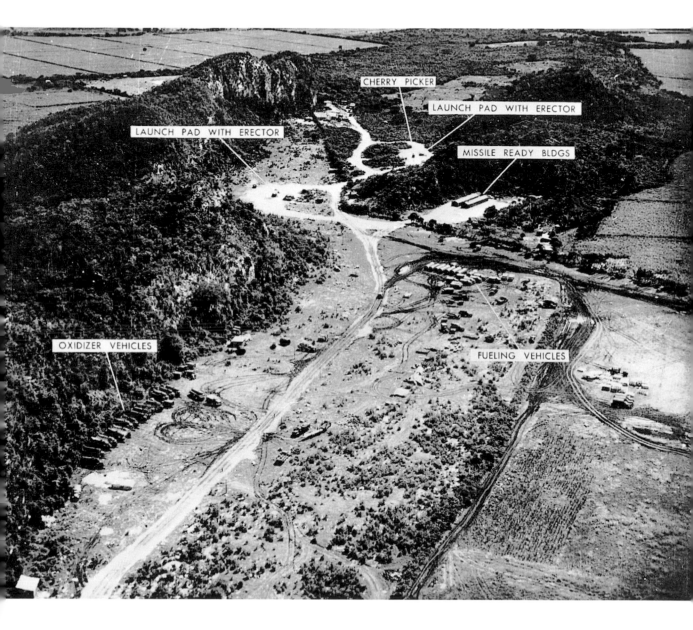

CHERRY PICKER

LAUNCH PAD WITH ERECTOR

LAUNCH PAD WITH ERECTOR

MISSILE READY BLDGS

OXIDIZER VEHICLES

FUELING VEHICLES

THE BEATLES
1963

The mop-tops from Liverpool—George Harrison, Paul McCartney, Ringo Starr, and John Lennon—in a group portrait. After the release of "Please, Please Me" in 1963, Beatlemania swept the U.K.

In the group image, styled in the manner of a seventeenth-century Dutch portrait, the four lead figures of the beat and pop scene resemble well-behaved schoolboys. Identical mop-top haircuts, college-style jackets, brilliant white shirts, and narrow ties defined their trademark look. The quartet seems happy and relaxed, standing arm in arm. Ringo Starr reaches out towards the viewer in a gesture reminiscent of images of Christ, his hand extending beyond the frame. Each detail of the photograph is carefully staged: wide eyes and open lips suggest that they are caught in a moment of action, perhaps during a rehearsal or on stage. The animated half-length figures of the musicians fill the frame, creating an immediate closeness to the viewer.

No other band changed post-war music and society as dramatically as the Beatles with their fresh and relaxed style. The euphoria of their fans, dubbed Beatlemania, was a phenomenon of the era. The frantic hysteria, which so shocked conservative society during the band's early performances in the U.K., became standard in the world of pop and rock 'n' roll.

The image of the Beatles is inseparable from the carefully groomed image of the newcomers, who achieved 1 million in sales with their first original single "Love Me Do" in 1962. The Beatles were original and appealing. They were also inspired composers, who gave their era a new direction in music with popular and innovative songs that combined beat with melodic and harmonic beauty and colourful instrumentation. After their early successes, the Beatles quickly mastered the art of marketing their group image, borne out in this individualistic portrait. Even after the band split up in 1970, their enormous popularity endured. I. L. S.

Mark Hertsgaard. *A Day in the Life: The Music and Artistry of the Beatles.* New York, 1995.

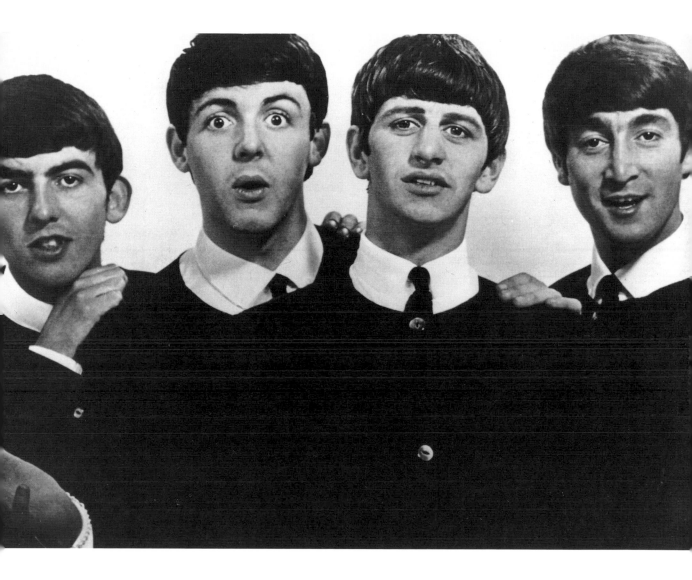

I HAVE A DREAM

March 28, 1963 Washington, D.C.

Over 200,000 people in a protest march demanding civil rights for blacks gather in front of the Lincoln Memorial, spilling over into the adjoining streets. Martin Luther King, the civil rights leader, gives his legendary speech at the conclusion of the demonstration.

Raising his right hand to command silence, the civil rights leader holds the manuscript in his left hand and leans on the rostrum. The photographer has chosen an angle to include the Washington Monument, the Capitol, and as much of the crowd gathered on the square and in the avenue as would fit into the frame. The crowd is listening to his speech "I Have a Dream" in which King outlines his vision of a world free of racial discrimination, hatred, and violence: "I have a dream that my four little children will one day live in a nation where they will not be judged by the colour of their skin but by the content of their character. On this day, I have a dream."

Martin Luther King, a follower of Thoreau's philosophy and a pacifist, was especially inspired by Gandhi's teachings on non-violence. He was a champion of oppressed black Americans. He fought against racism and for equality and tolerance: in 1955 he led the Montgomery bus boycott to protest the continued racial segregation in public transportation. The boycott ended in 1956 with a Supreme Court decision that made racial equality on public transport law. He became the leading figure of the civil rights movement, organized in the South under the banner of the Southern Christian Leadership Conference (SCLC). King, who became co-pastor of the Ebenezer Baptist Church in Atlanta in 1959, was largely responsible for the direction of the movement. He also led a major civil rights campaign in Birmingham, Alabama, organized voter registration for blacks in the southern states, and fought for better education and living conditions. Like most blacks, he felt that the Vietnam War was poisoning the atmosphere and pushing domestic problems into the background.

Although he was arrested several times for his political and humanitarian activism and despite several attempts on his life —after the non-violent protest in Montgomery, his home was set on fire—he fearlessly continued to appear in public, participating in demonstrations and marches. Soon a more radical branch of the civil rights movement emerged and voices were raised for immediate results "by any means possible." But Martin Luther King's influence was such that non-violence remained the official path of resistance. He never turned his back on these principles, despite repeated arrests, a face-off with black Baptists during his largest campaign in the North, or confrontations with armed white hooligans, led by neo-Nazis and Ku Klux Klan members. I.L.S.

Martin Luther King, Jr. *I Have a Dream*. San Francisco, 1993.

BARELY ONE YEAR AFTER Martin Luther King's "I Have a Dream" speech, on July 2, 1964, Kennedy's successor, President Lyndon Johnson, signed the Civil Rights Act followed in 1965 by the Voting Rights Act. Martin Luther King received the Nobel Peace Prize. He was preparing a march of the poor on Washington, D.C., when he was assassinated in a Memphis hotel on April 4, 1968.

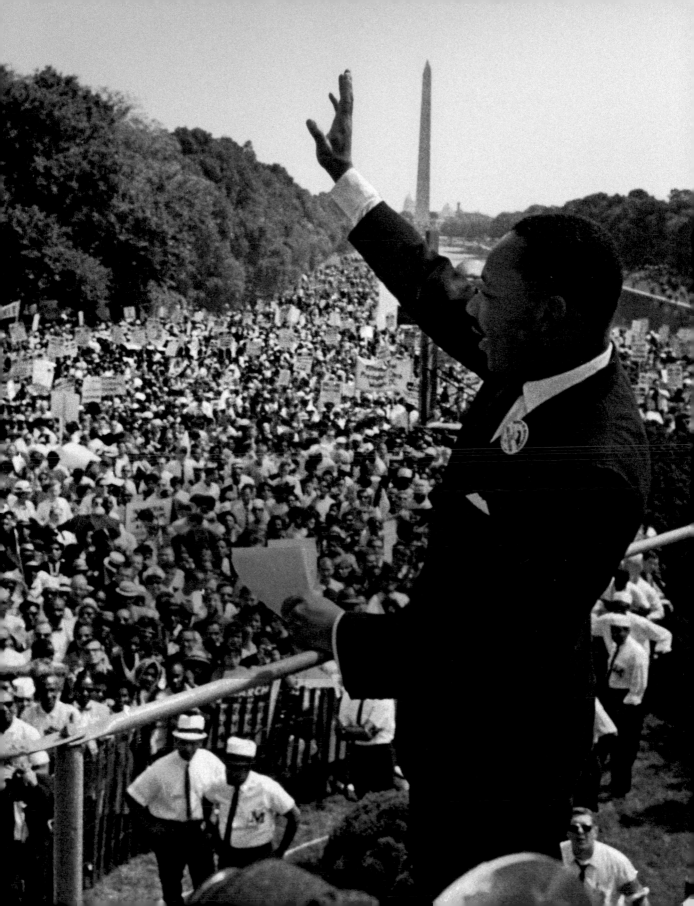

ASSASSINATION OF JOHN F. KENNEDY
November 22, 1963 Dallas, Texas

At 12:30 p.m., as the presidential motorcade moved through Dallas, Texas, John F. Kennedy waved to crowds waiting to glimpse the glamorous presidential couple even in this bastion of Southern hostility to his liberal policies. Shots rang across Dealey Plaza and he slumped back in the car, dying.

The open car racing to get away through void space, the vast blankness of the road behind the car as Jackie Kennedy cradles her husband—the assassination of John F. Kennedy marks the moment in modern history when an event becomes iconic and photogenic even as it destroys a nation's dream of itself. Kennedy was shot before an audience, both in the streets of Dallas and those who have pored over the photographs and film footage of that day ever since. Our visual image of Kennedy's assassination is fundamental to the way it continues to be debated and mourned. Conspiracy theories focus on what can or cannot be seen in photos and film footage; does the bullet enter Kennedy's head at the angle it should have done if fired from Lee Harvey Oswald's window in the Texas Book Depository?

There is something morbidly cinematic about Kennedy's death. The dying president and his First Lady are close enough for us to empathize with them, yet at the same time distanced, framed, by the car—as they were intended to be for the purposes of a ceremonial motorcade.

Since 1963 history has become visual. This new sense of history begins with media representations of the assassinations, riots and moonshots of the 1960s, but most of all it begins with JFK. The washed-out, ethereal look of this picture defined the way artists in the Sixties thought about their time. It was deliberately imitated in contemporary artwork that grieved for Kennedy while also analyzing the assassination as a media event. Andy Warhol's paintings of Jackie Kennedy and Robert Rauschenberg's collaging of Kennedy's face into images of a fragmented America consciously imitate the coarse, empty, paranoia-inducing look of images of the Kennedy assassination.

"When President Kennedy was shot that fall, I heard the news over the radio while I was painting in my studio. I don't think I missed a stroke . . . I'd been thrilled having Kennedy as president; he was handsome, young, smart—but it didn't bother me that much that he was dead. What bothered me was the way the television and radio were programming everybody to feel so sad."

—Andy Warhol

J. J.

Thomas Crow. *The Rise of the Sixties*. New York, 1996.

MUHAMMAD ALI KNOCKS OUT SONNY LISTON

May 25, 1965 Lewiston, Maine

Photographer: John Rooney

Cassius Clay—who changed his name to Muhammad Ali when he became a Muslim in 1964—took the world heavyweight boxing title from Sonny Liston earlier in the same year. In the return fight at Lewiston, Maine, on May 25, 1965, Clay felled the former champion with a knockout punch in the first round.

This is one of the most triumphant moments in a career that combined victory in the ring with political courage out of it, and is one of the legendary images of boxing. Through the character he displayed inside and outside the ring, Ali made boxing something more than two men punching each other senseless. Here, as cameras click away in the background trying to capture the sudden conclusion to the fight, Ali's famous way with words was working overtime. Liston was out for the count but the champion still talked at him, goading him to get up and fight.

Ali talked during fights, teasing his opponents as well as building up to the fight with poems and jokes that rattled those who fought him and made him a unique media figure. It was before the first fight with Liston that he claimed he would "float like a butterfly, sting like a bee." This photograph captures that articulacy, wound up here to an angry pitch. It is a very different image of boxing from the ones we are used to. In a film like Martin Scorsese's *Raging Bull* or in the persona of a contemporary fighter such as Mike Tyson, physicality is everything and the body speaks

brutally. In this picture, it is the personality of the fighter that dominates even though he has just knocked a man out. After his victory over Liston in 1964, he converted to Islam and adopted the name Muhammad Ali. In 1967 he was stripped of his title for refusing to fight in Vietnam and was banned from boxing until vindicated by the Supreme Court in 1970. In the years to come, Ali's voice became more politicized as he spoke for black Americans.

But here he stands for himself alone, in a moment of pathos as Liston is left shattered on the ground and the white audience presses against the ropes. Muhammad Ali had an impact far beyond boxing in the 1960s and '70s. As a high-profile supporter of radical black politics, he managed to get a message across to people who could not ignore his prowess and intelligence. Here we see him crowning himself "The Greatest." J.J.

Mike Marqusee. *Redemption Song: Muhammad Ali and the Spirit of the Sixties.* New York, 1999.

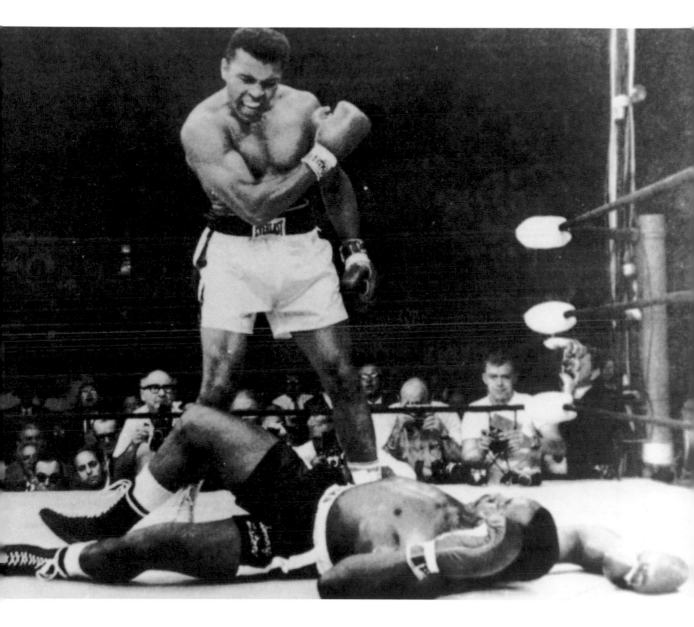

LOUIS ARMSTRONG IN PERFORMANCE
1965

Jazz trumpeter and singer Louis "Satchmo" Armstrong performing live in June 1965. The close-up of the famous King of Jazz (1900–1971) belting out a tune on his favourite instrument captures the physical and mental effort of the jazz musician in performance.

The artist's expressive face is focussed and full of nuance. The image is centred so perfectly on mouth, hands, and trumpet that the separate elements merge into one visual unit. No musician embodies the dramatic change in the world of music in the twentieth century more than Louis Armstrong. His refined technique, his uninhibited joy and spontaneity—in short, his musical spirit —have influenced generations of musicians.

As a child Armstrong learned to play the cornet and at seventeen he joined his first band in New Orleans, moving from band to band in the years that followed until a telegram fulfilled his life's dream in 1922. It was an invitation from King Oliver to join his renowned Creole Jazz Band in Chicago. Armstrong and his unusual style became the toast of Chicago. At twenty-five he recorded a series of original compositions known as *Hot Fives* (1925) and later *Hot Sevens* (1928), which have become classics of jazz. By 1929 he had achieved worldwide recognition. From 1935 onwards, he spent most of his time touring the world with the Louis Armstrong Orchestra. When tastes began to change in the 1940s, life became much more difficult for jazz musicians but Armstrong went on to form his most successful band yet, the Louis Armstrong Allstars, in 1947. And in 1963 he even managed to outdo the Beatles on the charts with his international hit "Hello Dolly." His most popular song was released in 1968: "What a Wonderful World" continues to capture people's hearts to this day. Armstrong was a likeable entertainer, a star on stage and film who refused to let racial barriers stand in his way. During the Cold War, he was sent by the U.S. government to perform behind the Iron Curtain. After battling illness for some time, Armstrong died in his sleep in 1971. I.L.S.

Louis Armstrong. *Satchmo: My Life in New Orleans*. New York, 1954.
Laurence Bergreen. *Louis Armstrong: An Extravagant Life*. New York, 1997.

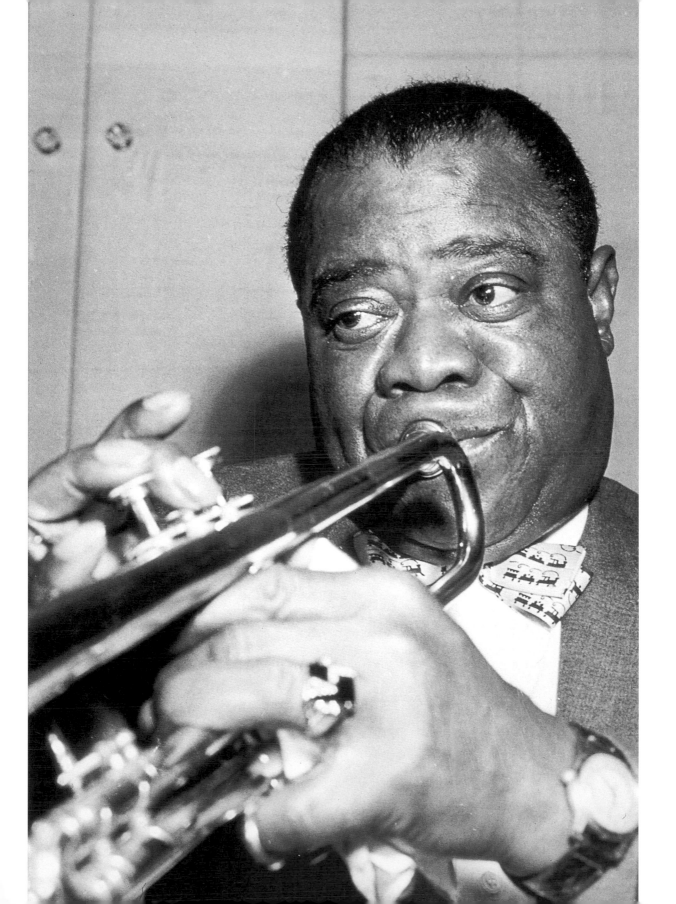

EXECUTION IN SAIGON
February 1, 1968 Saigon, South Vietnam
Photographer: Eddie Adams

Nguyen Ngoc Loan, South Vietnam's chief of police is photographed shooting a suspected Viet Cong collaborator who had been identified as a North Vietnamese officer. Fourteen years into the war in Vietnam, anti-war protests are building in strength while President Johnson pledges to continue to back the South Vietnamese.

Photographer Eddie Adams took this Pulitzer Prize-winning shot, one of the most memorable images in the history of war photography. In many cases of conflict reportage, the photographer is looking to capture the moment closest to death. This photograph is so powerful because we are seeing an individual's fear written on his face a fraction of a second before the loss of his life. The image is etched in our memories both because of its success in communicating the violence of war and its endless reproduction.

Adams's photograph appeared on the front page of *The New York Times* the day after it was taken and was soon syndicated worldwide. The Vietnam War has often been described as having been fought in the living rooms of homes around the world, with uncensored images of horror saturating newspaper and television reports. This was the last conflict during which photographers were given such freedom to independently record events around them. Photographs such as this one became key in the anti-war campaign and in rallying the American populace to question their government's involvement in this war.

The power relationships we can see between the three men pictured here articulate the violence of this moment. As another soldier looks on, the police chief stands in a casual yet authoritarian stance as he turns to kill what seems to be a very young man dressed in civilian clothes with his hands tied. The sense of terror in the man's face as he reaches his own death instantly implicates us as we look at his execution. Adams depicts here not only the particular violent act taking place, but also conveys the complexity of this war. American troops had been sent to defend the South Vietnamese under the rubric of protecting them from a communist onslaught perpetrated by the North Vietnamese with the support of China. The South Vietnamese chief of police is seen here executing a North Vietnamese officer. This went against the official propaganda that there were clear-cut good and bad sides in the war. L.L.F

Lucy R. Lippard. *A Different War.* Bellingham, Washington, 1989.

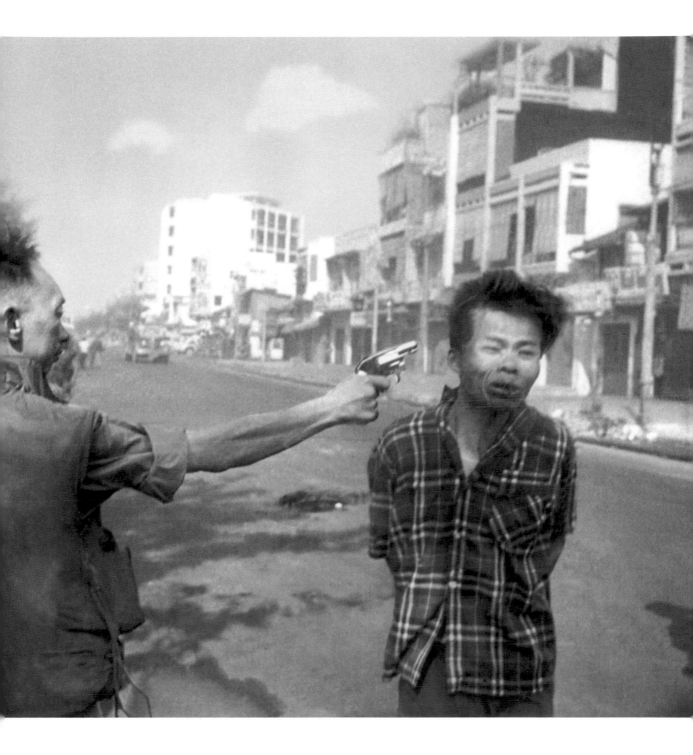

STUDENT UPRISING IN PARIS

May 3, 1968

May 1968 in Paris was marked by an outburst of civil discontent. Clashes between riot police and students filled the streets, with fierce fighting on both sides. To defend themselves against the surge of the police lines, demonstrators used paving stones and metal street grilles. This photograph shows the students using the very fabric of the city to defend themselves.

The events of this month of revolution were sparked by a meeting of students at the Sorbonne University on May 3, 1968, to protest against the closure of Nanterre University. Citing rumoured clashes between left and right activists, the governing body of the university called in the police. Students were escorted out of the university in groups of twenty-five, with female and male students separated. Women students were led out first. When it was the men's turn, they were immediately arrested on leaving the building. This angered the students, who clashed with riot police.

The crowd of protesters rapidly grew, and the police defended themselves with tear gas, which only served to increase the intensity of the fighting. Over the ensuing weekend students formed action committees and organized a mass protest for the following Monday. Marchers were met again by riot police, who charged on the protesters.

Photography was key to raising support among the populace, with public opinion soon siding with the students against the police violence. Media reports described initial student reaction to the arrests at the Sorbonne as being one of shock and bewilderment. The French government was quick to blame a small group of agitators who, they claimed, were not representative of the student body. As the days of unrest continued, however, it soon became clear that the discontent was not that of a minority.

In any political uprising the visual communication of events is at the heart of the establishment of power relationships. This grainy photograph captured a moment of struggle that, once fixed in this image, could not be denied by the authorities. By involving the viewer, it encourages a political stance in reaction to what is being depicted.

L. L. F.

Vladimir Fisera, ed. *Writing on the Wall: May 1968*. London, 1978.

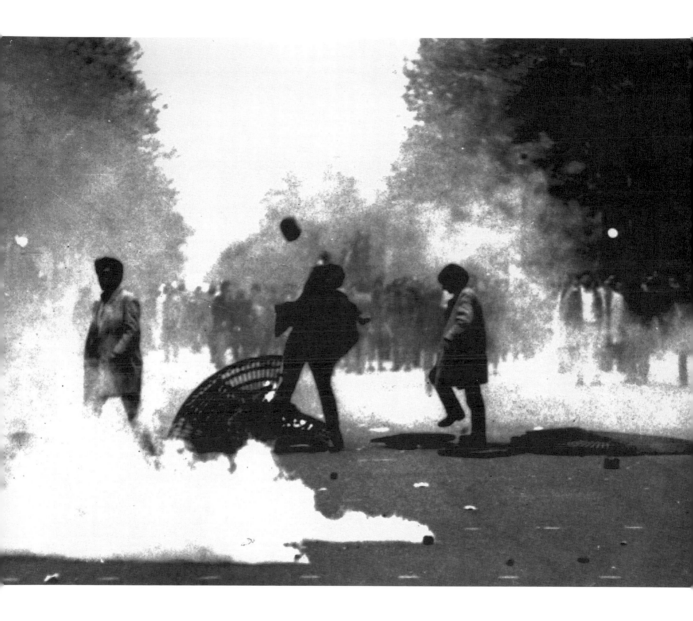

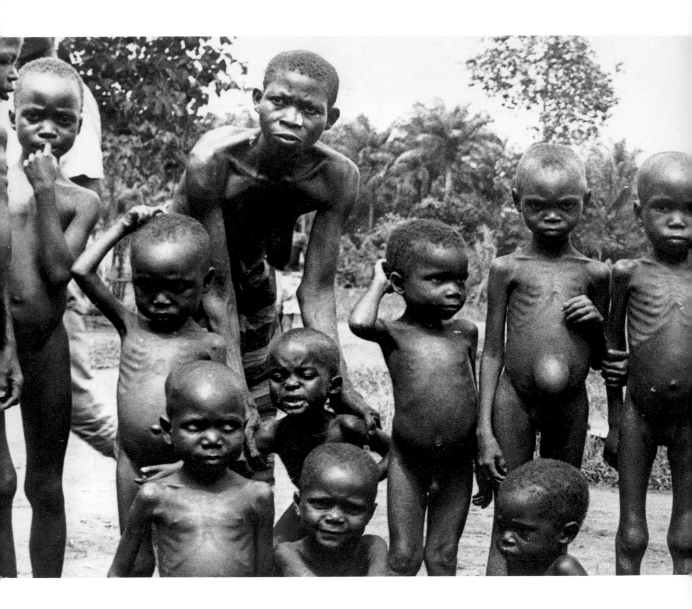

WAR AND FAMINE IN BIAFRA

July 1968 Biafra, Nigeria

A year after the outbreak of the Nigerian war of secession, the new Republic of Biafra suffered one of the worst famines in history. Continuing drought in the Sahel exacerbated an already desperate situation in a country overwhelmed by the stresses of war. Refugees—especially children—were the worst victims of the crisis.

Before the devastating war in Nigeria, the federal state consisted of three, largely autonomous regions. The north was ruled by the Hausa, the west by the Yoruba, and the east by the Ibo. In 1966, young Ibo officers carried out a failed coup interpreted as an attempt to enforce their own tribal interests. The Hausa in the north retaliated against the Ibo, who are a minority in the region. The atrocities that followed, claiming an estimated 8,000 victims among the minority Ibo, forced 1 million refugees to flee towards their homeland in the east. Fear of genocide propelled the eastern region to secede, to which the federal government responded with economic sanctions. On May 30, 1967, the eastern region declared its independence as the Republic of Biafra. Not least of all because Nigeria's oil fields were located in the region, the remaining federation unleashed a military attack against the new state. The war lasted for two and a half years, claiming over a million lives, most of them civilians starved to death.

This photograph is one of many documenting the famine in Biafra. It was taken in a refugee camp close to Aba. It may have been taken when representatives from a humanitarian organization visited the camp or during a visit by the press. It depicts a careworker with ten children, some of whom have only just outgrown their infancy. The malnutrition is drastically documented, although these children were relatively fortunate by comparison to those who received no care. In this sense, the photograph is perhaps less disturbing than others that documented the starvation in Biafra; it seems to appease Western consciences with the message that even in the chaos of war these children, at least, are "in good hands." After extensive coverage in newspapers, journals, and on television, humanitarian organizations arrived to offer some relief with the assistance of worldwide donations and eventually succeeded in delivering supplies to the people caught in the war zone.

P.S.

Joseph E. Thompson. *American Policy and African Famine*. New York, 1990.

IMAGES OF FAMINE have shaped the Western image of Africa as a "disaster continent." Wars, starvation, and natural disasters have become synonymous with Africa owing to one-sided photojournalistic coverage, to which the photos from Biafra have contributed substantially. The cliche is so pervasive that other regional topics are virtually ignored in the media. Thus the "African perestroika" (a term coined by Walter Michler), the democratic movement throughout Africa since 1990, has been ignored in the Western media, as has the fact that many African countries are stable and peaceful nations. When national television stations devote a tiny fraction of available air time to news from Africa, it is no wonder that we are "illiterate" when it comes to developments on the African continent.

THE END OF THE PRAGUE SPRING

August 21, 1968 Prague, Czechoslovakia

Photographer: Libor Hajsky, CTK

Young men stand on a military bus that they have just tipped over, and are waving the Czechoslovakian flag at Soviet T-55 tanks that have invaded the city. Hordes more demonstrators are on the back of a truck and on the roof of a bus behind it. In a gesture of determined solidarity the people of Prague have used vehicles to block the advance of the military convoy on the city center. The experiment of a Socialism with a human face threatens to collapse under Soviet military pressure.

When the five Warsaw Pact states bore down on Czechoslovakia on August 21, 1968, the campaign for a peaceful reform led by Communist Party secretary Alexander Dubček and supposedly sanctioned from "up high," was brought to an abrupt end. Dubček and his supporters wanted to build a more democratic and humane socialist society. To this end they were in favour of greater participation in government, civil liberties such as freedom of the press, market mechanisms for a more vital economy and removing ideological strictures from foreign policy. Soon the population at large began to participate in the political and social content of these reforms. They set in motion a dynamic movement, the Prague Spring. By February 1968 the Central Communist Party in Moscow was openly critical of the movement, and in mid-July, relations between the parties broke down. The Soviet leadership under Leonid Brezhnev announced that is was a "common duty" to ensure the safety of socialism. Warsaw Pact manoeuvres in Czechoslovakia were used as an open threat, but Dubček refused to yield. On August 17, the decision to invade was made. Gustáv Husák, a party hard-liner, replaced Dubček. These events presaged the implosion of "real socialism" that was to follow in the Soviet bloc countries twenty years later, from 1989 onwards.

In Libor Hajsky's photo groups of people have surrounded the tanks to vent their feelings and opposition at close range to the armed soldiers. Both sides avoid any escalation and the situation remains calm. In Czechoslovakia's second largest city, Bratislava, Ladislav Bielik's photo that became a symbol of the crushing of the Prague Spring was taken on the same day: the demonstrator who rips open his shirt in front of a tank, ready to die, thrusting his chest into the sights of the gun. More than 100 people are killed during the uprising, but the most prominent victim of the invasion by troops of the Warsaw Pact states will be the student Jan Palach, who douses himself with petrol in Prague and dies five months later as the result of his burns. The day of his funeral is to become a silent protest across the country against the occupation.

The Hungarian uprising of 1956 (see p. 84f.) even convinced many communists in western Europe of the inhumanity of the Soviet system. The crushing of the Prague Spring similarly enraged students outside the Iron Curtain who marched through the streets of university towns in sympathy, chanting "Dubček! Dubček!" After 1968, Dubček withdrew from public life and lived in obscurity. He wrote his memoirs and died in 1992—living long enough however to witness the changes in Eastern Europe.

E.I./P.S.

Jitka Vondorva and Antonin Bencik, eds. *The Prague Spring, 1968*. Budapest, 1995.

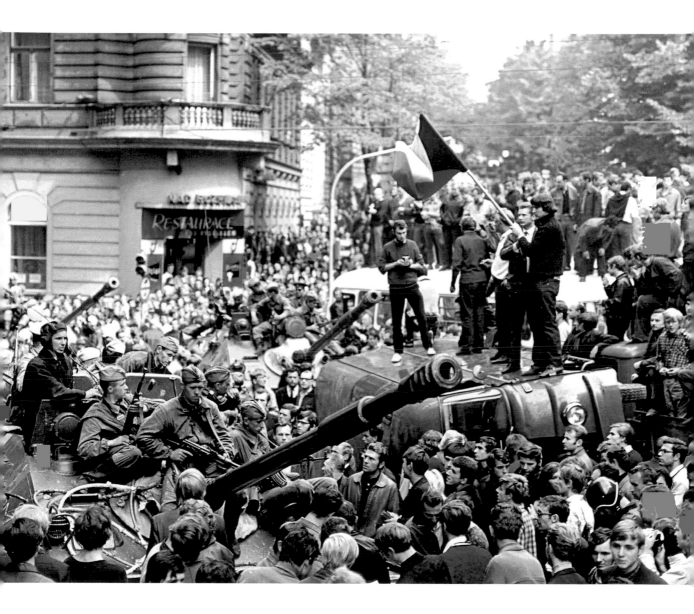

RESCUING THE ABU SIMBEL TEMPLE COMPLEX

1968 Abu Simbel, Egypt

The face of one of the four colossal statues of Ramses II is lifted into place, completing the rescue operation of the Abu Simbel temple complex. After the construction of the Aswan High Dam, the two temples at Abu Simbel were systematically taken apart and reconstructed 65 metres (213 feet) above the original site to save this unique Pharaonic monument from being flooded.

Aswan lies 280 kilometres (174 miles) south of the first Nile cataract at the border in Egypt near the Sudan. At the time of the pharaohs it was an important centre of trade. Ramses II built two temples into a rock cliff. Next to a smaller temple dedicated to his wife, Nefertari, who was identified with the goddess Hathor, Ramses II founded the Great Temple, dedicated to the gods Amun-Re, Re-Harachte, Ptah, and himself as deified ruler. The front is 38 metres (125 feet) wide and the temple reaches 65 metres (213 feet) into the rock. Four colossal statues of the seated Pharaoh Ramses II flank the entrance, each standing 20 metres (65 feet) tall. The second statue from the left had been destroyed in antiquity. Each of the colossi shows Ramses II wearing a false beard, uraeus snake and *nemes* headcloth. In reconstructing the temple, the engineers added the double crown of Lower and Upper Egypt to each of the colossi after each face had been lifted into place.

Every year on March 21 and September 23, when day and night are exactly the same duration, a beam of light shines directly into the long hallway and several rooms in the temple and illuminates the four statues at the back wall of the sanctuary. The light reaches Re-Harachte first, then shifts to Ramses II, and finally to Amun-Re, while Ptah, the God of Darkness, remains in the shade. The temple of Nefertari is the only Ancient Egyptian temple deeded to the wife of a pharaoh.

With the completion of the Aswan High Dam in 1963, a unique race began—against time and against the rising water level. The UNESCO-led efforts to save Abu Simbel attracted worldwide attention. First, a 360-metre (1,180-foot) dam was erected around the temple buildings. Next, the porous sandstone was hardened with injections of synthetic resin and cut into more than one thousand blocks weighing up to thirty tons each. With the aid of special cranes, the fragments were lifted 65 metres (213 feet) and shifted 180 metres (590 feet) inland, where they were reassembled. On September 22, 1968, the work was completed. The temple installations at Abu Simbel were declared a world heritage site in 1979.

I.L.S.

Bernadette Menu. *Ramses II: Greatest of the Pharaohs.* New York, 1999.

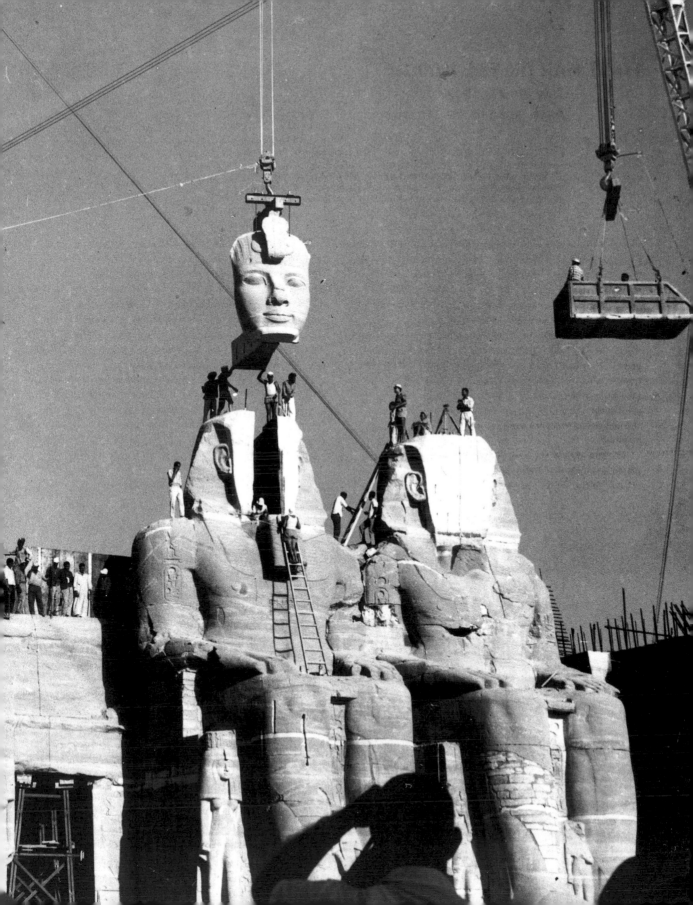

FIRST MAN ON THE MOON
July 20–21, 1969
Photographer: Neil Armstrong

On July 16, 1969, Michael Collins, Edwin Aldrin and Neil Armstrong blasted off from Cape Kennedy in *Apollo 11*. On July 20, Aldrin and Armstrong descended in the lunar lander and became the first human beings to set foot on the moon.

This picture of Edwin Aldrin standing on the surface of the moon with photographer Neil Armstrong reflected in the visor of his helmet changed the way we see ourselves and our planet. It was the culmination of a fascination with space in the 1960s. While Dr. Strangelove seemed to edge the Earth towards destruction, John F. Kennedy promised a mission to Earth's satellite.

For the vast majority of us, the moon remains a purely visual object; the only evidence that men ever landed there is photographic. No wonder there were conspiracy theories that the pictures were faked. It has become clearer, as NASA's long-term intentions towards the moon have proved nebulous, that *Apollo 11* and subsequent missions were as much publicity stunts as anything else and were undertaken largely to make photographs like this possible.

On the surface of the moon Armstrong and Aldrin bounced, played golf, raised the American flag. All this was caught on camera and watched by TV audiences all over the world. It was history as spectacle or—since the colonization of space implies an end to the earthbound chapter of the human story—the end of history as spectacle. Stanley Kubrick's *2001: A Space Odyssey* suggested this kind of transformation in its image of an astronaut passing into a higher stage of evolution. The sharp lines and deep shadows of this photograph describe an alien world. The man standing on this world has turned into an alien in order to go there, hidden deep inside his suit, his face invisible behind the visor's reflective surface. The implication for people on Earth was that humanity was about to enter a new phase in which the gravity of the existing world would vanish. Yet because all we have is the photograph, the utopian promise of *Apollo 11* remains a glimpse of something we are no closer to than William Blake in the eighteenth century when he drew a ladder to the moon with the caption "I want! I want!"

J.J.

Andrew Chaikin. *A Man on the Moon*. New York, 1994.

IMAGES FROM NASA'S MARS LANDER are the latest photographic relics of space travel. There is no human presence in the pictures except in the low, caterpillar-tracked robot Lander itself, slowly moving across the surface of Mars. Pictures taken by the Lander give us the same visual access to another world as this picture of man on the moon but, without the human figure, do not have the same impact.

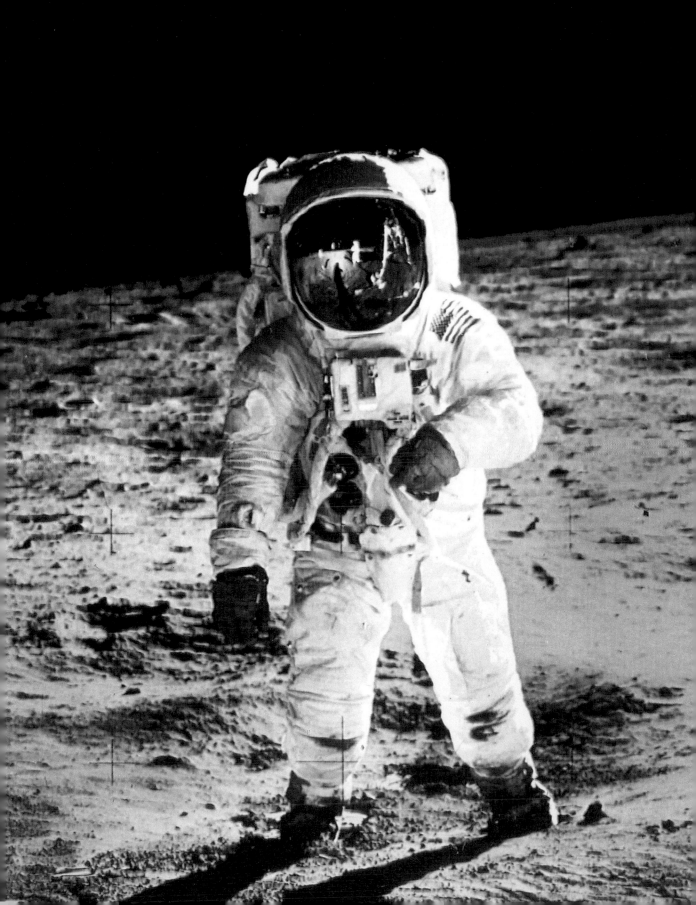

WOODSTOCK

August 15–17, 1969 Bethel, New York

From August 15 to 17, 1969, the largest rock festival in U.S. history was held in Bethel, New York, at which the leading rock groups performed to a crowd of half a million.

In the photograph a hippie couple is wrapped in a tight embrace. The blurred festival crowd on the farmer's field in the background becomes an anonymous tangled mass. The merged figures are an archetype of the generation known for flower power and rock 'n' roll. Their embrace symbolizes this generation's escape into various utopias. It became the cult icon of the sixties era. The photograph was used to market the music and film footage of the festival. Reproduced on millions of record covers, it set standards that market the festival to this day, helping to create the myth of freedom, flowers, and peace.

Over 400,000 people travelled to the Woodstock Music and Art Fair in New York State on August 15, 1969. The organizers had anticipated 200,000 visitors. No one was prepared for more than twice that number. The open-air stage was set up in Bethel, 80 kilometres (50 miles) from Woodstock, Bob Dylan's home.

Crosby, Stills, Nash, and Young played together for the first time. Creedence Clearwater Revival, The Band, and Jefferson Airplane joined the Grateful Dead, Janis Joplin, and Santana, making the music of the underground popular and establishing the sound of the 1970s. Jimi Hendrix gave his extraordinary "once in a lifetime" performance. His solo guitar riff to the tune of the *Star Spangled Banner* is perhaps the most memorable musical moment of a festival in which thirty-two bands participated. Still today, it remains one of the greatest guitar solos ever. The Who gave an extraordinary performance of their rock opera *Tommy*. After this

festival, rock music became a fixture in American popular culture, which began to exert a strong influence on Europe as well.

Woodstock also marked the beginning of the commercialization of music on a large scale, driving the cost of live performances to unprecedented heights. The event was a coolly calculated operation organized by Woodstock Ventures Inc., which attracted top bands with high fees and took care to professionally document the festival in sound and film, ensuring a steady stream of profits with ongoing marketing. At Woodstock the entire set-up—the musicians, their instruments—was interwoven. The individual, even the music itself, took second place to the event as a whole. All were victims—and victors—in a music industry that had fallen in love with ever-bigger spectacles. For American music and pop culture, this mass event turned out to be the single most influential festival ever. Fans, hippies, and members of the upper class all joined in a rendezvous with rock and pop groups, although the quality of the music at the event was uneven.

Woodstock achieved mythic status in the popular imagination. For the sixties generation, Woodstock became a legend in which drugs, the yearning for a different lifestyle, and the search for a common American identity merged into one. At the end of the twentieth century, however, the power of the legend has faded.

I.L.S.

Jack Curry. *Woodstock: The Summer of Our Lives.* New York, 1989.

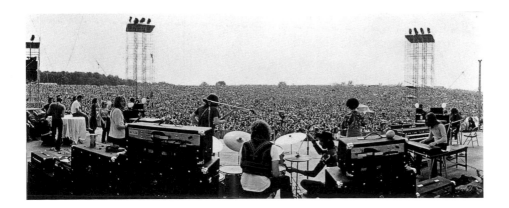

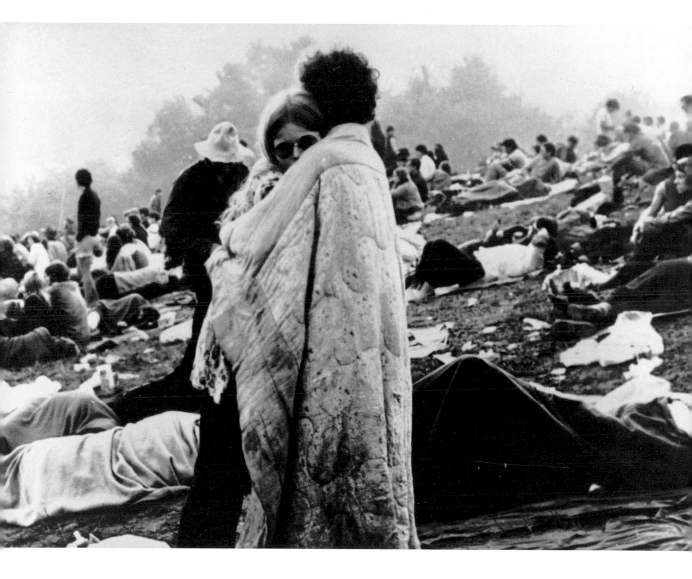

TRAGEDY AT KENT STATE

May 4, 1970 Kent State University, Ohio

Photographer: John Paul Filo

When Richard Nixon announces the U.S. invasion of Cambodia, renewed unrest spreads through American universities. During clashes between the National Guard and students on the campus of Kent State University, four students are killed and many others are seriously wounded.

John Paul Filo, a student at Kent State's school of journalism, took this Pulitzer Prize-winning photograph and gave a detailed account of the dramatic events. He recalled how on that particular Monday noon he was just leaving Taylor Hall, his classroom building, when he witnessed a confrontation between students and the National Guard, who were using tear gas. He saw a group of seventy-five Guardsmen in black gas masks and helmets run up a hill, pursued by stone-throwing students. Suddenly and without any warning whatsoever, the Guardsmen opened fire. He never imagined that they were using live ammunition. But then he saw a bullet rip through a metal sculpture. A moment later, a fellow student lay at his feet, shot in the neck and bleeding to death. A girl came running up the road and knelt next to the fallen youth. She trembled and cried . . . and screamed.

Four students were killed on May 4, 1970, among them Jeff Miller. Filo said: "Jeff wasn't a radical or a leader. He wasn't even politically active. He liked to play the drums, wore his hair long, was shy with girls, and worried about social problems. He was angry about the invasion of Cambodia and felt betrayed." The kneeling girl wasn't even a university student. She was a fourteen-year-old runaway from Florida named Mary Ann Vecchio. Her lament is at the centre of the image; the other people on the scene have not yet absorbed the magnitude of what's happened. Shots are fired, a man falls, a woman cries out: an archetypal image whose composition harks back to traditional paintings and sculptures of the Pietà. Like Edvard Munch's *The Scream,* it takes us straight into the existential abyss of despair. No doubt the kinship between the photo and its traditional models contributes to its powerful emotional impact. The newspapers snapped it up, and the picture helped shape the nation's opinion that "More than people died at Kent State." The death of the four students at Kent State was to the U.S. what the shooting of Benno Ohnesorg, a student, at an anti-Shah demonstration in Berlin was to West Germany in 1967. P.S.

Sheryle Leekley and John Leekley. *Moments: The Pulitzer Prize Photographs.* New York, 1978.

KENT STATE BECAME A SYMBOL of authoritarianism and the state's disregard for the human rights of its citizens. In the United States, student unrest began in 1968. The protests were aimed at U.S. involvement in Vietnam, at imperialism broadly defined, but also at racial discrimination, environmental pollution, and traditional university programs. In April 1969, black students rose in armed rebellion at Cornell University. Increasingly, the dissatisfaction with the Vietnam War spread through all levels of American society. By the time the Pentagon Papers were published, it had become a national identity crisis. The United States withdrew from Vietnam in April 1975.

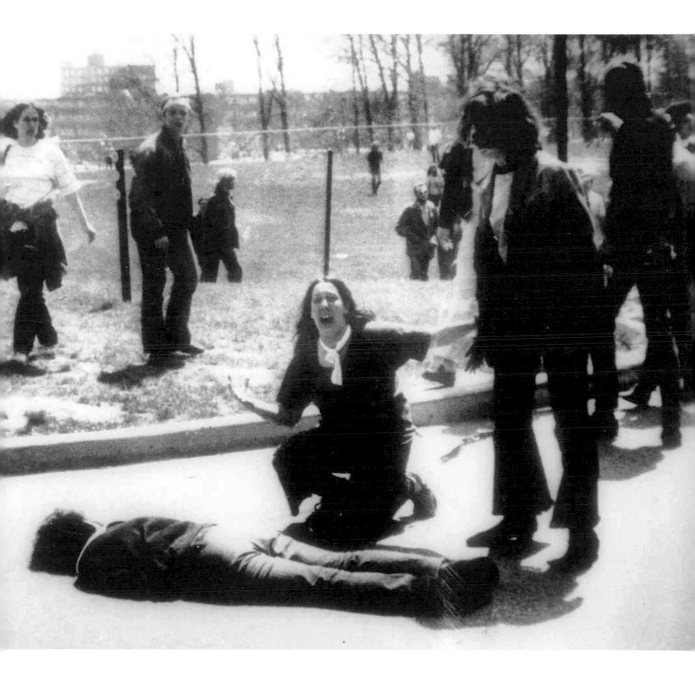

PELÉ LEADS BRAZIL TO WIN THE WORLD CUP

June 22, 1970 Mexico City

Brazil is world champion! Overcome with joy, Pelé raises the Jules Rimet cup into the air after the 4–1 victory over Italy in the final game. It is Brazil's third World Cup victory in twelve years.

Surrounded by team members, fans, and policemen, team captain Pelé carries the trophy around the stadium, holding the coveted cup high in the air for all to see. His enthusiasm is evident in his beaming smile. Some of his team members, among them Everaldo to his right, form a circle to shield their team captain from the excited fans streaming towards him. His victory dance is familiar from countless sportscasts; still, this was a special day even by those standards. After a disappointing start, the match stood at 1–1. Pelé led his team to victory by maintaining constant pressure on the opposing team's goal.

Mal Edson Arantes do Nascimento, better known as Pelé, was born in Brazil in 1940. A passionate soccer player even as a child, he was a technically brilliant and high-scoring forward. Between 1959 and 1968 he was five-time Brazilian champion with FC Santos, winning the championships in Chile in 1962 and in 1963, and becoming both South American and World Champion two and three times, respectively. Crowned the King of Goal Scorers, he scored in nearly every international match he played. He is known quite simply as the best soccer player there ever was.

Pelé was an icon, an institution, and an idol. For eighteen years he was an outstanding soccer player, scoring 1,220 goals between 1956 and 1974. The Brazilian style was acrobatic and contagious in its speed. It had flow and grace. In 1970 Pelé was elected Athlete of the Year. He helped to transform soccer tournaments into emotional events, affecting soccer fans around the world. Following his active career as an athlete he became a television commentator, president of the Brazilian soccer league and minister of sports.

I.L.S.

Pelé with Robert L. Fish. *Pelé: My Life and the Beautiful Game.* New York, 1977.

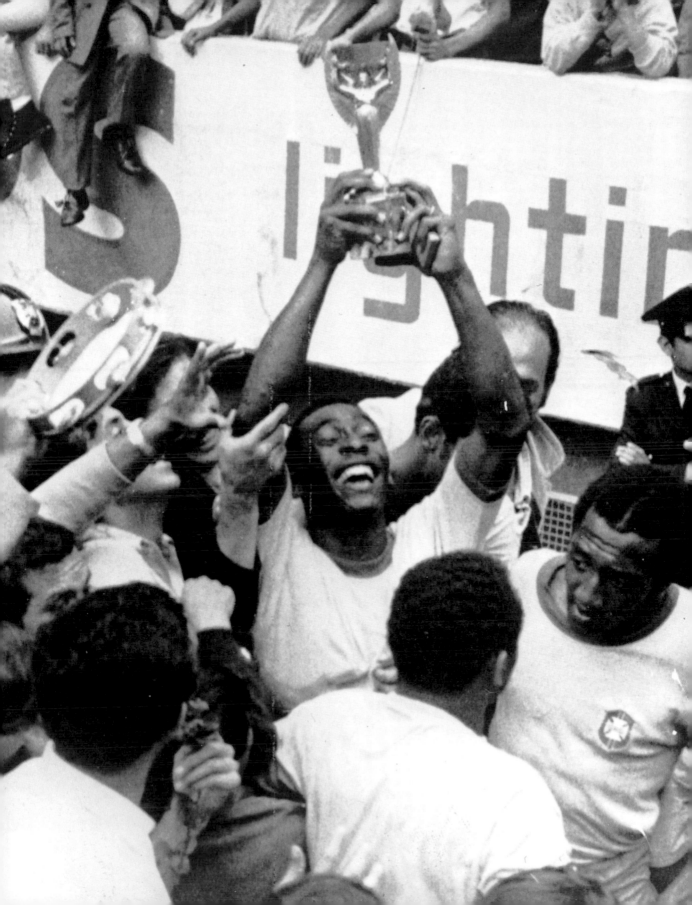

WILLY BRANDT
AT THE WARSAW GHETTO MEMORIAL

December 12, 1970 Warsaw, Poland

Photographer: Sven Simon

In 1970 Willy Brandt, the social democratic chancellor of West Germany, signed treaties with the USSR and Poland recognizing the Oder-Neisse line as the German-Polish border. In Warsaw, he visited the memorial to the Warsaw Ghetto uprising and—in what was apparently an unplanned gesture —knelt before it.

This image of humility and acknowledgement of guilt had a huge impact in Germany. Chancellor Willy Brandt's expression of apology before the memorial to the Jewish fighters in the Warsaw Ghetto who held out against the Nazis between April and May 1943 was a powerful and dignified gesture. In this photograph the crowd and photographers appear to be amazed by the spectacle —cameras click and whirr, people gawk—but Brandt himself is utterly absorbed in his thoughts as he kneels on the wet ground.

It is not an abject scene. The German chancellor does not prostrate himself. In fact this is as much an image of German national self-respect renewed as anything else; Willy Brandt looks strong in his humility and communicates to anyone who sees his gesture that it is a sign of national maturity to acknowledge the horrors of the Nazi era. Brandt himself had rejected his German citizenship in 1933 and emigrated to Norway. An exceptional post-war leader, Brandt was awarded the Nobel Prize in 1970 chiefly for his policy of Ostpolitik, a relaxation of the political tensions between Eastern and Western Europe.

The black bulk of Willy Brandt's coat and the religious connotations of his kneeling posture give this photograph the quality of an altarpiece. Like all the great iconic journalistic photographs, it captures something real yet ephemeral and has the poetic qualities of a work of art. Brandt, as the true author of this photograph, has created a grave and potent image with all the authority of a modern historical painting. J.J.

Dan Kurzman. *The Bravest Battle: The Twenty-Eight Days of the Warsaw Ghetto Uprising.* New York, 1976.
Barbara Marshall. *Willy Brandt: A Political Biography.* Basingstoke, 1997.

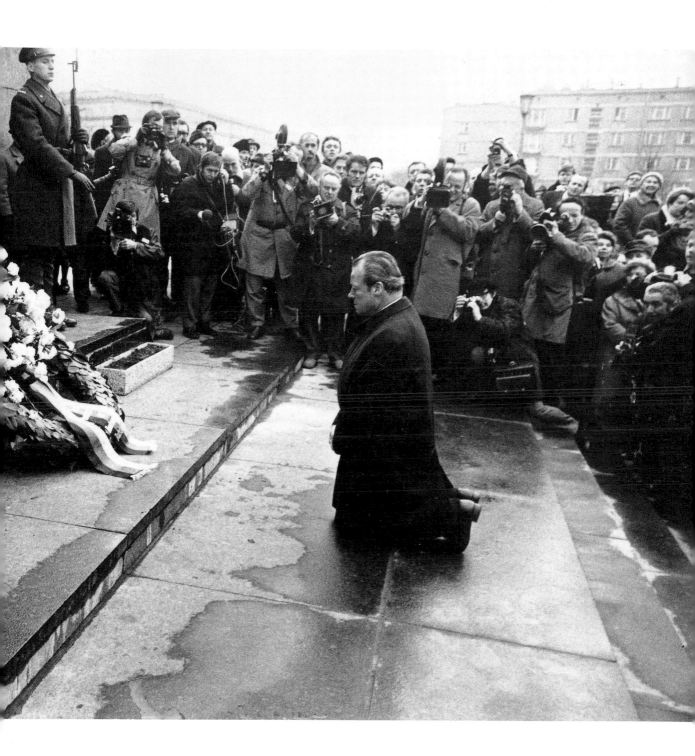

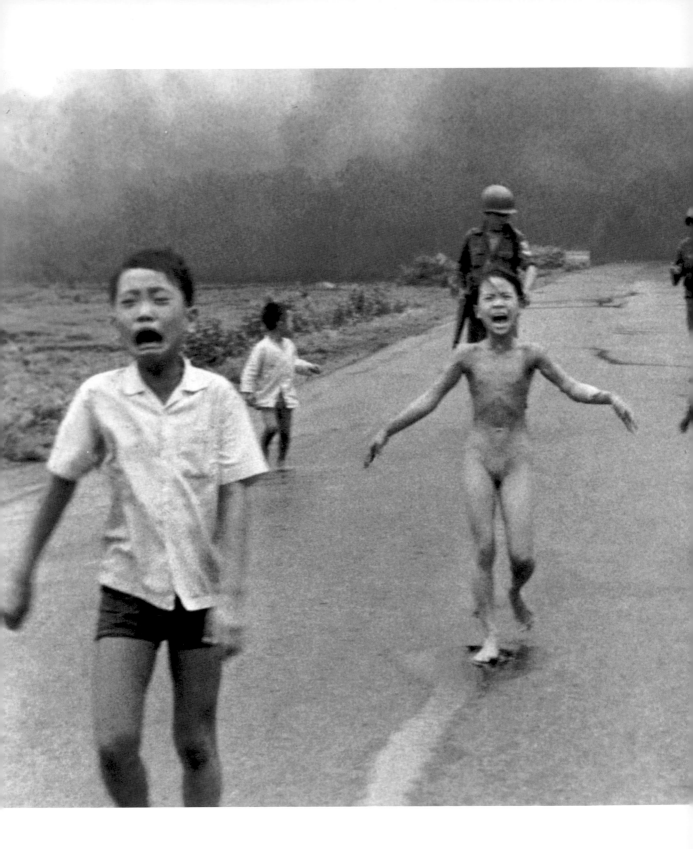

NAPALM ATTACK
June 8, 1972 Trang Bang, South Vietnam
Photographer: Nick Ut

On June 8, 1972, the American military ordered the South Vietnamese air force to attack the village of Trang Bang outside of Saigon, believed to have been infiltrated by enemy forces. The fighter plane swooped in and mistakenly dropped napalm bombs on a cluster of its own soldiers and on women and children hiding from the fighting.

Hung Cong (Nick) Ut took this photograph, which was first seen on the cover of *Time* magazine in 1972 and still has lost none of its harrowing impact. It is clearly an image of warfare that we are being presented with, yet it is the effects of war on individuals that we see before us.

Escaping from a cloud of napalm smoke just behind them, a group of children run down an empty road, followed by soldiers. The children's mouths are open in screams of pain; the central figure runs naked towards the camera. Looking at this photograph, we feel complete helplessness at the horror of war. The road, Route 1, continues to the horizon following the lines of perspective as the victims rush forward towards us, creating an apocalyptic feeling.

The naked girl who had torn off her clothes, which were covered in burning napalm, was nine-year-old Kim Phuc. Knowing the child's identity gave the photograph even greater impact. This image also shows the power of still photography as opposed to film. The same event was also captured on film, but it does not communicate the silent horror that we witness here.

This image raises a number of questions of responsibility that are key in debates around photojournalism. It is difficult not to ask what the photographer, or the soldiers, or indeed ourselves as viewers could have done to save these children from harm. In actuality, Nick Ut rushed Kim Phuc to the nearest hospital where she was treated for her burns. Facts that are not narrated directly by the image are in many ways irrelevant, however. Additional information can only be communicated through an accompanying text. It is the silent horror of this photograph that has imprinted it on our memories forever. L.L.F

Michael Anderegg, ed. *Inventing Vietnam: The War in Film and Television.* Philadelphia, 1991.

WOUNDED KNEE TAKEOVER
March 3, 1973 South Dakota

On the night of February 27, 1973, Native Americans occupied the historical site of Wounded Knee on the Pine Ridge Reservation in South Dakota. Here, in 1890, the U.S. Cavalry had massacred three hundred Miniconjou Sioux. The militants were members of the American Indian Movement, known as AIM. Eleven whites residing at the Wounded Knee Trading Post were taken hostage.

Holding a rifle, Oscar Bear Runner watches over the sovereign territory of the newly proclaimed Independent Oglala-Lakota Nation where the first tepee is being erected. The old flint rifle no longer works, but who cares: around the world, Bear Runner's photo signals a new Sioux uprising. The TV media will be fed some old-fashioned Indian pageantry: buckskin clothing, drums, traditional songs, angry words—and of course the silhouettes of guns.

The American Indian Movement leaders knew all too well that without news media their cause was as good as lost. Washington reacted to the symbolic occupation (Wounded Knee, after all, is on Indian land) by sending in the National Guard, tanks, helicopters, and later, the FBI. But round-the-clock media presence prevented the use of military force to break the stalemate.

The U.S. government used the media as well, portraying a reservation torn by internal strife and characterizing AIM as a terrorist organization with communist leanings, a militant mob of criminals. What the government failed to mention was that the white "hostages" sympathized with the rebelling Indians. Out of solidarity with the Indian cause, the whites had chosen to remain at the trading post during the occupation's first few days to ensure the safety of the hostage-takers. The members of AIM, most of whom came from Minneapolis-St. Paul, Minnesota, had been called

to the reservation by traditional Oglala elders to fight the tyranny of tribal chief Dick Wilson. Wilson, backed by the Bureau of Indian Affairs, ran a private police force, known as the Goons (Guardians of the Oglala Nation). The Goons terrorized anyone who opposed Wilson's policies—policies dead-set against traditional Indian values. AIM demanded the recognition of the tribal elders and a return to the traditional community structure. At the same time, AIM called attention to the desperate poverty experienced by Indians on reservations across the United States.

The occupation of Wounded Knee lasted seventy-one days; two Indians were killed by National Guard bullets. When the leaders of AIM were brought to court in Minneapolis, the judge, aware of the hoodlum tactics practised by the FBI—even his own private telephone line had been tapped—dismissed all charges against them. Wounded Knee became a symbol of resistance, launching an Indian renaissance that continues to this day; with new self-confidence Indian nations are proclaiming the sovereignty and sacredness of their lands.

C. B.

Leonard Peltier with Harvey Arden, ed. *Prison Writings: My Life Is My Sundance*. New York, 1999.

AT THE BEGINNING OF THE 1970s, Pine Ridge Reservation was embroiled in civil unrest. FBI agents collaborating with Chief Wilson's Goons had created a climate of terror. The sixty-four known murders of AIM sympathizers in the years following the Wounded Knee occupation remain unsolved. The symbolic figure at the centre of this turmoil was the AIM activist Leonard Peltier, who has been in prison since 1976. On June 26, 1975, following an exchange of bullets outside the village of Oglala, two FBI agents and an Indian youth lay dead. Two of the three Indians brought to trial for the FBI deaths were acquitted of charges; Peltier, however, due to witness testimony trumped up by the FBI, received two life sentences. To this day he has been denied a court appeal. Amnesty International considers Peltier to be a U.S. political prisoner.

Leonard Peltier, Leavenworth State Penitentiary, Kansas, 1994. Photograph by Dick Bancroft.

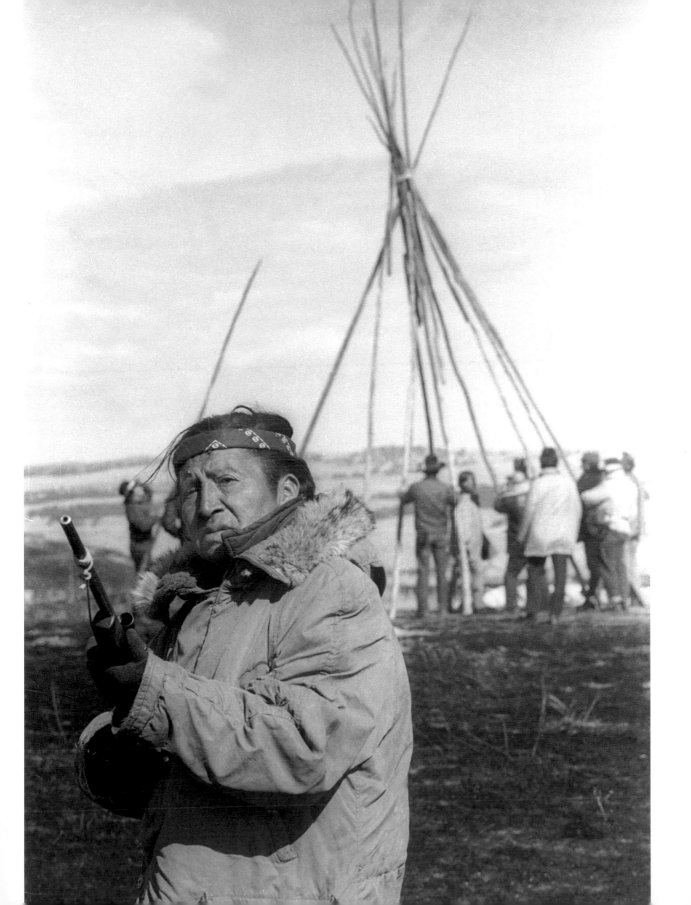

MILITARY COUP AGAINST SALVADOR ALLENDE
September 11, 1973 Santiago de Chile

Shortly after the third anniversary of Salvador Allende's election as president and a few days before the national holiday, Chile's right-wing military staged a coup: fighter planes bombed the Moneda, the governmental palace in Santiago.

On the morning of September 11, President Allende drove to the Moneda accompanied by an unusually strong escort and entered the complex under heavy guard. Salvador Allende, one of the most promising statesmen in South America, stepped in front of the main entrance for one last time to gain an overview of the situation and observe the low-flying planes circling over the city. Prepared for the worst, he wore a helmet and carried a pistol, and was accompanied by his personal doctor, chief of security and two armed bodyguards. Allende's stance expresses his readiness for action and his determination. The president stayed only for a brief moment. Then he walked back into the building.

Allende declined an offer by the putschists to be flown with his family to a country of his choice. Instead he addressed the Chilean people for the last time at 9 a.m. on Radio Magallanes: "I shall not resign. Placed in this critical historic situation, I will pay with my life for my loyalty to the people." Around 10 a.m. the first bullets hit the palace, and the tanks opened fire. During a short break in the fighting, Allende sent women and unarmed employees away from the palace, some leaving against their will. The putschists issued an ultimatum: Allende was to surrender by 11 a.m. or the palace would be bombed. Allende refused to reply. Minutes later, the Moneda was bombed by Hawker Hunters which destroyed parts of the palace and set it ablaze. Much weakened by the attack, the remaining loyalists were unable to stop ground troops from entering the palace. Two groups of loyalists were captured. Finally, Allende, who refused to surrender, and five of his bodyguards died in the crossfire.

Salvador Allende was elected president in 1970 with only a slight majority, after having run as a candidate in three previous elections without success. A doctor by profession, he was one of the founding members of the Socialist Party in 1933 and had been the opposition leader since 1964. Under his initiative three leftist parties joined in 1970 to form the *Unidad Popular,* which attracted many followers, especially among factory workers. But the *Unidad* also had many enemies among foreign corporations, industrialists, and landowners because of its sweeping social programs ("half a litre of milk for every child every day"), progressive agrarian reform, and radical economic policies, which included the nationalization of copper, coal, potassium nitrate, and oil. Nine months before the coup, Allende addressed the UN: "Chile is a country whose backward economy has been dependent upon foreign capitalist corporations. Yes, it was openly sold to them . . ." For the young generation rebelling against the establishment around the world, Allende became an hero, a figure who stood in dramatic contrast to the military dictators in other South American countries. During his election campaign he was supported by Pablo Neruda. Victor Jara—another victim of the coup—expressed these newly arisen hopes in many of his songs. Aided by the CIA, the right in Chile responded to Allende's reforms with escalating violence, assassinations, and paid strikes, which destabilized the economy and the infrastructure, furnishing them with an alibi for the coup. P.S.

Samuel Chavkin. *The Murder of Chile.* New York, 1982.
Pamela Constable and Arturo Valenzuela. *A Nation of Enemies: Chile under Pinochet.* New York, 1993

AFTER THE VICTORY of the reactionary right, a four-man junta seized power, succeeded by Augusto Pinochet. The constitution and civil liberties were suspended, and opposition parties prohibited. The junta unleashed a reign of terror with political persecution and torture; many fled into exile. Pinochet's terror lasted for seventeen years. Only after a plebiscite, a referendum, and the general elections of 1989 did he agree to Chile's return to democracy, but not without securing himself a peaceful old age as "senator for lifetime." His crimes go unpunished to this day.

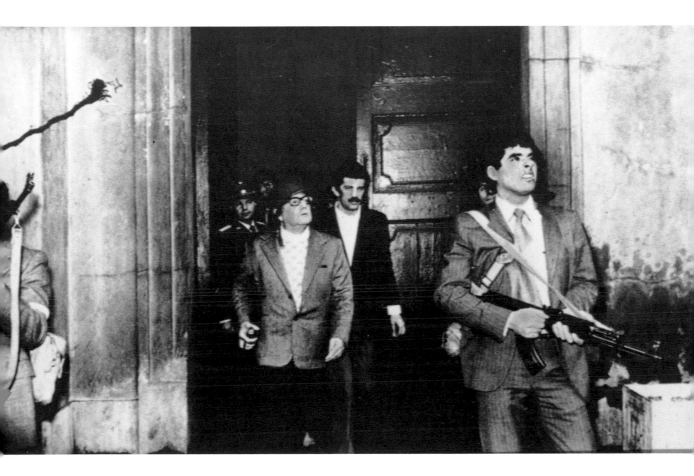

PORTRAITS OF THE CONDEMNED

1975 Tuol Sleng, Cambodia

A remarkable collection of photographs of Cambodian men, women, and children, all condemned to death, has been recovered from the notorious S-21 prison, located just south of the capital city of Phnom Penh. Under the Khmer Rouge, which seized power in Cambodia in 1975, the prison was controlled by the security police.

These chilling identity photographs (which may originally have numbered over 14,000) were made by a group of Cambodian photographers employed at S-21. The photographs were simply made and were either full-length or head-and-shoulders shots. Most of the prisoners are wearing a placard with a number on it. Like the photographs discovered after the liberation of the Nazi death camps, they have become documents of our time, incontrovertible evidence of genocide.

The photographs have been published extensively in the West. Their power lies in their simplicity and the weight of evidence which we know them to bear. Confronted with the camera, some of the prisoners appear terrified, some are expressionless. Others attempt to smile for the camera. More potent even than photographs of violent death, their normalcy is shocking.

Over the course of the twentieth century, photographs made by totalitarian regimes have become of great interest to historians of photography and culture. They show the ways in which photography can be used to document and control, the ways in which individuals become depersonalized by the camera. They have also been used by families searching for their loved ones. V. W.

David Chandler. *Voices from S-21: Terror and History in Pol Pot's Secret Prison.* Los Angeles, 1999.
Douglas Niven and Chris Riley, eds. *The Killing Fields.* Santa Fe, 1996.

THE PHOTOGRAPHS FOUND IN THE ARCHIVES of S-21 were made by the photography unit at the prison. Nhem Enh, one of the five photographers in the unit, has provided information about himself and the unit to investigators. He became a soldier in the Khmer Rouge army as a child and studied photography in China in the mid-1970s. The archive was first discovered by two Vietnamese photographers. The photographs were conserved and printed by two photographers from East Germany in 1981; further conservation was undertaken by Douglas Niven and Chris Riley of the Photo Archive Group. Many of the photographs are stored in electronic form at the Cambodia Genocide Program at Yale University. Thousands of documents and photographs found in the prison after the Khmer Rouge withdrew are now preserved in the Tuol Sleng Museum of Genocidal Crimes.

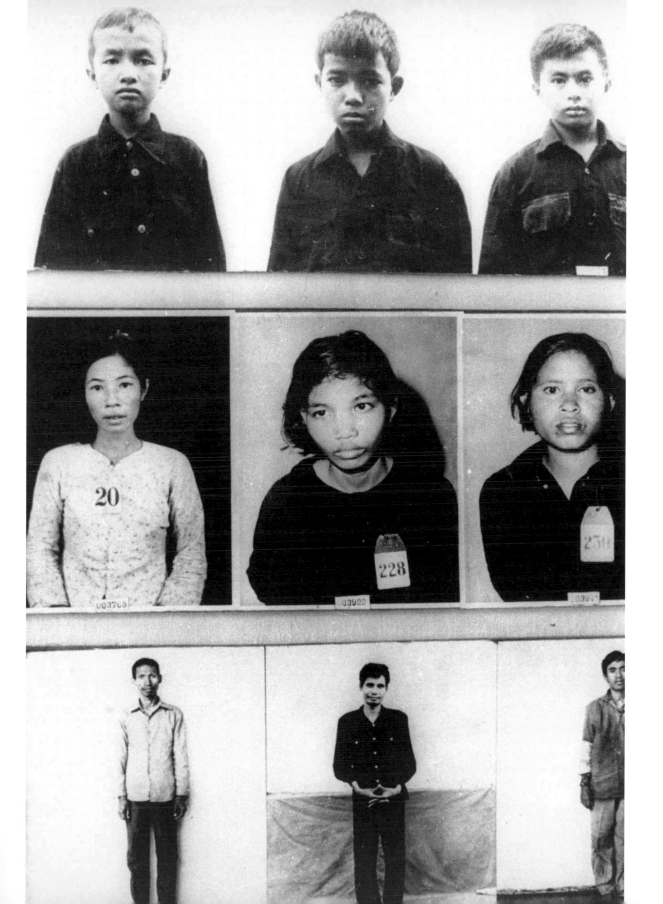

SOWETO UPRISING

June 16, 1976 Soweto, South Africa

In the black township of Soweto, southwest of Johannesburg, police clash violently with 10,000 student protesters. The students are protesting against apartheid and, more particularly, the decree issued by the government under Prime Minister John Vorster, adding the Afrikaans language as an official medium of instruction in black schools. Thirty-five people are killed in the police crossfire, 220 are wounded. The protesters respond by torching buildings. The chief of police imposes a ban on public assembly.

Despair is etched on his face. We don't know his name, just as we cannot truly know his suffering. We hear the news, but we cannot feel the pain. The young black man is carrying a mortally wounded fellow student to a waiting car. The victim is Hector Peterson, one of the first fatalities; the girl in the picture is Hector's sister, her hand raised in shock. Despite daily confrontations with the regime, the young protesters had not anticipated that the white police officers would respond with such deadly force.

The escalation of violence in the summer of 1976 spelled the beginning of the end for apartheid, South Africa's official policy since 1949. Chief of Police Jimmy Kruger declared that he had been forced to take drastic steps because the students were throwing rocks. Mounting confrontations between police and protesters would claim many more than the thirty-five victims of that first day. During the course of the following fifteen months, nearly 700 people were killed, most of them black youth. The fight against racial segregation raged on for over two decades. It was fought on the street by the poor and the disenfranchised, and on the political front by the African National Congress (ANC) and the Pan Africanist Congress (PAC), both in exile.

The racial unrest put Soweto on the map. Prior to the confrontation, white South Africa certainly had not been aware of Soweto. In the early days of the protests, the township had a population of 80,000; over the next twenty years the number would swell to nearly 4 million. Soweto is an abbreviation of South Western Township. Townships were ghetto-like urban developments governed by a white administration. No one was allowed to own a house, and "residential permits" were granted for a thirty-three-year period. On average, each asbestos-roofed "matchbox house" provided shelter for ten people. There was a constant and heavy military and police presence. Township inhabitants had to carry a pass at all times. As many as 250,000 Soweto residents worked in Johannesburg during the day but had to leave the city by 8 p.m. and return to the township. Without these black labourers and domestics, the infrastructure of Johannesburg would have collapsed.

The dead of 1976 have not been forgotten: under Nelson Mandela, the government has declared June 16 a national holiday, the Day of Youth, as it is now known. C.B.

William Finnegan. *Dateline Soweto: Travels with Black South African Reporters.* Berkeley, 1995.
Harold Scheub. *The Tongue is Fire: South African Storytellers and Apartheid.* Madison, Wisconsin, 1996.

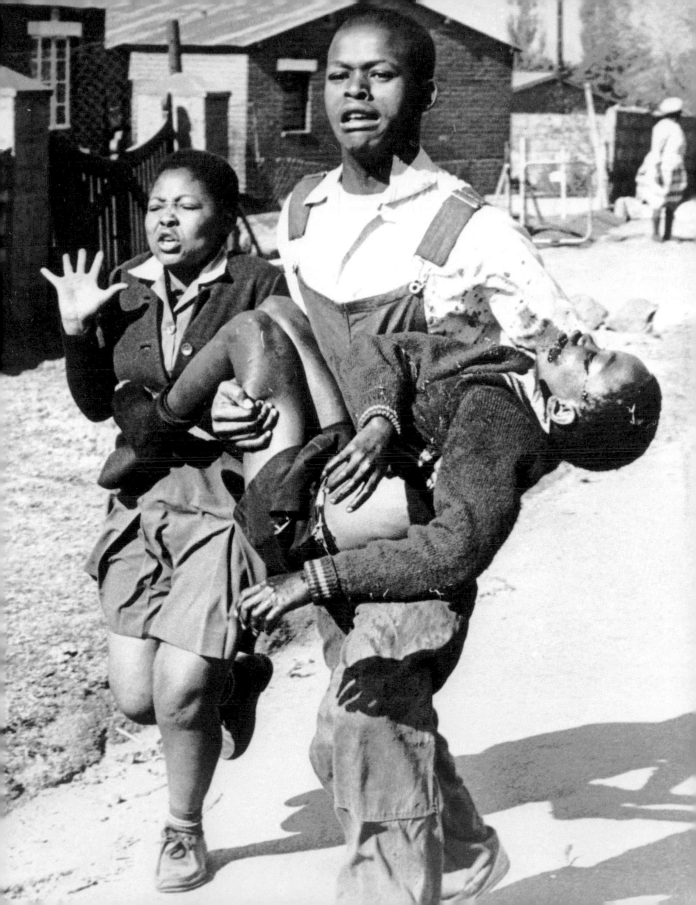

CAMP DAVID ACCORDS

September 17, 1978 Washington, D.C.

Egyptian president Anwar el-Sadat and Israeli prime minister Menachem Begin join in a ceremony at the White House to sign the outline of a peace plan developed at Camp David with U.S. president Jimmy Carter in the role of intermediary. After signing, the two statesmen shake hands as a solemn gesture of reconciliation. That same year, Begin and Sadat shared the Nobel Peace Prize.

The statesmen needed to mark the successful completion of the Camp David talks with a full-scale media event, all the more so because the accords stood on shaky ground. For the happy ending to this PR campaign, they pulled out all the stops: smiles for the camera, flags against a backdrop of cascading golden brocade, and the theatrical setting of the White House classical interior. Although we cannot "hear" the solemn emotion of the speeches or the thundering applause of the invited guests, the photograph more than compensates with the sonorous tone of its colours and the demonstrative elation it captures. It is the perfect snapshot of a great day in U.S. foreign policy.

The accords envisioned a five-year transition period for the West Bank and the Gaza Strip, then still under Israeli occupation, as well as a fully autonomous elected government. The "legitimate rights and just demands" of the Palestinians were formally recognized, and they were granted the right to be heard in the upcoming negotiations on the final status of the West Bank and the Gaza Strip, and in the peace talks between Jordan and Israel. In return, the Arab side acknowledged Israel's right to exist within safe and recognized borders. Moreover, the Camp David accords contained a draft for a peace treaty between Egypt and Israel (signed in 1979): this peace treaty proved to be the only lasting element in the Camp David accords (see p. 158). It guaranteed Israel's withdrawal from the Sinai, free passage through the Suez canal for all ships flying the Israeli flag, and ultimately led to normal diplomatic relations between Israel and Egypt.

The guests at the ceremony were members of the delegations, representatives of Congress, and other public figures. One seat remained empty, however: it had been reserved for Egyptian foreign minister Mohamed I. Kamel, who contributed decisively to the negotiations but suddenly resigned from office. Kamel was unwilling to support Sadat's concessions, especially since several resolutions were in direct contravention of Egypt's commitments to the Arab League. P.S.

Guyora Binder. *Treaty Conflict and Political Contradiction: The Dialectic of Duplicity*. New York, 1988.

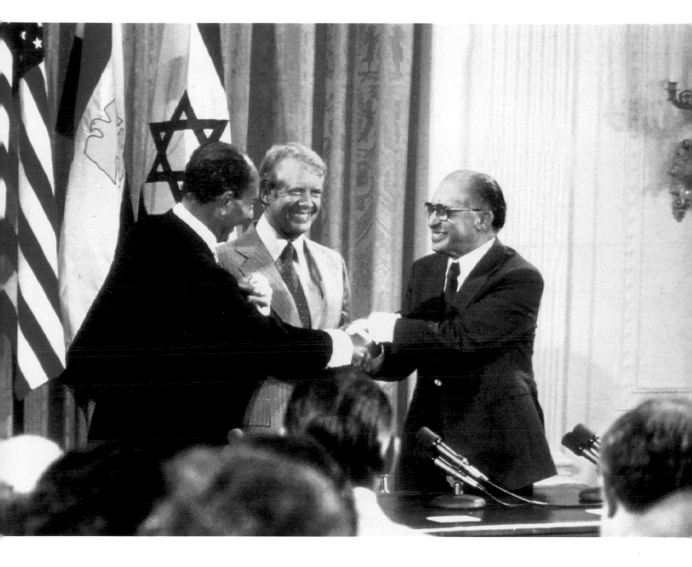

MOTHERS AND GRANDMOTHERS OF THE PLAZA DE MAYO

December 1979 Buenos Aires, Argentina

Photographer: Eduardo di Baia

The centre of Buenos Aires was in turmoil as Hebe de Bonafini, leader of Abuelas de Plaza de Mayo (Grandmothers of the Plaza de Mayo), led a march through the streets of the city. This group of grandmothers and relatives of the children who disappeared during Argentina's "dirty war" of the 1970s has worked tirelessly to discover the fate of the children, many of whom undoubtedly perished. Others, the group claims, were stolen by childless couples in the armed forces and in the service of the dictatorship.

Bonafini is determined to keep the memory of the disappeared alive and to trace any of the missing children who may have survived. Since the retirement of General Videla in 1978, it has become safer for Argentinians to protest openly, but until the promised return to democracy, campaigners such as Bonafini are still at risk.

This press photograph, made just before Christmas 1979, showed the world that the relatives of "the disappeared" in Argentina would mobilize every means at their disposal to publicize their cause both within Argentina and internationally. The photograph captures the anger of these ordinary Argentine women as they fight to locate their lost children and grandchildren. They shout and raise their fists, and the photographer, shooting from below, portrays them as three avenging angels. On the banner above are family photographs of the lost children, smiling and innocent. These photographs within a photograph show portraits and family images displaced from their usual private context to become symbols of tragedy and corruption. Their stillness and serenity contrast strongly with the energy and anger of the women demonstrators.

In a photograph such as this, we can feel the movement and the noise, the power of the crowd. Circulated by international press agencies, this image did much to draw international attention to the aftermath of the Argentinian tragedy. It also underlines the importance of photographs as evidence (some of the abducted children were indeed traced from the photographs used by the grandmothers) and as objects of remembrance.

This photograph was made during the time when Argentina, although still a dictatorship, was in the process of becoming a more open society. Few photographic records of the events of the dirty war have surfaced as yet, and it is likely that this particular human tragedy will be remembered more through the oral evidence of the victims of oppression than through photography.

V. W.

Iain Guest. *Behind the Disappearances*. Philadelphia, 1990.

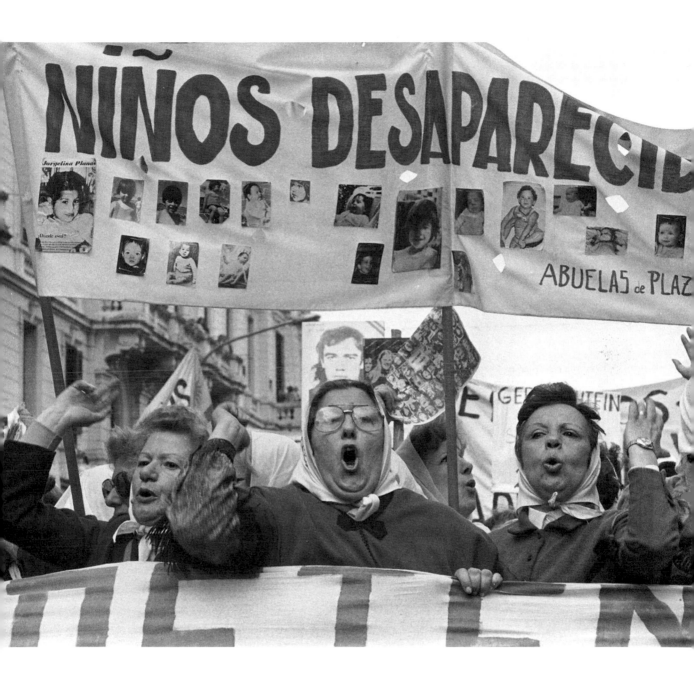

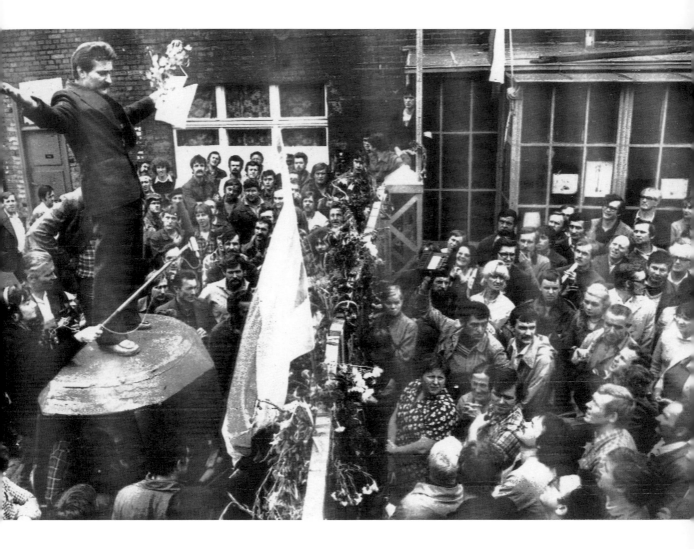

STRIKE AT THE LENIN SHIPYARDS

August 30, 1980 Gdansk, Poland

Photographer: Peter Knopp

After the penultimate round of negotiations with the state commission, Lech Walesa, the chairman of the strike committee, steps out to address the crowd gathered in front of one of the shipyard gates. He announces that the first agreement has been signed, ensuring among other things the right to self-governing trade unions in Poland.

Brezhnev still ruled in Moscow and the memory of what had happened in Czechoslovakia was still fresh: the last serious attempt to soften Soviet dogmatism had been silenced with tanks in Prague and Bratislava (see p. 120). In 1980, the chances for successful resistance against Moscow seemed slim indeed. Previous strikes at the Lenin shipyards in December 1970 had claimed dozens of victims among the workers, shot by the military and the militia.

On August 14, 1980, the protest gained momentum. The workers issued a list of demands: the reinstatement of crane operator Anna Walentynowicz and electrician Lech Walesa; the erection of a memorial for the "December Victims;" a wage increase and family benefits comparable to those enjoyed by the militia. Furthermore, they wanted a guarantee that the strikers and strike leaders would be safe from political persecution once the protests were over. Within three days, twenty-eight other companies followed the example of the Lenin shipyards, creating the ISC or Interenterprise Strike Committee—the core of the future Solidarity movement. Their chairman was Lech Walesa. The demands now focussed on universal civil rights: the right to free unions, the right to strike, freedom of opinion, and the abolition of censorship. "We have been lied to for thirty-five years," a strikers' bulletin proclaimed. People had had enough of "party politics" and especially of those "up there, sitting on their soft chairs."

The shipyard gates were the focal points in the strike events. Gate 2 was the main gate of the Lenin shipyards. Here Lech Walesa spoke to the crowd—family members of the striking workers and sympathizers—and to the shipyard management standing behind the crowd. Here he announced the arrival of donations for the strikers and their families from all over Poland. And here the announcements were followed by the singing of the national anthem and *Boze cos Polske,* a traditional hymn. The gate itself became a political icon. Crowned with the Polish flag, it was decorated with flowers and an image of the Pope. A large wooden crucifix stood in front. Solidarity delegations were received at the gate, masses were read, and representatives of the world's press agencies jostled to gather the latest news. Gate 3 was decorated with an image of the Virgin Mother of Tczew.

August 30, a Saturday, was the seventeenth day of the strike. The ISC now had a membership of several hundred companies and strikes had broken out across the country. Subject to tremendous public and international pressure, the government agreed to negotiate. The government negotiator, Mieczylsaw Jagielski, travelled back and forth between Warsaw and Gdansk on a daily basis. The remaining points in the list of demands were signed the following day. The Lenin shipyards became the cradle of Polish democracy.

P. S.

Robert Eringer. *Strike for Freedom! The Story of Lech Walesa and Polish Solidarity.* New York, 1982.

THE ROYAL WEDDING

July 29, 1981 Buckingham Palace, London

Prince Charles and nineteen-year-old Lady Diana Spencer were married at St. Paul's cathedral in London on July 29, 1981. Thousands of people crowded the route of the wedding procession to watch the culmination of what had been widely described as a fairy-tale romance. Millions more watched the ceremony on television. In this photograph, one of the most published images in the world, the Prince and Princess kiss on a balcony at Buckingham Palace after the ceremony.

When Lady Diana Spencer stepped out of the royal carriage to walk up the aisle of St. Paul's cathedral, the beginning of her relationship with the camera was clear. Enveloped in a voluminous dress and trailing veil, she offered the British public and the world press a new icon of glamour. Diana was the perfect embodiment of the style then emerging from the drab 1970s. She was simultaneously the princess who shopped 'til she dropped, the tragic bulimic trapped in a failing marriage and a family obsessed with protocol, the tireless campaigner against land mines, and the valued supporter of AIDS victims and the homeless—an enigmatic and charismatic figure who engaged the imagination of the world.

In this photograph, the contrast between the Prince's formal pose and Diana's emotional physicality is clear. Viewed in hindsight, it is an ill omen of a marriage that ended in acrimony and public quarrels. For a time, however, the marriage retained its fairy-tale gloss.

Photography and photographers became an integral part of Diana's life. It could be said that she remodelled not only her appearance, but her whole persona, based on the photographs of herself which she studied intently. For press photographers, she proved to be a godsend and her every move was documented. Originally a shy young woman, Diana learned to perform for the cameras and relied on photography to create an image of a beautiful, stylish, caring celebrity, an image that became increasingly important as her rift with the royal family deepened. Only a small proportion of the public ever saw Diana in real life, but through the millions of photographs taken up until the time of her death, she became a familiar and fascinating figure. She was said to be the most photographed woman in the world. Pursued by press photographers, she died in a car accident in Paris on August 31, 1997.

V. W.

Nicholas Davies. *Diana: The People's Princess*. Secaucus, 1997.

EVERYONE PHOTOGRAPHED PRINCESS DIANA, from high-society portrait photographers such as Lord Snowdon and Lord Litchfield to the international paparazzi waiting to surprise her in an unguarded moment. Photographers such as U.K.-based Tim Graham and *Sun* newspaper veteran Arthur Edwards photographed her constantly for almost twenty years. One newspaper editor remarked that she was "the biggest story of all time," and she appeared on the covers of all major international magazines. Candid photographs of Diana and her children at the beach, Diana at the gym, and Diana on her last holiday with Dodi Fayed earned huge sums of money for the paparazzi who took them. It could be said that she began the boom in celebrity photography in the 1980s and stirred public interest in the British royal family, which shows no sign of diminishing.

Flowers in front of Kensington Palace, London, September 8, 1997.

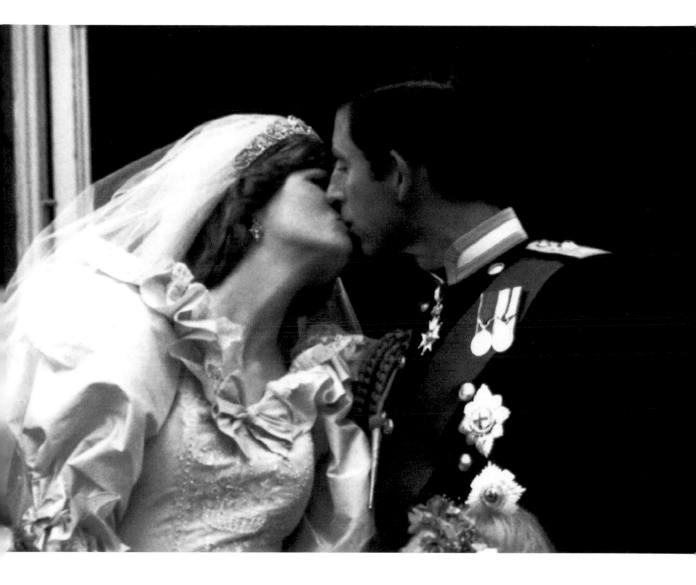

DESTRUCTION OF THE YANOMAMI TERRITORY

August 1983 Brazil-Venezuela border

Photographer: Harald Herzog

The first great threat to the Yanomami were diseases brought into their lands during the building on the Perimentral Norte, a section of the Transamazonica, from 1974 to 1977. The search for gold in this region has proven to be even more fatal. In 1988 the Yanomami were forced to retreat to 'reservation' islands only 30 percent the area of their original settled lands, and even these modest refuges have been threatened by the waves of intrusion of those hungry for gold. In August of 1993, Yanomami males of the Haximu and Simao communities were massacred.

We are looking into the eyes of a Yanomami, a member of one of the rainforest's last native peoples. Kajapo, Txukaramai, Kogi, Yanomami: names of tribal nations whose way of life is threatened by the global economy. Increasingly, the custodians of lands still rich in raw materials are indigenous cultures. The extermination of peoples living in vital connection with the earth is part of the unspoken agenda of the twenty-first century. The only hope these cultures have is that we come to our senses before it is too late.

In scattered communities ranging in size from 40 to 250 members, some 20,000 Yanomami live along the tributaries of the Amazon in the state of Roraima in northern Brazil, as well as near the headwaters of the Orinoko in southern Venezuela. They were once ten times that number. In Venezuela their round communal dwellings have a leafed roof that is open at the centre *(Shapono)*; in Brazil, the centre is roofed *(Maloco)*. The Yanomami, who take their personal names from plants and animals, are a semi-agrarian, hunter-gatherer people—a way of life that allows communities to harvest and move on. For thousands of years the Yanomami have relied upon the rainforest for all their food and medicinal needs; their knowledge of native flora and fauna is profound. Their traditional territory—rugged rainforest spiked here and there with mountains—comprises some 19 million contiguous hectares. It is one of the world's largest ecological reserves.

The Yanomami are among the last tribal peoples left on earth who still follow the traditional way of life. As the world's cultural diversity shrinks, the struggle of the Yanomami to survive reflects a broader trend. Endangering the world's biodiversity as well, profit is always the enemy. In the case of the Yanomami, the industrialized nations' greed means gold. During the 1980s *garim-*

peros (wildcat gold miners) by the thousand began streaming into Yanomami territory; already by the early 1990s—as the military and police closed their eyes, and as FUNAI (Brazilian National Indian Foundation) powerlessly looked on—over 120 illegal landing strips had been cut through their land. The *garimperos* brought with them malaria and other diseases, and their quest for gold invited ecological catastrophe. Mercury, a toxic heavy metal used to separate gold from ore, contaminated the region's rivers, streams, and groundwater, poisoning the Yanomami through the food chain. And what becomes of the *garimpero* gold? According to a report issued by the World Watch Institute in 1993, 85 percent of the precious metal is fashioned into commercial jewellery —worldwide, a total of some 2,550 tons annually.

Violence rules the last frontiers: the genocide of tribal peoples is never a reason to invoke an emergency session of the UN Security Council. In July 1994, Davi Kopenawa, a spokesperson of the Brazilian Yanomami who appeared in Geneva before the UN Working Group on Indigenous Peoples, said: "The land of my people is the last that you will overrun. This is the last invasion. First the Indians suffer, and then so too will the whites. For then you will be swallowed by war."

C. B.

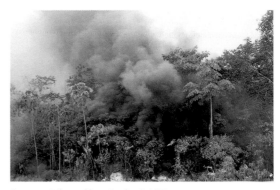

Amazon rainforest ablaze, October 3, 1997.

THE RAINFOREST BURNS. Satellite photos document the unrelenting deforestation of the Amazon basin. For years we have watched and done nothing. The burning continues, destroying the land of the rainforest dwellers. Entire ethnic groups are massacred—for only then is their territory recognized as empty, unpopulated, ripe for plunder. Often, missionaries are the lone whites who act without compromise on behalf of the threatened peoples.

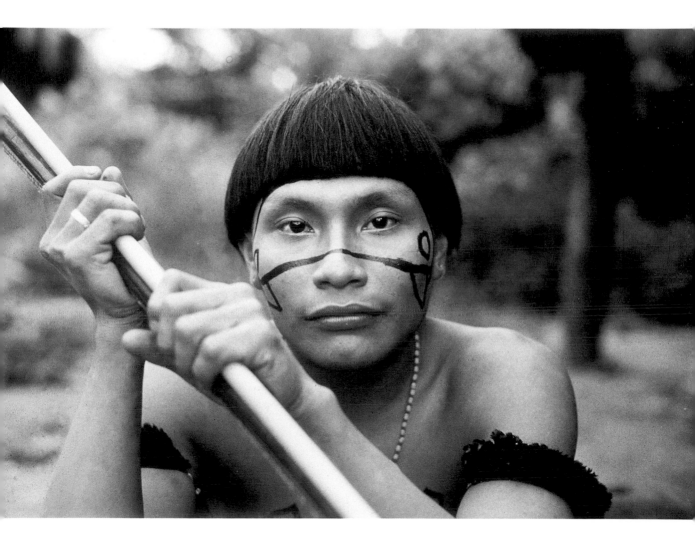

NUCLEAR DISASTER IN CHERNOBYL
April/May 1986 Ukraine, USSR

Sweden's Fosmark nuclear power plant registered a marked increase in atmospheric radioactivity on April 28, 1986. Twelve hours later the Kremlin announced that a fire had broken out in Chernobyl's Unit 4 reactor on April 26, that the fire had since been extinguished, and that the local population was being evacuated.

A photograph taken from the dark of transport helicopter discloses the ruins of one of our nuclear society's temples of energy. With his Geiger counter, a scientist in white protective clothing is measuring the levels of radioactivity issuing from the danger zone following the Chernobyl nuclear disaster, the worst accident in the history of nuclear power.

The chain of events leading up to the accident revealed yet again that nuclear technology allows no room for human error: one simple mistake can edge the world to the brink of disaster. The Chernobyl Power Complex, built around two type RBMK-1000 reactor pairs, had been in operation for twenty-five years; the damaged reactor, Unit 4, had gone on line in 1983. The Soviet-designed RBMK is a graphite-moderated pressure-tube reactor capable of producing 1000 megawatts of power. The graphite moderator enclosing the fuel rods slows down the neutrons released during fission and controls the nuclear chain reaction. Steam generated from the water coolant turns the turbines. Reactor power levels are steered by neutron-absorbing control rods inserted into the core.

The reactor's emergency cooling system was shut down during a test to determine whether cooling of the core could be ensured during a power-loss scenario. Additional emergency systems were also shut down. At 1:23 a.m. on Saturday, April 26, 1986, the Unit 4 reactor became unstable and slipped out of control. A surge of power caused the fuel rods to rupture: uranium pellets reacted directly with the water coolant, creating a steam explosion that destroyed the reactor core, catapulting the 1,000-ton roof from its anchoring. Water coming in contact with the glowing graphite moderator caused a second explosion and created a graphite fire.

A plume of smoke carried reactor debris and fission particles high into the air. Radioactive clouds spread the catastrophe. Clouds moving towards Moscow were seeded to rain—rain that fell upon the city of Nowosibkov.

More than 5,000 tons of lead and boron were dumped on the open reactor to smother the fire. Containment with a massive reinforced concrete slab required some 400 men working continuously in three-hour shifts over a period of six months. The UN International Atomic Energy Agency (IAEA) authorities in Vienna recorded thirty-one fatalities arising directly from the accident, all of whom were firefighters and plant workers. Even today, the IAEA publishes this number, despite the thousands who have died from thyroid cancer during the years following the accident, and despite the extremely high incidence of cancer in the Ukraine (3 million). According to the 1991 IAEA summary statement: "There are no health deficiencies which can be directly attributed to the radioactive contamination."

The catastrophe bolstered the international anti-nuclear movement but did not lead to a widespread pull-out from nuclear power. Across Europe, scientific determination of acceptable radiation exposure levels—an altogether arbitrary act—differs from country to country. The accident resulted in a change of public energy policy only in Austria: in November 1988, the construction of the Zwentendorf Nuclear Power Plant was abruptly terminated.

C. B.

John May. *The Greenpeace Book of the Nuclear Age*. New York, 1989.
Vladimir Tschernosenko and Joanna Macy. *Poison, Fire, Sacred Earth: Proceedings of the World Uranium Hearing*. Munich, 1993.

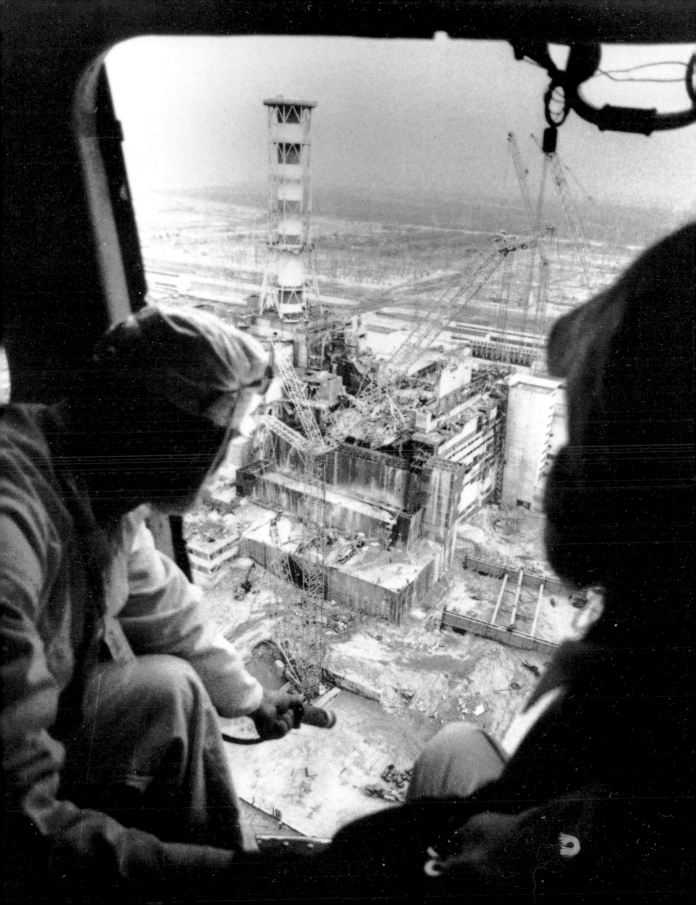

WORKERS IN A SERRA PELADA GOLD MINE

1986 Pará, Brazil

Photographer: Sebastião Salgado

Every day during the dry season between September and January, 50,000 men climb into a crater the size of a football field where they dig for gold in a vertical pit. Brazil has issued individual prospecting licenses, each for an area of 20 square metres (approximately 200 square feet).

The scene is reminiscent of Dante's *Inferno* or medieval images of the Last Judgment. The dizzying angle of the panorama reveals working conditions that call to mind the building of the Babylonian ziggurats or the Egyptian pyramids by armies of workers. Because of the difficult terrain, no machinery is used in the pit. An average of ten men work each plot *(barranco)*: faceworkers, bearers, and supervisors. The bearers carry the excavated material in sacks to the upper levels, climbing rickety wooden ladders that defy all safety standards. At the top, each sack is counted and marked in a ledger. The workers receive twenty cents for each sack. When gold is found, the licensee pays 10 percent of the value to the co-operative. Supervised by the Pará militia, the mineworkers *(garimpeiros)* earn slightly more than their supervisors do. Sebastião Salgado, the photographer, recounts: "There was often tension between the two groups. As representatives of the power of the state, the policemen, already earning less, were determined not to have less prestige as well. Sometimes they drew their weapons during a dispute and fired, to which the workers responded by throwing rocks." But even without such conflicts, deadly accidents are daily occurrences.

As the price of gold soared in the 1980s, Brazil was gripped by gold fever. Nearly half a million people rushed to the Tocantins Valley in search of gold. At the height of the boom in 1987, 90 tons of gold were officially mined. The mercury used in prospecting rendered vast areas uninhabitable and threatened the lives of indigenous peoples (see p. 152).

Salgado—always more interested in creating a sequence of images rather than individual shots for his social reportage—included photos from the Serra Pelada gold mine in his 1997 book *Terra*, devoted to documenting the misery of the roughly 5 million landless people in Brazil. A full 40 percent of Brazilians live in poverty. Four successive presidents promised land reform, but a corrupt police force and the private armies of the landowners persist in maintaining the status quo, sabotaging any legislation that would offer even minimal improvement in living conditions. In *Terra*, José Saramago speaks of "ongoing, systematic, and cruel persecution, which has claimed 1,635 victims between 1964 and 1995 and has added grief to the misery of the rural workers in all states of Brazil." The search for gold offered an alternative source of income to the landless. Throughout the 1980s they streamed from the north and northeast to try their luck in the Serra Pelada. As Salgado says, "While it's true that no one was forced, they all became slaves to the dream of making a fortune, and the necessity of enduring inhumane living conditions to achieve that dream. Once caught in the vicious circle, it was impossible to escape." The Serra Pelada gold mine no longer exists as it is shown in this photograph; today, gold is mined with heavy machinery. P. S.

Sebastião Salgado, with an introduction by José Saramago and poems by Chico Buarque. *Terra: Struggle of the Landless*. London, 1997.

SEBASTIÃO SALGADO (born in 1944 in Brazil) is one of the most dedicated contemporary documentary photographers. After studying economics and agriculture, he worked for the International Coffee Organization in London before turning to photojournalism in 1973. Salgado became an associate member of the Magnum agency in 1979 and a full member in 1984. He left Magnum to found his own agency, Amazonas Images, in 1994. *Other Americas* (1986), *Sahel: Man in Distress* (1986), *An Uncertain Grace* (1990), *Men at Work* (1993), *Terra: Struggle of the Landless* (1997), and *Exodus* (1999) are among Salgado's many projects.

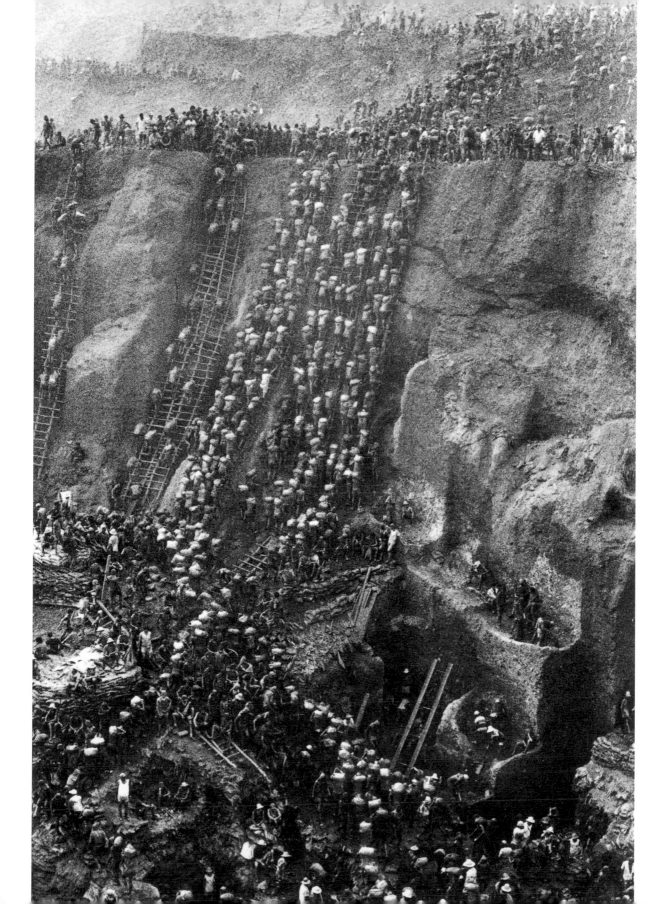

THE INTIFADA
December 12, 1987 West Bank

On December 12, 1987, during a shopkeepers' strike, violent confrontations erupt again with the Israeli authorities. Stone-throwing youth began the Intifada, the insurrection of the Palestinians in the Israeli-occupied territories, on December 8.

A group of young people throw stones in the town of Nablus, their postures and gestures clearly aggressive. The street becomes a battleground between the youth and the police.

Against the backdrop of houses, some barricaded, the crowd moves along the narrow street towards the photographer, who captures the whole group in a modern battle photograph. They carry in their midst the Palestinian flag. The composition is a distant echo of Eugène Delacroix's *Liberty Leads the People*, which is also centred on a storming crowd carrying a flag forward.

Four years after the Yom Kippur war of 1973, Anwar el-Sadat, the president of Egypt, visited Menachem Begin, the Israeli prime minister, in Jerusalem. This visit led to the 1978 Camp David peace accord between Egypt and Israel. Contrary to the agreement, however, the conservative Begin government moves ahead with new settlements in Gaza, which Israel had occupied during the Six-Day War in 1967, and on the West Bank. In 1982, Israeli troops invaded Lebanon to establish a "New Order" in the Near East. With that, the decades-long political conflict of Israel with its Arab neighbours reverted to the fundamental conflict between Jews and Arabs over the control over Palestine. The first demonstrations by the Palestinians occurred on December 5, 1987, in the refugee camps in Gaza. The participants in this civil disobedience were mostly young men and women motivated by nationalism and calling for an end to the occupation.

The Intifada, which means "insurrection" in Arabic, lasted for five years. In the beginning, the Israeli leadership underestimated its significance but then reacted with sanctions, deportations, and shutdowns. The Intifada reached a tragic climax with the riots of May 1990. All told, 2,200 Palestinians and 200 Israelis lost their lives, and many more were injured. The autonomy agreement, signed in 1993, led in 1994 to Palestinian self-government in Gaza and Jericho. I.L.S.

Zachary Lockman and Joel Beinin, eds. *Intifada: The Palestinian Uprising against Israeli Occupation.* New York, 1989.

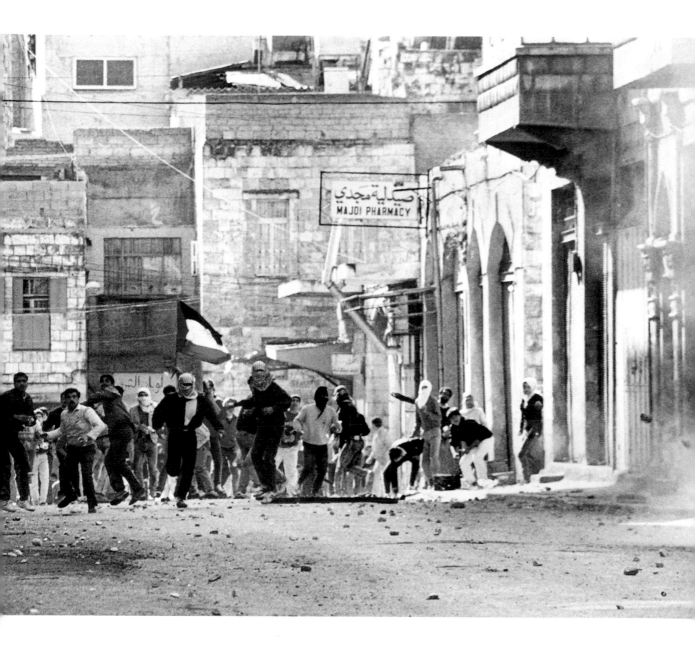

EXXON VALDEZ OIL SPILL
March 1989 Alaska
Photographer: Rob Stapleton

Four minutes after midnight on March 24, 1989, shortly after leaving the Trans-Alaska Pipeline terminal at Valdez, the *Exxon Valdez* runs aground on Bligh Reef in Prince William Sound. Within a few days some 250,000 to 260,000 barrels of crude oil leak from the tanker, contaminating over 2,000 kilometres (1,240 miles) of Alaska coastline. The environmental calamity threatens the traditional fishing economy of the native population.

An aerial photo like so many others of a leaking oil tanker. An accident like so many others, but with one major difference: the *Exxon Valdez* oil spill has the unhappy distinction of being the largest in the history of oil transport. The smaller *Exxon Baton Rouge* strikes anchor to pump the oil from the grounded vessel's cargo tanks. Three-quarters of the crude oil can be recovered. Despite the good weather, the oil boom cutting a swath through the water cannot impede the spread of the oil slick.

The Trans-Alaska Pipeline stretches some 1,300 kilometres (800 miles) from Prudhoe Bay south to Valdez harbour. In operation since 1977, the pipeline has a projected lifetime of twenty years. It, too, invites a future oil catastrophe.

The National Transportation Safety Board determined that the probable cause of the grounding of the *Exxon Valdez* was the failure of the third mate to properly manoeuvre the vessel because of fatigue and excessive workload; the failure of the captain to provide a proper navigation watch because of alcohol impairment; the failure of the Exxon Shipping Company to provide a fit captain and a rested and sufficient crew for the *Exxon Valdez*; the lack of an effective vessel traffic service because of inadequate equipment and manning levels, insufficient personnel training, and deficient management oversight; and the lack of effective pilotage services. The findings deflect public attention from the real cause of the calamity: the *Exxon Valdez*, like 60 percent of ocean oil tankers, has no double hull. Only 25 millimeters (0.1 inch) of steel separate these vessels from the next oil spill.

Exxon financed the cleanup operations at a cost of $2.1 billion over four Arctic summers. Some 10,000 workers were hired to scrub the oil from the rocky shoreline and the wildlife. A civil settlement decreed that Exxon must pay the state of Alaska and the federal government $900 million for the restoration and replacement of injured natural resources. In a class-action suit, Exxon was fined $5 billion in punitive damages, a settlement that was to be divided evenly among 14,000 Alaska fishermen and businesspeople, white and native alike. Exxon appealed the verdict; to date, no funds have been paid to the plaintiffs. In the aftermath of the accident, the U.S.-based multinational raised the price of its gasoline products, received $780 million in insurance compensation, and was able to deduct the costs of the cleanup from its corporate taxes.

The international guidelines for oil transport were tightened in 1990, but the so-called tougher guidelines reflect a society that defines itself in terms of profit: older tankers are allowed to travel the oceans for another twenty-five years—not until 2015 must all tankers have a double hull. In the ten years following the accident, Exxon, the world's second-largest oil company, has yet to order a single double-hull vessel. At the same time this company, based in Houston, Texas, projects optimism about the future: in a report issued at the end of 1999, it characterizes the Prince William Sound ecological system as being "healthy, robust, and full of life."

C.B.

John Keeble. *Out of the Channel: The Exxon Valdez Oil Spill in Prince William Sound*. Cheney, Washington, 1999.

Oil-smeared red-necked grebe, Knight Island, March 30, 1989.

THE CRIES OF THE SEAGULLS and ducks smeared with oil could be heard day and night. The *Valdez* calamity killed some 250,000 sea birds (pictured here: a red-necked grebe), 5,000 sea otters, 300 seals, 150 bald eagles, and over a dozen orca whales. Losses to the herring, salmon, and mussel populations are beyond estimation. Native fishermen refer to Easter Friday 1989 as "the day the water died." Only 15 percent of the spilled crude oil could be removed from the coastal environment.

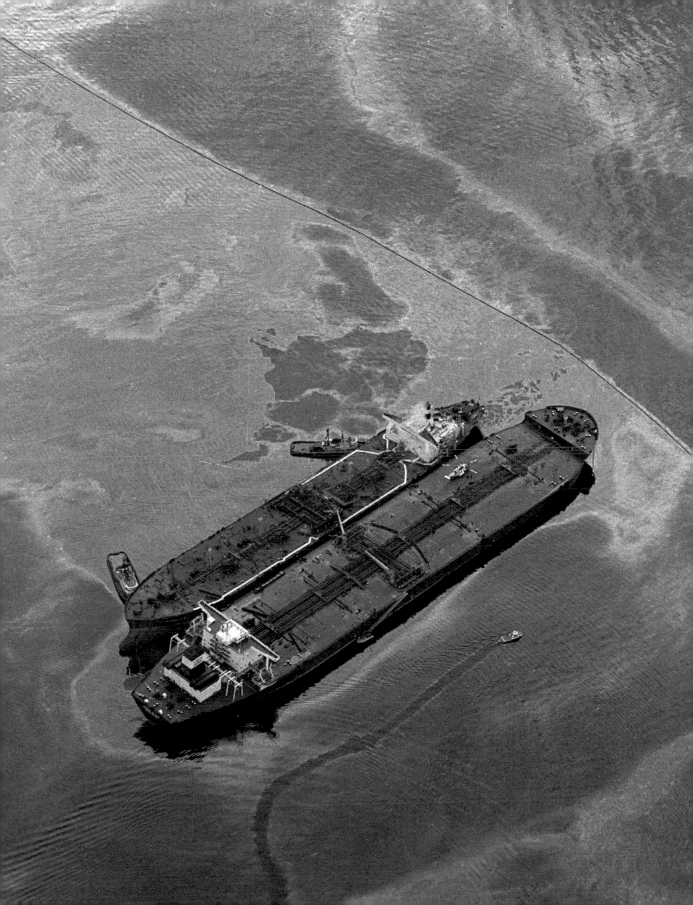

MASSACRE IN BEIJING

June 5, 1989 People's Republic of China

Video still: Jeff Widener

Thousands of students and pro-democracy protesters demanded democratization, human rights, and an end to corruption. Their placards read: "Deng Xiaoping: Thank You and Goodbye," "No more lies," "Never again, Li Peng." As the pressure mounted, the government called in troops from distant provinces. The peaceful demonstration was brutally suppressed.

For the first time the world has dramatic proof of totalitarianism in China, confirming the many clandestine reports that have circulated for decades. This time, the massacre doesn't occur in a remote region where the media have no access. It takes place for all eyes to see in the centre of the capital. The Tibetan genocide (see page 86), the Uigur genocide (which continue as this volume goes to print), the millions of victims of the Cultural Revolution, Xining's labour camps with more than 10 million prisoners, reminiscent of Nazi concentration camps . . . all these stories gain intensity and authenticity in light of the events on Tiananmen Square.

The photograph of a young man stepping into the path of the tanks as they enter Changan Boulevard has become the symbol of the brutal crackdown on the pro-democracy movement in China. Martial law was declared, and on June 4, one day before this scene was filmed, the student rebellion was violently suppressed by the military. Twenty-four hours later, protests have dwindled to isolated attempts, while acts of reprisal and revenge by the students sweep through the city. This scene, which took place at noon, was observed by a television cameraman nearby and was broadcast on stations around the world. A young pro-democracy protester forces a convoy of tanks to a halt on Changan Boulevard. Warning shots are fired, and the young protester eventually gives up. This image doesn't show the executions or the victims, but it does capture the confrontation between one individual and the overpower-

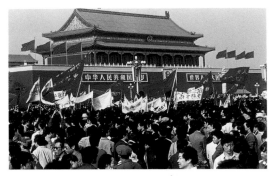

Demonstrations on Tiananmen Square, April 27, 1989.

ing might of the military, technology, and political force. It is a sister image to the famous photograph of the suppression of the Prague Spring (see page 120), albeit more distanced and less emotional.

China made not to release information on the exact number of casualties of the Beijing massacre. The information available on the identity of the man in this photograph is also contradictory—it is not even clear what his name was, or what happened to him after he took his stand. P.S.

Theodore Han and John Li. *Tiananmen Square Spring 1989: A Chronology of the Chinese Democracy Movement.* Berkeley, 1992.

MEDIA COVERAGE FROM BEIJING was severely restricted at the time this picture was taken. Reports filed by international journalists stationed in Beijing were subject to censorship; clearance was given once they had been screened word by word. Martial law prohibited the use of cameras and video cameras, or the recording of interviews. Journalists quartered in the Hotel Peking were under house arrest. However, the restrictions were less successful than the authoritarian regime had hoped. Many photographs and extensive film footage did reach the outside world. In the wake of the massacre—an estimated one thousand dead and thousands more wounded—China was forced to answer to massive international protests, which affected economic relations between China and the international community. Unfortunately, Western nations are only too eager to compete for a share of the Chinese market and all too soon the events that shook Beijing in May and June 1989 were forgotten.

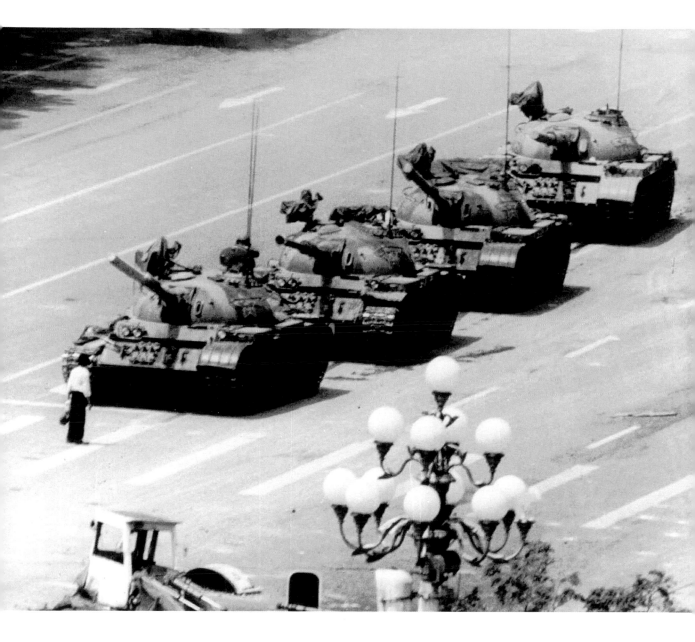

FALL OF THE BERLIN WALL

November 10, 1989

Photographer: Andreas Springer

In a surprise move, the East German government opens the border between East and West Berlin. In no time, large numbers of people gather on the Western side in view of the Brandenburg Gate to celebrate. There are still Soviet and GDR flags flying over the Brandenburg Gate and in front of the Arcades. But at the Wall, and even on top of the Wall, crowds of people are milling about. The menacing stone edifice is replaced by a chaotic, exuberant human wall: the vital symbol of the unification of East and West.

Andreas Springer photographed the people who had travelled through the night to be at the Wall for this historic moment. The oblong shape of the photograph is appropriate—history can rarely be experienced so concretely.

On December 22, 1989, the Brandenburg Gate is opened to traffic. The Wall with its colourful graffiti has been torn down, sold, auctioned off, and buried. For weeks afterwards, people stream to the Brandenburg Gate, reestablishing its central position in the city and turning it into a symbol of the new era.

During the summer of 1989, thousands of East German citizens had fled through Hungary for the West. Demonstrations demanding free elections and unrestricted travel took place in all major East German cities. The Communist system began to falter. On November 9, 1989, a hastily composed press release was issued by Günter Schabowski, secretary to the Central Committee of the East German government, regarding the opening of the border between East and West Berlin and the Federal Republic. This caused a sensation, and people gathered even before daybreak at the crossing points to test the "Interim Directive in Advance of the Proclamation of a New Travel Law."

Alerted by radio and television broadcasts, people from all over Germany poured into Berlin. That very night, masses of people gathered at the Wall. Nothing could hold the people back, and they took the Wall by storm. The city vibrated with excitement. Camera floodlights and car headlights turned night to day. Everyone in the streets knew that they were witnessing one of the great moments of the century.

I.L.S.

Peter Schneider. *The Wall Jumper: A Berlin Story*. Chicago, 1998.

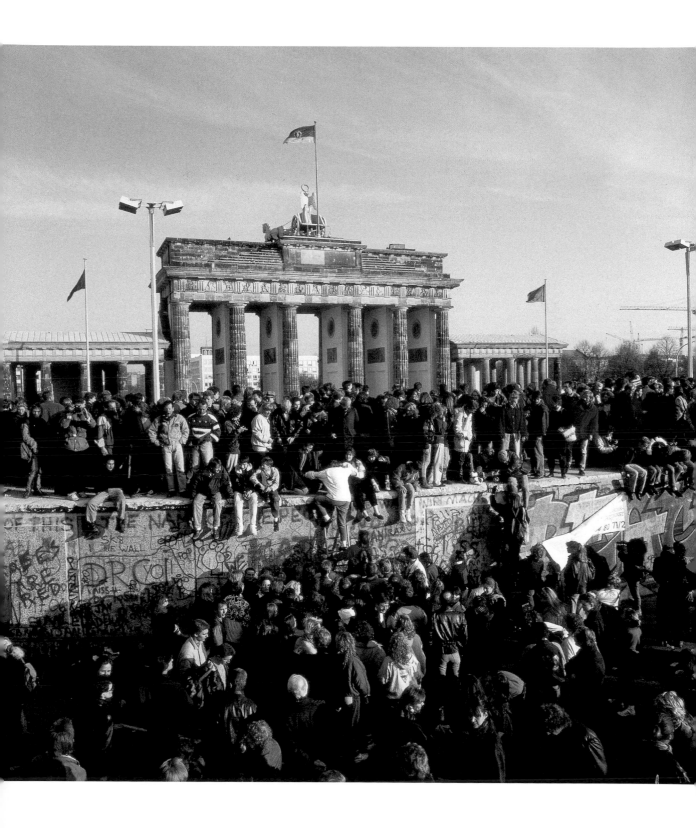

NELSON MANDELA'S RELEASE FROM PRISON
February 11, 1990 Cape Town, South Africa
Photographer: Greg English

Exiled African National Congress (ANC) leader Nelson Mandela walked to freedom as he left Victor Verster Prison near Cape Town. Held in detention by the South African government for twenty-seven years, Mandela's exile to remote Robben Island had been opposed by all Western democracies. There was wide expectation that Mandela would become president of South Africa when the country returned fully to democratic rule. Mandela was accompanied by his wife Winnie, who had campaigned tirelessly for his release.

This photograph of Nelson Mandela and his wife, Winnie, appeared in newspapers all over the world as the international community celebrated Mandela's release from a South African jail. Only one year after the fall of the Berlin Wall and the collapse of communist regimes across Europe, Mandela's release was seen as yet another victory for democracy.

Arms raised in the victory salute, the Mandelas seem to be the epitome of hope and strength. Behind the couple throng their supporters, watchful and less obviously jubilant. The photograph shows that, despite the joy of release and the promise of a reversal in the fortunes of black South Africans, the situation was still tense. The years of imprisonment and solitude have taken a toll on Mandela, who seems frail and aged. But, despite this, it is a photograph full of joy and light, conveying the energy of a country on the move.

Mandela has been photographed extensively during his time as President, becoming something of a media celebrity as he met with the world's stars, anxious to share in the celebration of the changes in South Africa. The promise of a renewed relationship with his wife, suggested so clearly in the photograph, was not fulfilled. Winnie Mandela was accused of corruption and violent crimes committed during the time of Mandela's imprisonment, and the marriage eventually fell apart. Nevertheless, as a moment of high hope and optimism captured on film, this photograph is truly remarkable.

V. W.

Nelson Mandela. *Long Walk to Freedom: The Autobiography of Nelson Mandela.* Boston, 1995.

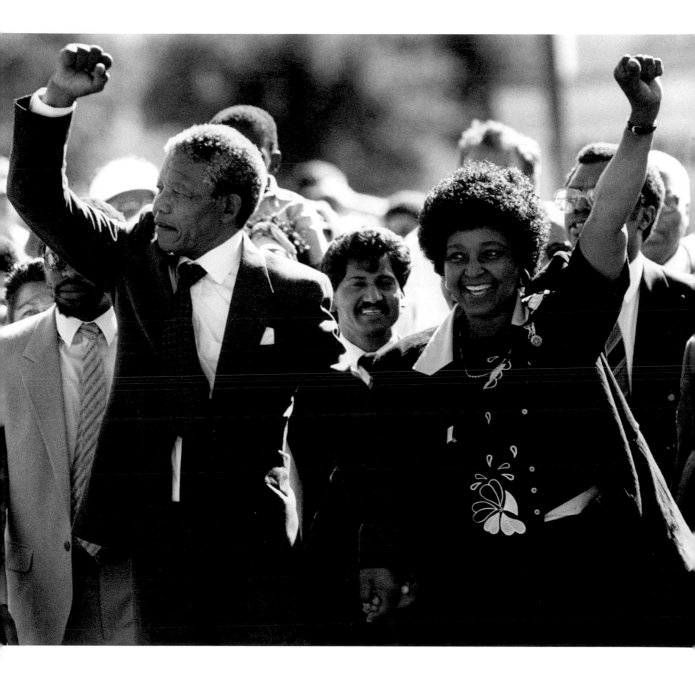

THE GULF WAR

March 2, 1991 Kuwait

Photographer: Michael Lipchitz

Following the expiration of a final UN deadline, Operation Desert Storm was
launched on January 17, 1991 from Saudi Arabia. Carried out by an allied coali-
tion headed by the United States, the military operation was aimed to force
Iraqi dictator Saddam Hussein out of Kuwait, a country his army had occupied
since August 2, 1990.

Barefoot, a worker at an oil refinery kneels on the desert floor
—ground rich with black gold, the fuel of the industrialized
West which brought prosperity to Kuwait, then war. It is Saturday,
March 2, 1991, a few days after the final ceasefire. But no military
accord can extinguish the inferno raging in the background. As
the Iraqi army retreated, it set fire to the oil fields. Not until seven
months later, on November 6, 1991, was the last of the eight hun-
dred burning oil wells finally extinguished.

Operation Desert Storm flew 80,000 missions; roughly that
same number of soldiers and civilians lost their lives in Iraq. Not
since the Second World War had such numbers of troops and
weaponry been assembled: the twenty-eight-nation coalition had
725,000 soldiers; Iraq, some 545,000. The United States had at its
disposal 4,200 tanks, 1,800 fighter planes, and over 100 warships;
at the beginning of the war the Iraqis could muster 4,200 tanks,
3,100 cannons, and 500 planes. Casings bearing depleted uranium
enhanced the penetration of U.S. shells. Today, the Kuwait-Iraq
border is saturated with the scrap of such shells, a radioactive
menace threatening the health of the local population.

Washington shied from no trick to make the war palatable to
the U.S. public. When a bombardment of Baghdad killed hundreds
of civilians in an air-raid shelter, the Pentagon issued statements
maintaining that the bunker had been used as a military headquar-
ters. After the forty-two-day war, it was disclosed that the "baby
murders" attributed to the Iraqi army had been a fiction dreamed
up by an American advertising agency. Kuwaitis had hired the firm
to spread anti-Iraqi horror stories. The public was led to believe
that occupying soldiers had snatched fifteen premature infants

from their incubators and dashed them to the floor. As an "eyewit-
ness" to the atrocity, the agency used the daughter of the Kuwaiti
ambassador to the United States, a woman who belonged to the
Shabahs ruling family. A "chief physician" at a Kuwait City hospi-
tal spoke of seventy additional baby murders. He turned out to be
a dentist living in the United States who had somehow found his
way to Kuwait and onto the advertising agency's payroll.

The Gulf War was one of the most senseless military conflicts
of the last hundred years. It brought no solutions to the Gulf
region; instead, the war compounded political differences and
exacerbated environmental problems. Even before the outbreak of
the war, it was apparent to the world that the diplomatic mission
of the UN was powerless to modify the collision course between
Saddam Hussein, the power-hungry dictator anxious to consolidate
his country's position in the region, and U.S. president George
Bush, with his vision of a new world order.

Former U.S. attorney general Ramsey Clark, who today is a
prominent human rights attorney, offered the following analysis
of Operation Desert Storm: "The Gulf War did not take place to
restore the sovereignty of Kuwait, but instead to maintain Ameri-
can hegemony over the Persian Gulf and to secure access to the
region's stores of oil." An International War Crimes Tribunal
assembled by Clark found the United States guilty on nineteen
counts of violating international rights. C. B.

Ramsay Clark. *The Impact of Sanctions on Iraq: The Children are Dying*. New
York, 1996.
John R. MacArthur. *Second Front: Censorship and Propaganda in the Gulf War*.
Berkeley, 1993.

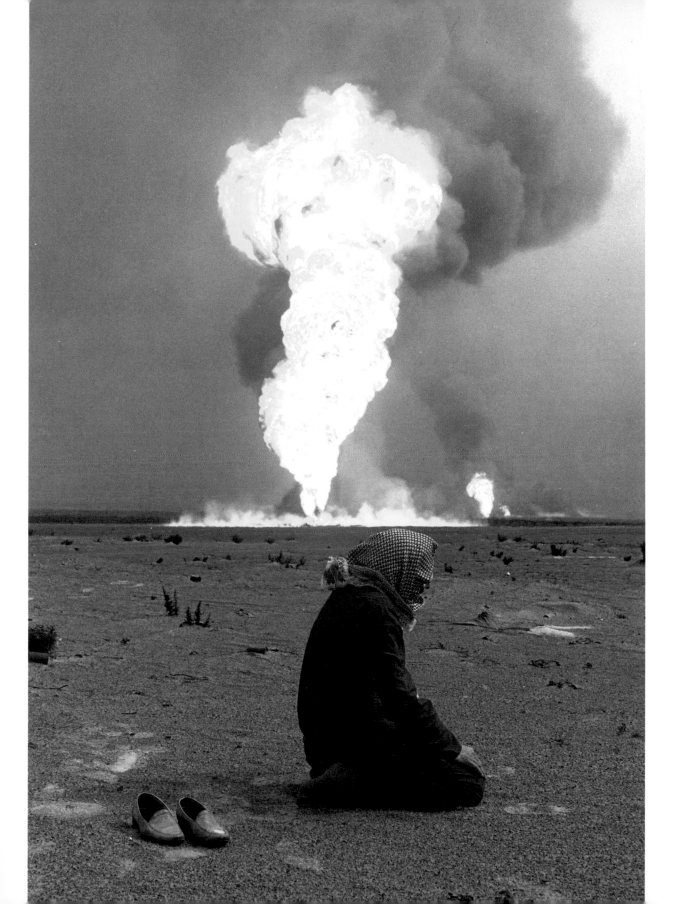

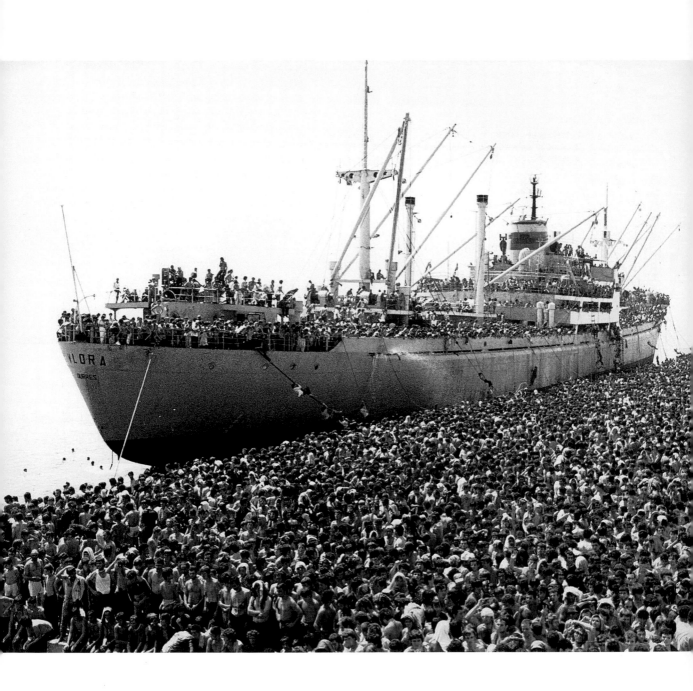

ALBANIAN REFUGEES

August 8, 1991 Bari, Italy

Photographer: Luca Turi

As Albania descended into armed anarchy in 1991, refugees fled to southern Italy, including these people who sailed to Brindisi from the Albanian port of Durazzo on a hijacked ship.

This picture recalls Weegee's photograph of a holiday crowd on a beach at Coney Island from the *New Yorker* magazine. There is the same extraordinary mass of humanity on a hot, sunny day by the sea. But where Weegee's crowd was happy, this one is anxious and creates anxiety in the viewer. Since the dismantling of the Soviet Bloc in the late 1980s, the boundary between western and eastern Europe has ceased to exist, but the West has not faced up to what that means. Instability and comparative poverty have led to huge movements of people westward and across Europe. The more affluent states refuse to acknowledge the permanence of this new migration.

This photograph of people fleeing Albania, an unstable country that was unable to feed itself following an economic crisis produced by speculation, might stand for many other recent waves of forced migration, and the image of a massing of people, a sea of people, sums up the anxiety such "floods" of humanity—as the leader of the British Conservative party recently called refugees —provoke. Yet this is a picture anyone can empathize with. It is an image of hopeful, democratic humanity, and the comparison with Weegee is not coincidental. These are the same "huddled masses" who emigrated to America from Europe at the beginning of the twentieth century. Today the movement is from impoverished Europe to rich Europe, postcommunist Europe to democratic Europe. This picture's significance is not yet decided. It will be part of the history we make. J.J.

Anita Böcker. *Asylum: Migration to the European Union*. Nijmegen, 1997.
Craig Donellan, ed. *Refugees and Asylum Seekers*. New York, 1999.

TUTSI GENOCIDE

July 1994 Rwanda

Photographer: James Nachtwey

President Juvenal Habyarimana was killed when his plane was shot down over Kigali, Rwanda's capital city. Within hours of the crash, civil war broke out in the small African country. Hutu militiamen slaughtered nearly a million Tutsi. Three months later the civil war turned in favour of the Tutsi, and hundreds of thousands of Hutu fled before the Tutsi army, crossing the borders into neighbouring Zaire and Tanzania. In November 1994, the UN establishes the International Criminal Tribunal for Rwanda (ICTR).

This man is a Hutu: machete scars run so deeply through the skin that they seem to divide the skull into three segments. When Radio des Mille Collines, the government radio station, urged the Hutu people to wipe out the Tutsi minority, he refused to take part in the slaughter. Soldiers with machetes decided to teach him a lesson. One deep thrust injured his larynx, rendering him mute—with his left hand he covers the wound. The photograph voices his silenced cry. James Nachtwey, a Magnum photographer, encountered the maimed man at an International Red Cross Hospital in July 1994.

The Tutsi and Hutu were engaged in a barbaric tribal war —or such was the message broadcast by the media. But the intense rivalry between these two clans living near Africa's Great Lakes has roots in the colonial period. The Tutsi and Hutu are related, speak the same language, spring from the same traditional lands. Following the German occupation of Rwanda from 1890 to 1916, the League of Nations transferred the colonial mandate to Belgium. To secure colonial authority, Belgian officials, working hand in hand with the Catholic clergy, co-opted Tutsi support by extending special privileges to the clan. Suddenly the Tutsi, who made up only one-tenth of the entire population, became the local nobles. They were considered by the Europeans to be members of the more athletic and intelligent "race."

When the Tutsi requested Rwandan independence after the Second World War, Belgian officials labelled the clan a communist threat and struck up an alliance with the Hutu. The move sharpened ethnic tensions, launching between the two "races" a hateful spiral of blood feuds. Once Rwanda was granted independence in 1962, the Hutu government under Grégoire Kaybanda, embracing the politics of segregation, pushed the Tutsi onto reservations; no army, police, or administrative position could be occupied by anyone other than a Hutu. After a successful coup placed him in power in 1973, Habyarimana followed the same policies. Reciprocal massacres mar to this day the history of Rwanda—the 1994 Tutsi genocide is distinguished in this chronicle solely by its magnitude.

"We had instructions not to use the word 'genocide' or else the Convention of December 9, 1948, would require us to intervene," reported Boutros Boutros-Ghali, the UN general secretary at the time of the massacres. "Unfortunately no one was interested in a war taking place in the remotest part of Africa, an area where there wasn't even any oil." Also admitting to the failure of the international community to respond are U.S. president Bill Clinton, U.S. secretary of state Madeleine Albright, Boutros-Ghali's successor Kofi Annan, the Belgian Senate, and the French National Assembly.

C. B.

René Lemarchand. *Burundi: Ethnocide as Disourse and Practice.* Washington, D.C., 1994.
Gérard Prunier. *The Rwanda Crisis.* New York, 1995.

SOME 700,000 HUTU REFUGEES fled from the Uganda-based Tutsi troops to the neighbouring countries of Zaire and Tanzania, where 50,000 died of cholera and dysentery. The butchers had become the victims; the exodus broadcast to the world the message that the Hutu were being repaid for their extraordinary crimes. The fresh human tragedy almost erased from memory the acts of genocide. In the meantime, often kept under inhumane conditions, thousands of Hutu filled Rwandan jails.

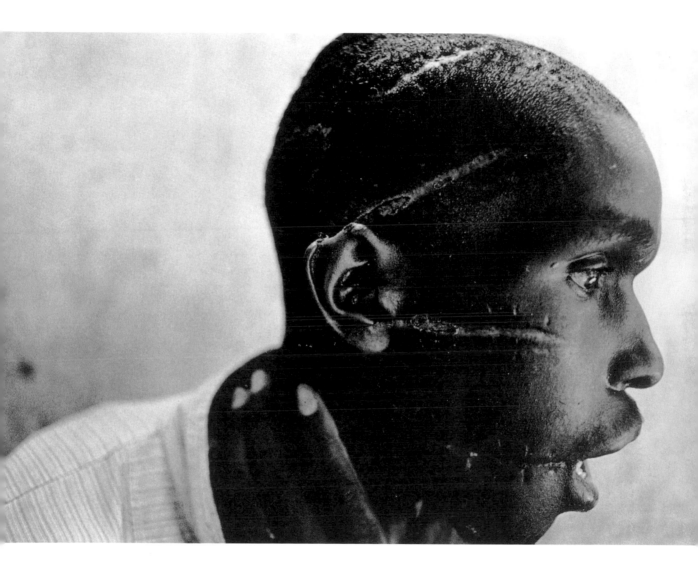

GREENPEACE CONFRONTS SHELL OIL

June 16, 1995 North Sea, Great Britain

Photographer: David Sims

In the North Sea 190 kilometres (118 miles) north of the Shetland Islands: a water cannon from a Shell oil rig fires at the crew of the *Rainbow Warrior* to stop them from delivering supplies to activists on the rig. Greenpeace had occupied the rig two weeks earlier in protest against Shell's plans to scuttle it.

A war of nerves on the high seas: a multinational oil company decided to tow an offshore oil rig into the Atlantic with the intention of scuttling it there in blatant disregard of the environmental risks involved. Concerned citizens mounted a media campaign to protest the imminent environmental crime in the hope of mobilizing a wider public. Their boycott of gas stations soon proved effective: at the height of the campaign Shell marked a drastic drop in revenues, especially in Germany, and this forced the company to revise its plans. On June 20, 1995, Shell announced that it would dismantle the *Brent Spar* rig on land instead. Three years later the OSPAR (Oslo-Paris-Commission) environmental ministers from fifteen member states voted unanimously to ban the sinking of offshore rigs, a decision opposed by multinational oil companies from the U.K. and Norway.

In addition to coverage on television and in the daily press, photographs like this one contributed to the increase in public support for Greenpeace. In this image, a six-man crew dressed in oil slickers in a tiny inflatable boat confronts a rusting steel giant: clearly, this was no pleasure excursion in a yacht. The smoke- and oil-stained rig looks dangerous and threatening, as does the pitch-black sea. Appealing images of brightly coloured offshore installations sparkling in the sun—skilfully produced by commercial photographers and commonly used by manufacturers and distributors in advertising brochures—were powerfully contradicted in these shots of the Greenpeace protesters. Here, David fought against Goliath, and in the end forced the oil giant to his knees. P.S.

Tony Rice and Paula Owen. *Decommissioning the Brent Spar.* New York, 1999.

AS A RESULT OF MISGUIDED ENERGY and transportation policies, oil and gas continue to fuel the industrial nations. It follows that multinational oil companies are among the greatest economic forces in the world. The French company Elf Aquitaine, for example, was powerful enough to exert direct control over governments in some African countries. Nigeria's leading oil company, Shell, is responsible for severe environmental damage in a region that is home to the Ogoni of the Niger Delta. With the sinking of the *Brent Spar* offshore drilling rig, 130 tons of waste, some of it toxic, and 100 tons of oil would have been spilled into the Atlantic. The dumping of diluted acid, the combustion of toxic waste on the high seas, and the sinking of nuclear waste count among the environmental crimes of the twentieth century (see p. 160). Some 400 offshore oil rigs are scheduled to be scrapped in the North Sea in the coming years. Even now, the pollution that surrounds these platforms is so severe that at least 5,000 square kilometres (2,000 square miles) of ocean floor are buried in sludge, destroying the ocean habitat.

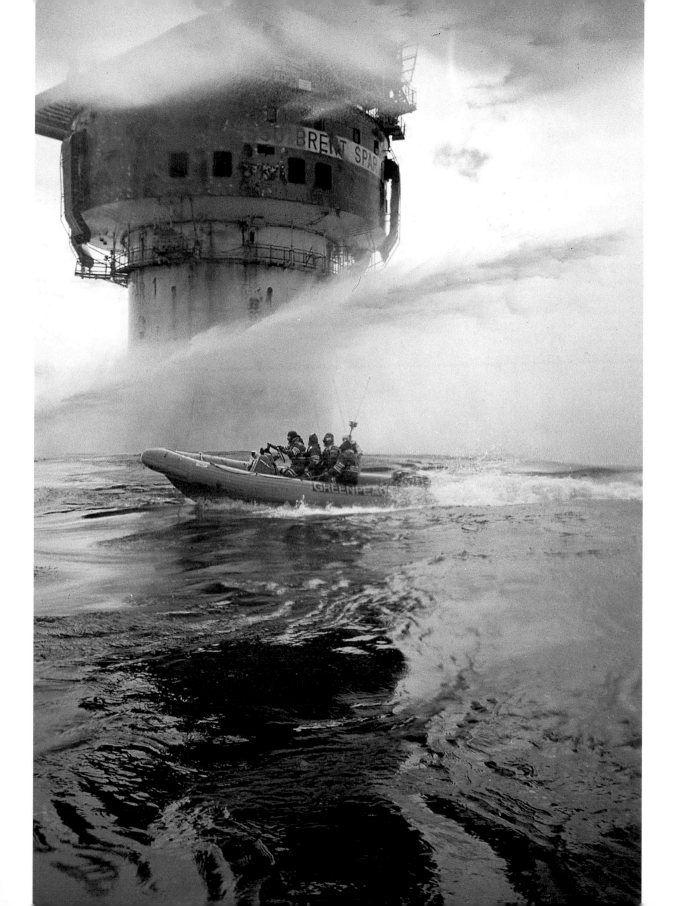

MUSLIM EXPULSION

July 13, 1995 Bosnia

Photographer: Nick Sharp

Srebrenica is overrun by the Bosnian Serb army on July 11, 1995. Over 20,000 Bosnian Muslims are forced to take flight from what had been the world's first United Nations Safe Area. The Serbs detain 8,000 men and boys. Over a period of five days they are systematically massacred.

Exodus: survival is the sole wish of these refugees. They take with them only what they can carry. Wheelbarrows are used not for toting possessions, but to transport the most frail towards safety —assuming the escape route remains passable. The refugees trust in Allah—the UN has forsaken them. They have endured four years of bombardment and near starvation. In Srebrenica they have left behind their homes, possessions, and murdered friends and family members. They are fleeing towards the eastern boundary with Bosnia-Herzegovina, from a village called Potocari to a Muslim-occupied town called Kladanj, near Olovo. The refugees number 20,000. Nick Sharp took this photograph on July 13, 1995.

Yugoslavia's collapse began in 1980 with the death of President Tito and was hastened by Gorbachev's perestroika in the Soviet Union starting in 1986. The system of one-party rule was at an end. But the prospect of a federal republic made up of a collective of different ethnic peoples, each outfitted with an individual constitution, did not suit Belgrade. Backed by the army, the new nationalistic government in Serbia, led by President Slobodan Milosevic, propagated the dream of a Greater Serb Republic. Embracing this dream, Bosnian Serb president Radovan Karadzic and General Ratko Mladic left behind a trail of bloody carnage. All three men have been indicted by the UN War International Criminal Tribunal for genocide and crimes against humanity. Many

Bosnians, most of them Muslim, were incarcerated in camps where torture, rape, and execution were a daily occurrence.

Srebrenica is today a synonym for the most brutal case of ethnic cleansing since the Second World War. According to the Women's Movement in Srebrenica, approximately 2,000 women and children remain unaccounted for. That over 8,000 men are buried in mass graves is common knowledge. According to a report issued by the "Society for Endangered Peoples," UN troops from the Netherlands could have limited the genocide "had they not collaborated with the Serbs."

On October 10, 1995, some three months after the Srebrenica massacre, the warring factions in Serbia, Croatia, and Bosnia— under pressure from the United States—agreed to a two-month ceasefire. A short while later, presidents Milosevic (Serbia), Izetbegovic (Bosnia), and Tudjman (Croatia), gathered in Dayton, Ohio, for a series of peace talks. The talks, brokered by U.S. secretary of state Warren Christopher, end three weeks later with the Dayton Accord—an agreement establishing the boundaries between the republics. But to this day the Accord has not been successful in creating the circumstances that would allow more than a million refugees to return to their homes. C. B.

Anthony Loyd. *My War Gone By, I Miss It So*. New York, 1999.

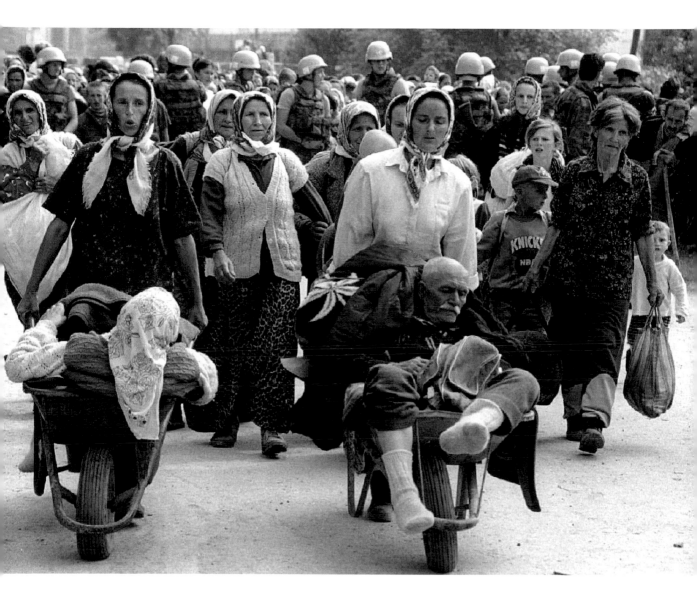

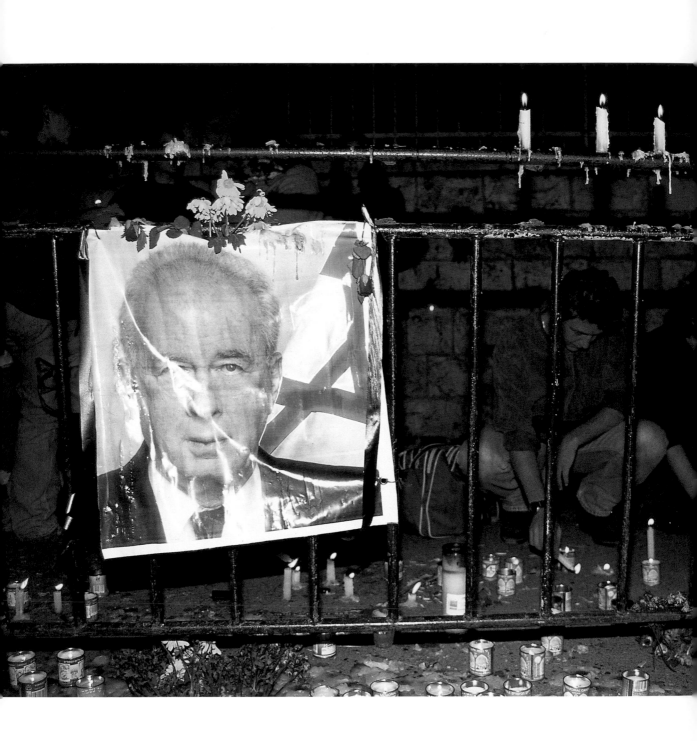

MOURNING YITZHAK RABIN
November 4, 1995 Jerusalem
Photographer: Joerg Waizmann

Mourners light candles in front of the house of Yitzhak Rabin on November 4, 1995. During a peace rally earlier that day, Rabin had been assassinated by a right-wing extremist Jewish student.

Joerg Waizmann's photograph centres on a portrait of Rabin. Flowers and candles surround it, conveying the atmosphere of deep sadness that followed his death. Two students kneel behind the barrier and light fresh candles: an image of reverential calm and silence. Others stand in the shadows on the left behind the photographic portrait, deep in conversation. The surface of the brightly illuminated image of Rabin shimmers with refracted light; the alert gaze of the politician draws the onlooker relentlessly into the scene of mourning.

Rabin's assassination during a peace rally in Tel Aviv shocked the world and put the Near East peace process in jeopardy. Rabin's efforts towards accommodation with the Palestinians and neighbouring Arab states had enjoyed a cautious approval by the war-weary population of Israel. The assassination exposed the fragility of the peace process. With Rabin's death, the youth of Israel lost hope for a better and more peaceful future. Throughout the country, sadness found expression in fields of burning candles lit for days and nights on end. I.L.S.

Nathaniel Harris. *Israel and the Arab Nations in Conflict.* New York, 1999.
Dan Kurzman. *Soldier of Peace. The Life of Yitzhak Rabin: 1922–1995.* London, 1998

ZAPATISTA UPRISING IN CHIAPAS

October 10, 1996 La Realidad, Mexico

Photographer: Scott Sady

On New Year's Day 1994, Indian *guerilleros* living in the state of Chiapas rose in rebellion. They occupied five towns and cities, among them San Cristóbal de las Casas with its 80,000 inhabitants. They set fire to the court building and took over city hall. They demanded the resignation of the president, land reform, work, education, and improved health care. The occupiers, declaring war on the Mexican army, called themselves—after Emiliano Zapata, the Mexican revolutionary assassinated in 1919—the Zapatista National Liberation Army.

The *guerilleros* came out of the forest, out of Selva Lacandonia. They are Mayan. In their language the word for forest is also the word for world. The rainforest is their ally; modern civilization with its destructive practices of deforestation, their enemy. They take from their past to give to their future. They fight for the preservation of Mayan culture, and for the traditional territory that makes them Mayan. Their leader is Subcommandante Marcos—a mysterious Mestizo, a pipe-smoker, poet, intellectual (at center in the photograph, shown with a pipe). When not toting a gun, he authors children's books. The Mestizos and the Indians revere this charismatic rebel. The Subcommandante is known to the outside world only by his eyes—before cameras he always wears a dark ski mask pulled down over his face. His public manner is somewhat reminiscent of Crazy Horse, the Oglala-Lakota war chief who never allowed his photograph to be taken. In the photograph we see Commandante Ramona on the right. They are on their way to meet with representatives of the government at the rebel stronghold La Realidad. The next step will be Ramona's involvement in the national congress of indigenous groups in Mexico City, the first time that a member of the Zapatistas from Chiapas will have officially have been allowed to leave the territory.

On November 17, 1983, Marcos and five comrades founded the Zapatista National Liberation Army—EZLN. For ten years the group remained underground. Marcos says: "We were a small band that wanted to change the world in order to confirm to ourselves that it was worth the trouble to do what it was we wanted to do, or what we planned on doing, although we didn't know at the time that one day we would really do it." On January 1, 1994, the time to do it arrived. The enemy of the Zapatistas is the Institutional Revolutionary Party (PRI), which—sometimes by manipulating election results—had remained in control of the government since 1929. The government answered the Indian uprising with bombs. Both sides suffered casualties.

The uprising began as NAFTA—the free-trade agreement between Mexico, Canada, and the United States—went into effect. This was no coincidence, for Subcommandante Marcos understood the role of the Zapatistas within the context of capitalism. He knew that cheap U.S. goods dumped onto the Mexican marketplace would increasingly marginalize the lives of poor farmers.

The liberation army took up weapons to promote its policies. Looking to the future, EZLN hoped to enter into a political coalition strong enough to reform the state and culture. The Zapatistas could depend on the support of the impoverished peasant populace—the majority. Don Samuel Ruíz Garcia, the Bishop of San Cristóbal, was also on the side of this indigenous movement. The Bishop stepped down from his position as negotiator, however, when the government refused to enter into a meaningful dialogue with the revolutionaries or to honour the Peace Treaty of San Andrés—an agreement that made some concessions to autonomy. To this day the conflict has moved no jot closer towards a solution.

C.B.

Neil Harvey. *The Chiapas Rebellion: The Struggle for Land and Democracy.* Durham, 1998.
Subcommandante Marcos. *Our Weapon Is Our Word: The Selected Writings of Subcommandante Marcos.* New York, 1997.

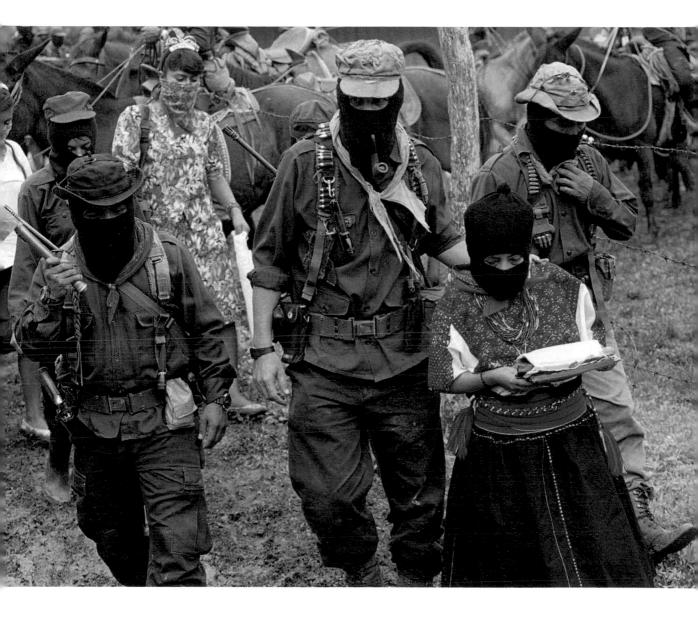

AIDS MEMORIAL QUILT

October 11, 1996 Washington, D.C.

Photographer: Paul Margolies

This may be the quietest and most moving "demonstration" ever to have been mounted in the U.S. capital: over 40,000 quilts are spread across the entire length and breadth of the Mall. Each quilt, 90 x 180 centimetres (3 x 6 feet), is dedicated to a victim of AIDS.

Paul Margolies had to climb into a helicopter to get a full view of the scale of the demonstration. Fascinated by the austere grid created by the quilts, he emphasized the powerful symmetry by focussing on the axis between the Lincoln Memorial and the Capitol. The aerial shot of the park flanked by government buildings conveyed both the power of the demonstration and the scale of the epidemic. Over a million visitors reportedly streamed into the city on that October weekend to view the world's largest communal textile project.

Life partners and parents, siblings and friends worked together to create the quilts. In memory of the deceased, each included small symbols: mementos such as baseball caps, jackets, teddy bears, and other animals; flowers and phrases were sewn onto pieces of fabric that matched the dimension and style of inscription commonly found on tombstones, only more imaginative and far more personal. Thus one quilt bears the inscription: "Michael Scott Welsh, June 15, 1963–Eternity" followed by a poem written by Michael two months before his death: "It's not too late. I'm still alive. Let's celebrate." Eight quilts were stitched together to form larger pieces laid out in strict symmetry with space in between for visitors to walk among the quilts and look closely at each one. The American tradition of the patchwork quilt provided to be the inspiration for the AIDS quilts: groups of people meeting to sew blankets in memory and honour of deserving individuals.

The making of each quilt was an individual act of mourning, but the public exhibition of the combined Memorial Quilt became a political act. The "carpet of mourning and of lost lives" was intended to draw attention to the growing number of victims, many of whom died in great pain. But it also served as a fundraising tool. In the U.S., the protest commemorated 350,000 AIDS victims between the early 1980s and 1996. The event was thus simultaneously an exhibition, memorial service, mass therapy, and religious ceremony. It also sparked protests about the high cost of treatment for individual AIDS patients: the "cocktail" costs $25,000 a year for each AIDS sufferer, far more than most could afford. With its large black population, the U.S. capital was especially hard hit by the disease. Blacks are ten times more likely to be infected than their white counterparts; AIDS became the leading cause of death among blacks between twenty-two and forty-four. The timing of the AIDS Memorial Quilt was perfect: three weeks before the presidential elections, Bill Clinton, Al Gore, and their wives came to visit the Mall and joined in the recitation of the victims' names.

P.S.

AFTER WORLD AIDS DAY marches on December 1, AIDS Rides, and the wearing of red ribbons, the AIDS Memorial Quilt drew public attention to the AIDS epidemic in the United States more than any other awareness campaign had done before. Initiated by the Names Project Foundation in San Francisco in 1987, more than 1,000 full or partial presentations of the collective quilt have been mounted around the world. The initiative was started by Cleve Jones, who had asked the participants in a march organized to commemorate the slain Gay Supervisor of San Francisco in 1985, to write the names of friends who had died of AIDS onto poster-sized pieces of paper. After hundreds of these placards had been attached to the walls of the federal building in downtown San Francisco, the idea for the project was born. In 1987 the first AIDS Memorial Quilt event took place in Washington, with 1,920 memorial panels displayed on an area the size of a football field. Europeans are less comfortable with such public demonstrations of grief.

"The AIDS Memorial Quilt was created out of the unique situation and solidarity among young homosexuals who, in their desperation, consciously threw traditional rituals of mourning overboard." —Christian Becker

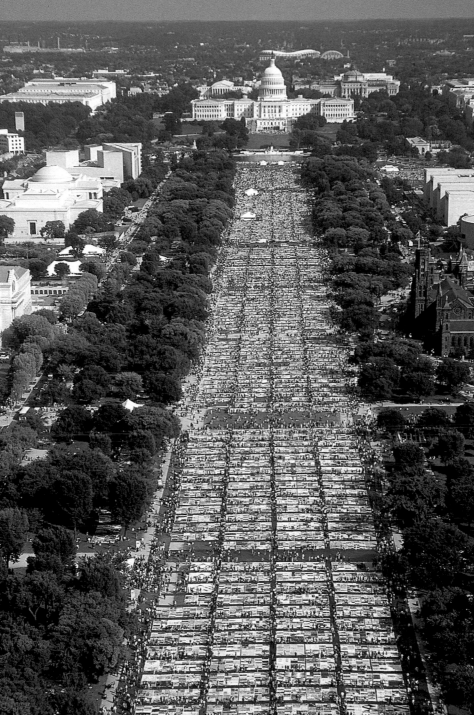

ATTACK ON THE WORLD TRADE CENTER

September 11, 2001 New York

Photographer: September 11, 2001, New York

On the morning of September 11, 2001, nineteen members of a radical Islamist terror network simultaneously hijacked three planes with passengers and crew on board, and flew two of them like gigantic projectiles into the New York World Trade Center and the third into the Pentagon in Arlington, Washington, D.C.; a fourth aircraft crashed in a field southeast of Pittsburgh. Later, the Saudi terrorist leader Osama bin Laden would claim to have masterminded the attacks.

The photo shows United Airlines Flight 175 seconds before impact into the South Tower of the World Trade Center at 9.03 a.m. Eighteen minutes earlier, a Boeing 757, American Airlines Flight No. 11, with hijacker Mohammed Atta on board, had smashed into the North Tower. Carrying tens of thousands of liters of fuel for a flight from Boston to Los Angeles, the jet hit at over 700 kilometers per hour and exploded, setting the building's upper stories on fire. Nearly 3,000 people died in the attack on the Twin Towers. Since the Japanese bombardment of Pearl Harbor (p. 54f.), the U.S. had never experienced an assault of these dimensions on its own soil, and, as in 1941, the government responded with a military counterstrike, first against the Taliban regime in Afghanistan, then against the dictator Saddam Hussein in Iraq.

The photo and video images of what the German philosopher and sociologist Jürgen Habermas once termed "the citadel of capitalism" are textbook examples of the visual fascination of horror. For days, even weeks afterwards, they continued to flicker like an endless loop across television screens worldwide. The pictures taken by accidental eye-witnesses and later by professional photographers and camera people derived their dark fascination from the force of archaic patterns: the fall of the Tower of Babel, the apocalyptic infernos of a St. John of Patmos or a Dante Alighieri, even the skyscraper-snapping of the likes of King Kong. Yet no Hollywood director could have staged this mass murder more spectacularly than the real-life impact of high-tech machines sending fireballs through real mega structures. On September 11, the world of science fiction invaded the real world.

Hiroshima and Nagasaki (p. 68f.), Korea (p. 76f.), and Vietnam (p. 134f.) were thousands of miles distant from America. This time, horror was unleashed in the heart of two of the country's greatest cities, an event unparalleled since the Civil War. Such acts of aggression against places like New York and Washington could not help but be doubly injuring. The victims' death and the pain of the bereaved were as archaic in their depth as the perpetrators' methods were banal. The suicide pilots had taken flight training, purchased tickets, smuggled knives on board, and finally overwhelmed the cabin personnel and flight captains. Despite suffi-

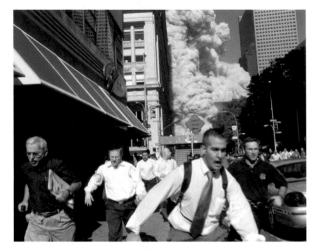

People run from the collapse of World Trade Center Towers, Sept. 11, 2001. Photograph by Suzanne Plunkett.

cient advance warning, sophisticated radar surveillance, and chains of information and command, air defense proved helpless when faced with such pussyfooted schemers.

In the wake of the attacks, Ground Zero became an inexhaustible source of image generation. Every phase of the tragedy was recorded in millions of photos and films, from the collapse of the former tallest buildings in the world and the despairing search for survivors, to the mourning of the bereaved, the candlelight vigils, and the months-long removal of the wreckage. No other human catastrophe had ever had such media presence, day and night, around the globe. New York, the hub of this media activity, became a community united in mourning and anger, and at the same time a gigantic press office, which inadvertently supplied the freshly elected Bush administration with those millions of images which were to help justify the declaration of another war, on those who were supposedly behind the attacks. P.S.

184

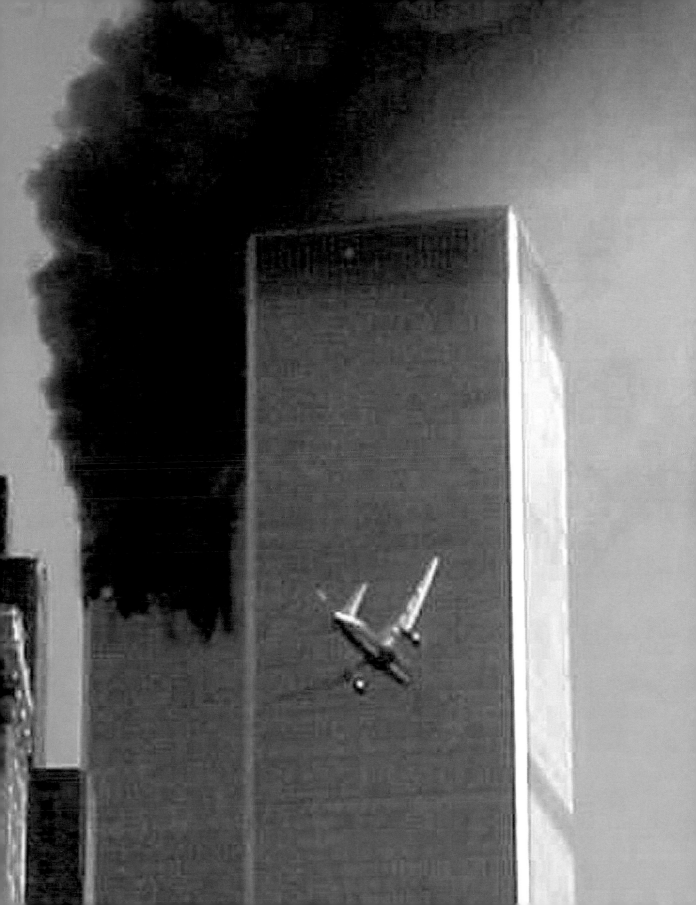

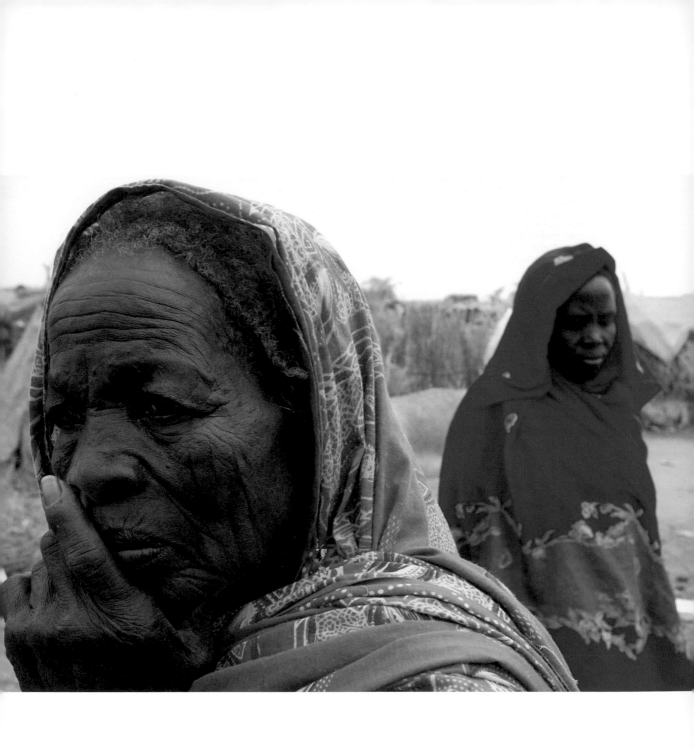

GENOCIDE IN DARFUR, SUDAN

June 30, 2004 Zam Zam Refugee Camp, El-Fashir

Photographer: Karel Prinsloo

The first genocide of the third millennium is proving to be one of the worst in recorded history. Since June 2003 it has been taking place not in front of rolling cameras but hidden from the world's view, in the African hinterland. At the time of writing, it has claimed over 300,000 lives. Darfur is a region in the far west of Sudan, on the border to Chad. For centuries an independent nation, it was annexed in 1916 by Sudan and then systematically marginalized. In 1984-85, 95,000 inhabitants of Darfur already fell victim to a famine. When Islamic fundamentalists came to power in the Sudanese capital, Khartoum, in 1989, the situation gradually began to escalate.

Even journalists are reluctant to visit the scenes of this crime. It is indicative of the tragedy that no photographs of sufficient symbolic force have been made, images that might have brought the events into sharp focus – pictures of the marauding, raping hordes of mounted militiamen who ravaged entire villages leaving a trail of blood behind them. The many photos from the refugee camps only half reveal the horrors involved. This image, taken during UN Secretary General Kofi Annan's visit to camps in Darfur, shows two displaced women in a camp on the periphery of the town E. Fashir in the heart of the Darfur region. The aesthetic "beauty" of the image is deceptive. We cannot see the atrocities these women have witnessed, although we can imagine the lasting wounds they have left behind. This is a timeless image of uprooted lives.

The political turmoil that led to the genocide could not be more confusing, especially since yet another disaster was ravaging Sudan – the war inflicted by the Khartoum regime on the primarily Christian-animistic south, which cost 1.5 million lives (peace treaty signed on January 9, 2005). The Darfur conflict has often been misunderstood as an assault on local, non-Islamic tribes. In fact, the settled population is itself largely Islamized. In face of a campaign of "Muslims versus Muslims," the West initially saw little reason to intervene. In addition, the conflict had been partly fomented from outside, Libya under Ghaddafi having for years attempted to annex Darfur.

In Darfur, as previously in southern Sudan, the Khartoum regime mounted a campaign of air strikes and ground attacks, supported by the Muslim Janjaweed, Arab rider nomads who shrunk from no brutality. The Sudanese army, bolstered by increasing numbers of Janjaweed, at times had a troop strength of 40,000. The scope of the horrors they perpetrated is unimaginable. By late 2004, two million people had fled from terror and devastation. Many of them found refuge in camps in Sudan or just across the border in Chad.

Apart from emergency food supplies, the international measures taken had little effect – military observers from the African Union, and, a premiere for Africa, NATO troops sent in their support. On July 30, 2004, the UN Security Council demanded that Khartoum disarm the government-supported Janjaweed militia, bring those responsible for the genocide to justice, and facilitate international aid measures. Yet war crimes and ethnic cleansing are still occurring on a daily basis. The catalyst of the Sudan conflicts is oil, which is being pumped in the south and is thought to exist in Darfur. The issue of who is to control these resources in the long run – Khartoum or the regions – remains undecided. Apart from religious differences, a racism directed against people of "inferior blood" by Arabs of the Nile Valley is behind this inhumanity to man. P.S.

Gérard Prunier. Darfur: The Ambiguous Genocide, Ithaca, New York, 2005.

UNDERSEA QUAKE IN THE INDIAN OCEAN

December 26, 2004 Koh Raya, Thailand

Photographer: John Russell

In the early morning hours of December 26, a sudden shifting of continental plates on the sea bottom off the northwest coast of Sumatra triggered a tsunami of a violence this region had not experienced in living memory. Many coastlines along the Gulf of Bengal, the Andamen Sea, and South Asia, an especially in Indonesia, were devastated. Over 200,000 lives were lost, and more than 1.7 million people became homeless.

The present photo was taken on the Andamen Island of Koh Raya, off the west coast of Thailand, about twenty-three kilometers from the island of Phuket. Local people and tourists stand behind a building near the shore and, as the palm trees already bend under the strain, seem oblivious of the impending disaster. Only two men in the foreground make their escape before it is too late. It is this painful tension between unsuspectingness and imminent destruction that marks this snapshot by John Russell, a tourist who escaped uninjured. Many other photos of the tsunami show people fleeing in panic before the approaching masses of water, or the hellish scenes of death and destruction left behind by the retreating sea.

It all started with three flood waves that rolled over the coasts in this region. A first, weaker wave was followed by a heavier one that washed wooden houses away, then by a third, devastating wall of water, which the photographer described as "ripping apart the cement buildings like they were made of balsa wood." For the space of a full hour, wave followed upon wave, only gradually diminishing in force. In Thailand nearly 8,000 people lost their lives; in Indonesia – by far the hardest hit, followed by Sri Lanka and India – the death toll was twenty times higher.

The omnipresence of cameras and, since the beginning of the new millennium, cell phone cameras, has enabled the recording of events of this kind literally in the making. "Amateurs" tend to be closer to the crisis than "professional" photographers, who generally do not appear on the scene until the worst is over. In the field of unpredictable disasters, laymen have become sought-after visual journalists, a sign of the advancing democratization of the medium, in which hardly anyone can still claim to possess exclusive rights. In addition, the satellite transmission of visual documents has reduced the factor of physical distance on the earth's surface to a psychological one. Yet while camera technology and mobile communications have become a profitable business whose products even children can operate, the installation of early warning systems for undersea quakes lags far behind state-of-the-art technology. The responsible government agencies, especially in Indonesia, veritably slept through the brewing of the tsunami, and their indolence contributed to making this natural occurrence the devastating catastrophe it became. P.S.

Aftermath of the Tsunami, Phi Phi Islandes, Ton Sai Bay, Thailand, photo Stuart Franklin, Magnum

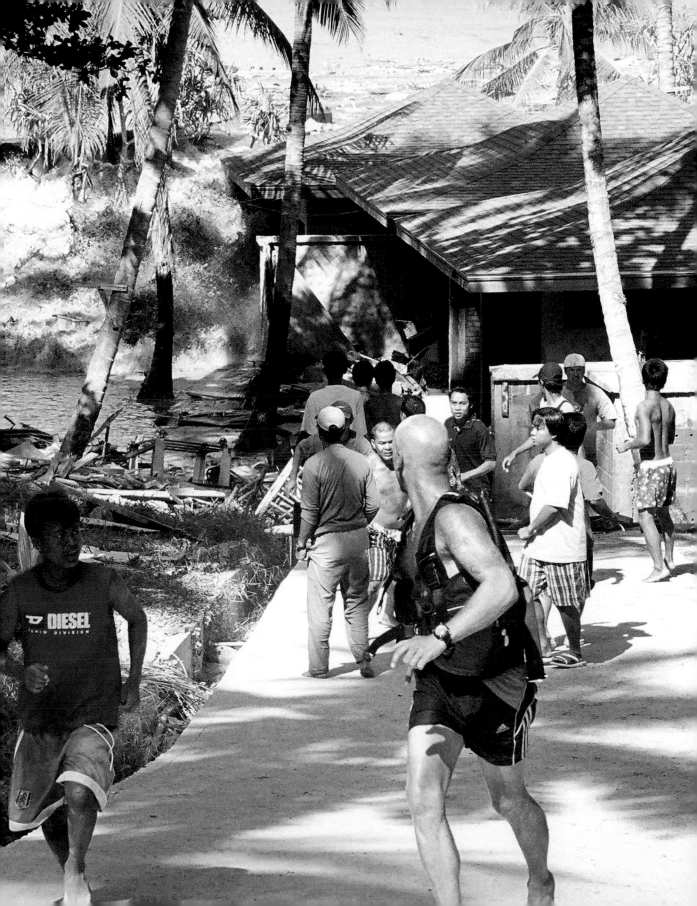

HURRICANE KATRINA DEVASTATES NEW ORLEANS
August 30, 2005
Photographer: David J. Phillip

Although meteorologists had predicted for days that the tropical storm brewing over the Gulf of Mexico would endanger Louisiana and the adjacent states, the evacuation of New Orleans, the coordination of disaster relief efforts in the hurricane's wake, and aid from Washington, were anything but adequate. Disaster management became bogged down in the no-man's land between federal, state and regional competencies as infrastructure broke down and lawlessness spread.

When they established their second Orleans near the mouth of the Mississippi, the French were already aware of the precarious ground on which their new city rose. Ever since, increasing settlement and building caused the ground level inexorably to sink, until areas of present-day New Orleans came to lie meters below the level of river, sea, and nearby Lake Ponchartrain. Miles of dikes, locally known as levees, and sophisticated pump systems were built to keep the city dry, in the full knowledge that these hydraulic measures would not suffice to stop the masses of water a full-fledged hurricane would bring. Experts' warnings that the levees were in urgent need of renovation remained unheeded.

The present photograph of downtown New Orleans, taken from the air shortly before eight o'clock in the morning, reveals the extent of the catastrophe that struck the city on August 28, 2005. Residences stood knee-deep in water, and of the streets, only bridges and overpasses jutted above the flood. The levees had burst at several points, and water from Lake Ponchartrain inundated the city. Eighty percent of its area was flooded, in parts over seven meters deep. Visible in the haze are the skyline and the damaged Superdome, New Orleans' football stadium, where – in addition to the Convention Center – those who had not left, or were unable to leave, the city in time took refuge. Due to the incapability of the city authorities and despite a "Hurricane Evacuation and Sheltering Plan" in force, a whole fleet of school buses at a depot was rendered useless (see illus.). When the situation in the Superdome worsened due to water and electricity cut-offs and rising flood levels, and criminal incidents at the Convention Center multiplied, the remaining refugees were evacuated by bus and airlift to the Astrodome in Houston, Texas, and other locations. The threat of epidemics led to the declaration of a state of health emergency; widespread looting, shots fired at helicopters, and assaults on rescue teams necessitated the proclamation of martial law. A week after this photo was taken, Mayor Ray Nagin ordered the compulsory evacuation of the last of the city's inhabitants.

Although a second hurricane brought further flooding and evacuations, New Orleans was largely dry by the middle of October, despite predictions of the city's ultimate demise. The results were devastating enough. The number of casualties and homeless, not to mention the damage costs, reached astronomical proportions, making every previous U.S. hurricane pale by comparison. But New Orleans will go on. Tourism has already begun to recover, although interest in the famous, largely unscathed French Quarter is now rivaled by curiosity about the districts hit hardest by the disaster. P.S.

Aerial photograph of a school bus depot in New Orleans, September 1, 2005. Photograph by Phil Coale.

Photo credits

© Associated Press, Frankfurt/Main Cover, 15, 54/55, 61, 83, 107, 114/115, 117, 121, 129, 134/135, 137, 141, 147, 160, 161, 163, 167, 169, 170, 181, 184, 185, 186, 190, 191
Courtesy Claus Biegert 136
Bilderdienst Süddeutscher Verlag, Munich 10, 31, 57, 143, 148
Corbis 187
© Teo Allain Chambí 21
© dpa 131, 158/159
© The Estate of Diane Arbus, New York 101
© Focus, Hamburg 50/51, 157, 188
© Greenpeace 175
© Gabriele Herzog-Schröder 153
© Getty Images / Tony Stone 2, 23, 28, 93, 189
© Keystone Pressedienst, Hamburg 22, 71, 81, 92, 111, 113, 123, 150
Dorothea Lange Collection, The Oakland Museum of California 49
Münchner Stadtmuseum, photo collection 101
© NAMES Project Foundation 183
National Archives Still Picture Branch, College Park, Maryland 17
© Reuters 177
Sächsische Landesbibliothek – Staats- und Universitätsbibliothek Dresden 62/63
Courtesy Wolfgang Smuda, Munich 91
© Ullstein Bilderdienst, Berlin 11, 19, 24/25, 26, 27, 32, 33, 35, 36, 38, 39, 40, 41, 43, 45, 47, 52/53, 58, 59, 65, 67, 68, 69, 72/73, 75, 77, 79, 84/85, 87, 89, 90, 94/95, 97, 99, 102, 103, 105, 109, 118, 125, 126, 127, 132/133, 139, 145, 151, 152, 155, 162, 165, 173, 178/179